The Beauty of Zentangle®

In the Garden by Karen Polkinghorne, CZT

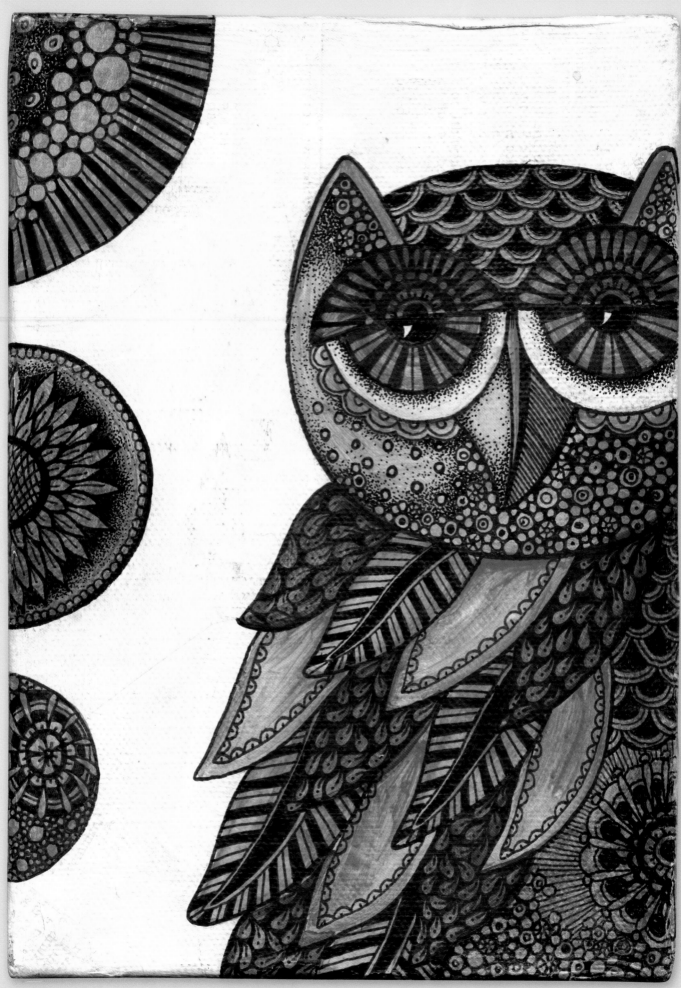

Wise and Tangled Owl by Lorrie M. Bennett

The Beauty of Zentangle®

Inspirational Examples from 137 Tangle Artists Worldwide

Suzanne McNeill, CZT
and Cindy Shepard, CZT

Design Originals

an Imprint of Fox Chapel Publishing
www.d-originals.com

Mooka and Morning Glories
by Helen Williams

ISBN 978-1-57421-718-6

Library of Congress Cataloging-in-Publication Data

Shepard, Cindy.
 The Beauty of Zentangle / Cindy Shepard and Suzanne McNeill.
 pages cm
 Includes index.
 Summary: "Zentangle is fast becoming a worldwide phenomenon, attracting individuals from all walks of life. Created by Rick Roberts and Maria Thomas, the Zentangle method is an easy-to-learn, relaxing, and fun way to create beautiful images by drawing structured patterns. The Beauty of Zentangle celebrates this simple but elegant new craft with hundreds of sensational one-of-a-kind designs from around the world. Selected by the editors of Design Originals, the #1 publisher of Zentangle art, this amazing collection of Zentangle-inspired masterpieces encompasses a wide range of styles. Stunning works are included from breakthrough artists and CZTs like Suzanne McNeill, Cindy Shepard, Marie Browning, Sandy Steen Bartholomew, and many more. Their inventive tangles are at the forefront of a new wave of creative expression and personal freedom"-- Provided by publisher.
 ISBN 978-1-57421-718-6 (pbk.)
 1. Drawing--Themes, motives. 2. Repetitive patterns (Decorative arts) in art. I. McNeill, Suzanne. II. Title.
 NC715.S54 2013
 741.9--dc23
 2013020335

Cover art: *Morning Song* by Lorrie M. Bennet (see page 28).

Back cover art from left to right: *Sampler* by Sandy Hunter, CZT (see page 63), *Black-Eyed Susan* by Sue Jacobs, CZT (see page 65), *Inch by Inch* by Cris Letourneau, CZT (see page 74), and *Postcard* by Penny Raile, CZT (see page 96).

Printed in China
Second printing

Acquisition editor:
Alan Giagnocavo

Copy editor:
Colleen Dorsey

Cover and layout designer:
Jason Deller

Editor:
Katie Weeber

Gallery photographer/scanner:
Scott Kriner

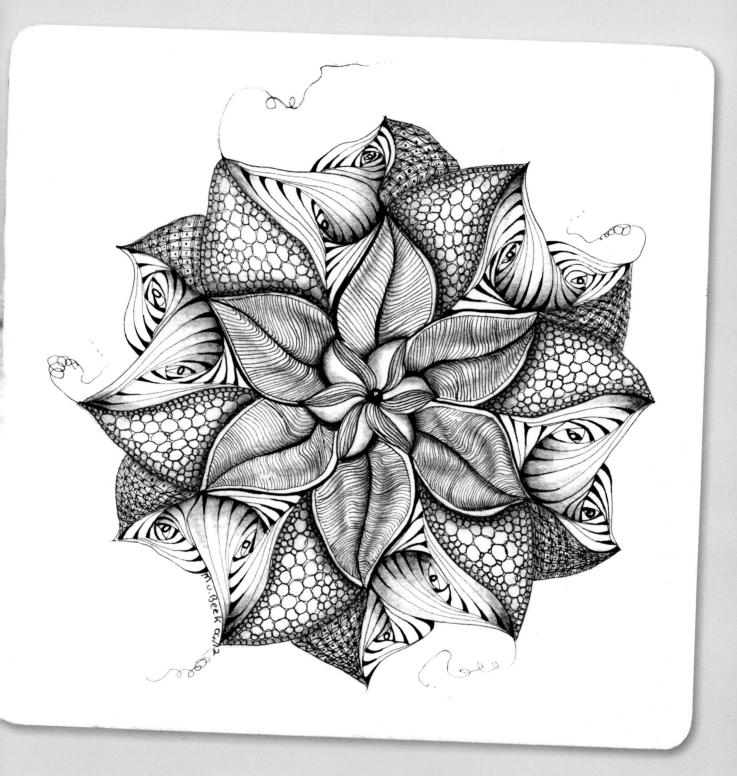

Husband's Love by Marizaan van Beek, CZT

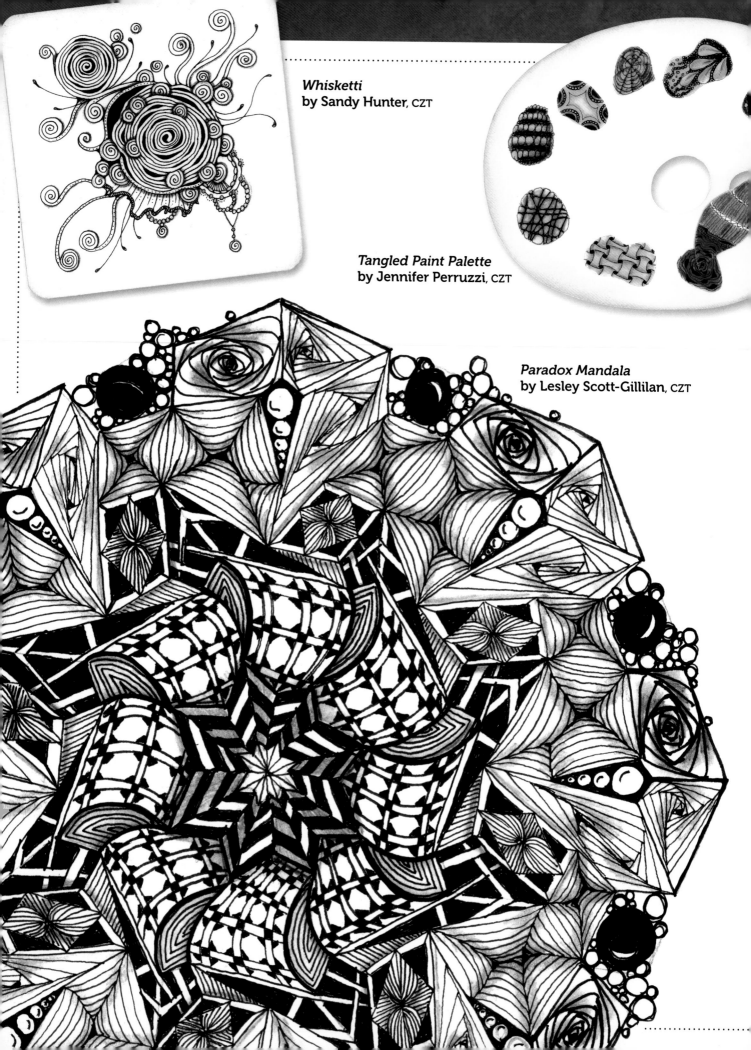

Whisketti
by **Sandy Hunter**, CZT

Tangled Paint Palette
by **Jennifer Perruzzi**, CZT

Paradox Mandala
by **Lesley Scott-Gillilan**, CZT

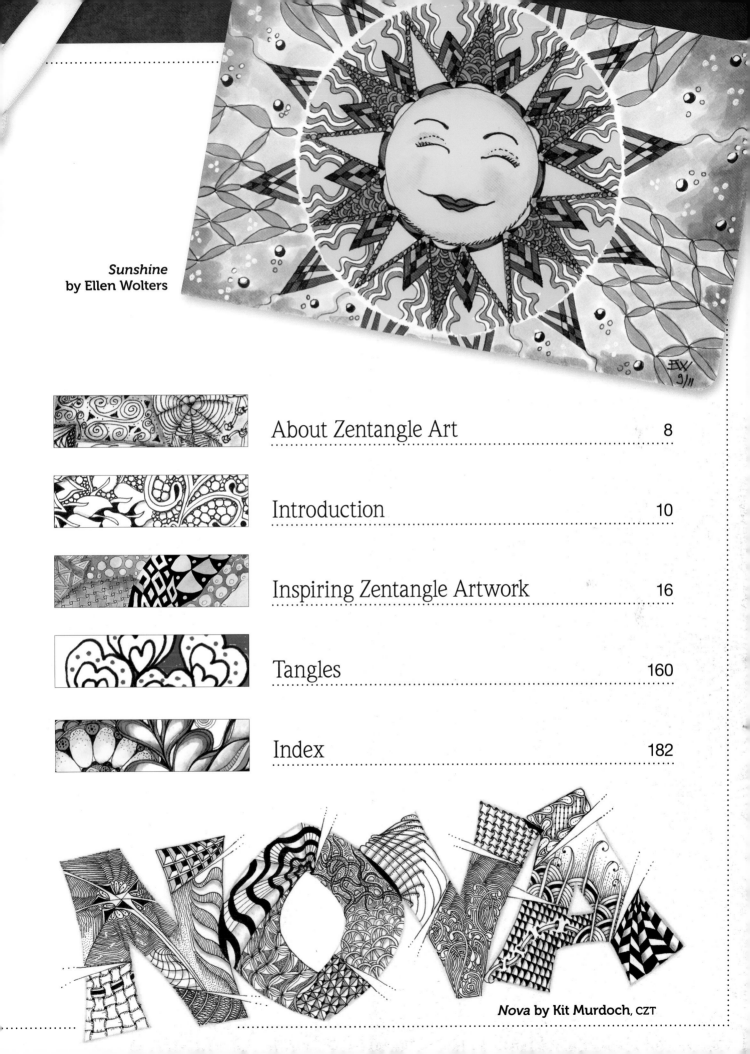

Sunshine
by Ellen Wolters

Nova by Kit Murdoch, CZT

About Zentangle® Art

If you are new to Zentangle, you might not be familiar with some of the terms used throughout this book. Just so we are all speaking the same language, it's good to know some of the terminology used within the Zentangle community:

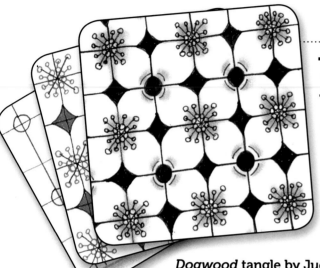

Tangle

Step-by-step patterns to fill Zentangle art

A tangle is a repetitious pattern that is used to fill a space in a piece of Zentangle art. Tangles can be simple two-step constructions or more complicated designs with several steps. Some tangles have little tricks to their construction—at first glance, the designs looks complicated, but when you follow the steps, creating them is actually very simple.

Dogwood tangle by Judy K. Burkett, CZT

Classic Zentangle

Black and white art on custom Zentangle tiles

A true classic Zentangle is created on a custom Zentangle die-cut paper tile, either square (3½" x 3½" [9 x 9cm]) or round (4½" [11.5cm] in diameter), made of Fabriano Tiepolo archival print-making paper. A graphite pencil is used to draw the string on the tile. Tangles and your signature are added in pen (a Sakura black 01 Pigma Micron pigment ink pen is recommended). The artwork is created using the Zentangle method, a series of steps developed by Rick Roberts and Maria Thomas that are designed to focus your attention.

A simple ritual is part of every classic Zentangle piece:

1. Begin by making a dot in each corner of the paper tile with a pencil.
2. Connect the dots to form a border.
3. Draw guideline strings with a pencil to divide the area into sections.
4. Use a pen to draw tangles to fill each section formed by the string. It is ok to leave some areas open.

Artwork created using this method has no top or bottom, so the finished piece can be viewed from any direction.

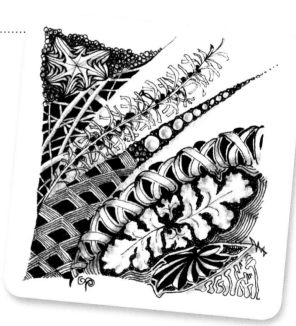

Ribbon by Virginia Dejewska Slawson, CZT

Creative ZIA

Art incorporating tangles

ZIA refers to Zentangle-Inspired Art. This art incorporates tangles, but is not a classic Zentangle. ZIA designs often have a distinct shape. When the outline of a heart or a bird shape is filled with tangles, it is considered a ZIA. Shapes have a top and a bottom, and must be viewed from a specific direction. Adding color to Zentangle art also makes it a ZIA. You will see many color ZIAs from artists in this book. Finally, drawing tangles on larger paper or on an object also makes the finished piece a ZIA.

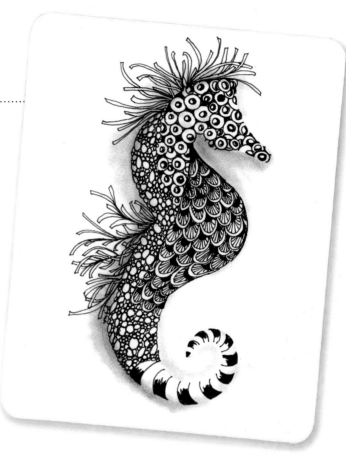

Seahorse by Marta Drennon, CZT

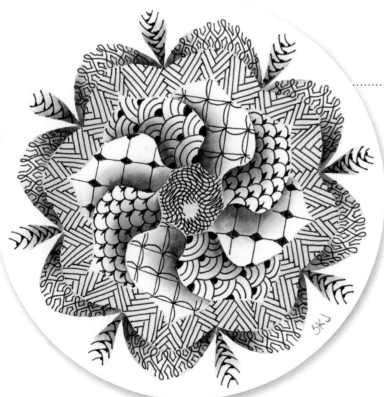

Zendala by Sue Jacobs, CZT

Zendala Rounds

Zentangle art on circular tiles

A Zendala is a Zentangle piece done on a circular tile. Working on these wonderful shapes can make for an especially meditative drawing process. Zen mandalas are personal interpretations that alter the size of the circle and often create images that are viewed from a specific direction.

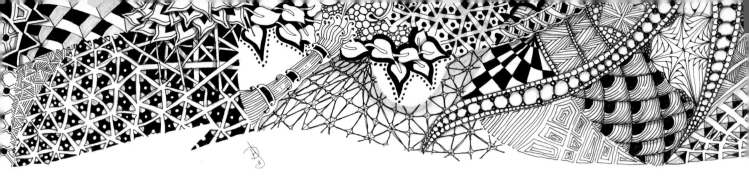

Introduction:
Ignite Your Creativity with Beautiful Zentangle Art

Although it might seem simple, "the beauty of Zentangle" is a phrase encompassing many aspects of the Zentangle method and Zentangle art. Even for individuals who have never seen a Zentangle piece before, the beauty of the art is immediately apparent, whether it's through the striking black and white patterns of a classic Zentangle, the natural symmetry of a Zendala, or the bright colors of a ZIA. Zentangle art draws on mindful patterns that can be found all around us in our daily lives, giving the art a natural feel that just seems "right."

Beyond the beauty of the art, though, is the beauty of the Zentangle method, which has the power to transform. Thousands of individuals practice the Zentangle method with thousands of different positive results, including increased self-confidence, a new ability to focus and solve problems, and a rejuvenated sense of inspiration and creativity. Individuals have used the Zentangle method for pain management, to cope with mental illness, for meditation, and simply to take a break from a hectic life and relax. Practicing the Zentangle method is an experience that is unique to each person and their own life, and the positive results are tremendous.

Beauty by Donna Hornsby, CZT

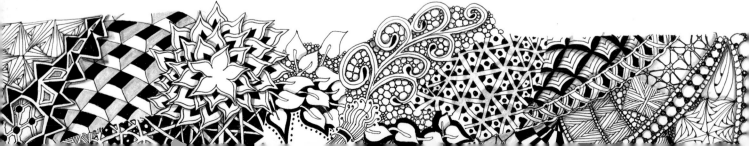

About the Book

My own journey with Zentangle began with a chance email from a friend. The email contained a link to *zentangle.com* with the note, "You might be interested in this…" You may know that I love all types of handwork—painting, journaling, mixed media, sculpting, quilting, embroidery—if it is creative or made by hand, I love it. So it should not be surprising that I loved the look of what I saw on the Zentangle website and wanted to get started right away. I ordered a kit and could feel my interest in drawing tangles growing.

Soon, I saw a post on *zentangle.com* about a class being offered in Massachusetts. Although Massachusetts is quite far from where I live in Texas, I fly to Boston when I'm on my way to visit my daughter in Maine. I signed up right away, excited by the opportunity to take a class about an art form that was new to me and to visit my daughter. I guess I was so excited about taking the class that I didn't read the fine print, because I didn't realize until I arrived in Massachusetts that the class was for individuals who wanted to become a Certified Zentangle Teacher (CZT)!

The CZT Network

The number of CZTs (Certified Zentangle Teachers) worldwide is constantly growing. Each one has attended a four-day seminar with Zentangle method creators Rick Roberts and Maria Thomas to receive their certification. Learning directly from the creators gives these individuals the greatest understanding of the Zentangle method, making them an excellent resource if you are seeking to learn more about Zentangle.

With their vast and growing numbers, there is likely a CZT in your area. Locating a CZT is simple. The Zentangle website (*zentangle.com*) contains a list of CZTs with their contact information, so finding a CZT is as simple as clicking a link. If you are interested in learning more about the Zentangle method, please reach out to a CZT near you.

To make a long story short, during the class, I fell in love with the Zentangle method and its developers, Rick Roberts and Maria Thomas. During my time in Massachusetts, I met many amazing people from all over the world and had the opportunity to visit Rick and Maria's home, studio, and gallery. It was an incredibly inspiring experience. Upon returning home, my love for Zentangle did not dim. I drew tangle tiles every night and shared the Zentangle method with my family and friends.

Many people asked me to teach them the Zentangle method, but I just didn't have time for every request. Soon, I realized that a small book on the subject would be very helpful. With the blessing of Rick and Maria, I gathered up my sample tiles, samples from my sketchbook journal, and original tangles and published a small booklet. Soon, *Zentangle Basics* was ready for readers to enjoy. I followed the first Zentangle booklet with a new one every six months, and then, the opportunity to create this book arose.

Fox Chapel Publishing and I have continued to produce Zentangle books together, but recently we discussed enthusiasm for a book that would feature tangled art from individuals around the world. The book would be an inspiration piece for anyone and everyone, from people who had never heard of the Zentangle method to those who had been practicing it for years. Being part of the Zentangle community is a wonderful experience. I knew there were amazing Zentangle artists out there and that they were producing fabulous art. This book seemed like the perfect way to share their talents.

Fellow CZT Cindy Shepard and I began contacting tanglers and CZTs around the world about this exciting opportunity. The response was immediate and overwhelming. Every day was like Christmas, with emails flying in and packages of beautiful artwork arriving in the mail. And the art was more fabulous than we could have imagined. It was so exciting (and just a little hectic!) to talk with tanglers across the globe and to see their stunning creations. Now that it is all in one place, I hope you enjoy viewing this art as much as we enjoyed gathering it for you.

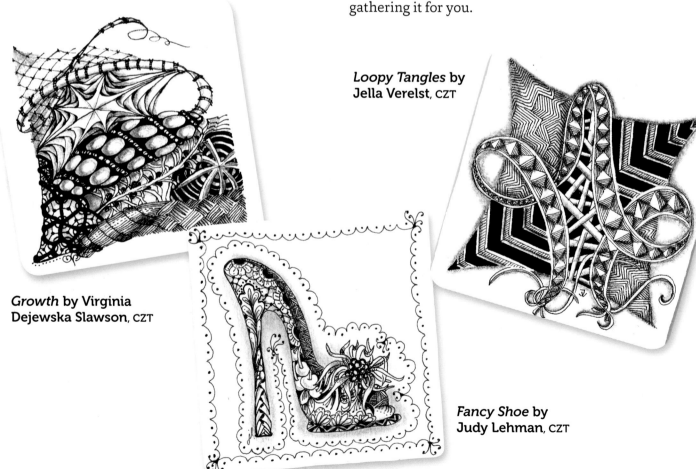

Loopy Tangles by **Jella Verelst**, CZT

Growth by **Virginia Dejewska Slawson**, CZT

Fancy Shoe by **Judy Lehman**, CZT

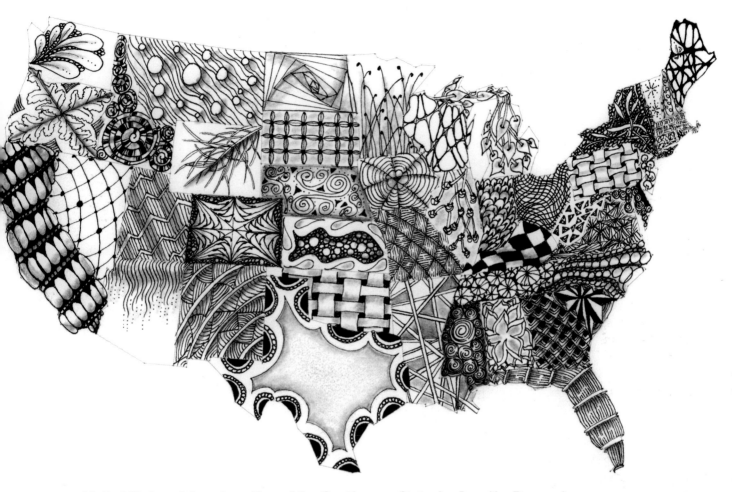

United States of America—Map of the Contiguous States by Jennifer Perruzzi, CZT

The artwork in *The Beauty of Zentangle* enraptures the mind, engages attention, and fires up creativity. This amazing collection of Zentangle-inspired art encompasses a universal range of styles. Included are stunning works from CZTs and breakthrough artists, as well as inventive tangles that are at the forefront of a new wave of creative expression and personal freedom.

This collection of art was created by artists and CZTs who love the Zentangle method and have felt its impact in their lives. They are from around the world, representing places such as Africa, Australia, Belgium, Canada, Greece, Hong Kong, India, Italy, the Netherlands, Norway, Peru, Taiwan, the United States of America, and the United Kingdom. The book contains website and blog information for many of these individuals, and I encourage you to

visit these sites so you can learn more about their experience with the Zentangle method. Many of these CZTs also teach classes.

More important, while I encourage you to reach out to the artists in this book, I also encourage you to try the Zentangle method for yourself. *The Beauty of Zentangle* celebrates the simple, elegant design of Zentangle art. The exquisite nature of the pieces in this collection may initially lead you to conclude that Zentangle is an elite art form for trained artists and CZTs only. This is not the case at all. Anyone who can hold a pen can learn to tangle and create stunning art, just like the art found on these pages. I hope that once you start tangling, you'll not only create beautiful art, but will feel the impact of the Zentangle method in your life.

What is Zentangle?

Rick Roberts and Maria Thomas developed the Zentangle method of mindful pattern drawing to make art accessible to everyone. As they say, "Anything is possible, one stroke at a time," and this is the experience you will have each time you sit down to tangle.

Often thought of as only a drawing technique, the Zentangle method is actually so much more. The process is relaxing, calming, mindful, and intended to spur creativity. The ritual can help anyone experience a meditative calm, solve problems, and turn perceived mistakes into positives. Most people feel such a sense of accomplishment once they start tangling that they don't want to stop. Drawing simple tangles is a wonderful way to release the artist within, to explore your own creativity, and to build self-confidence.

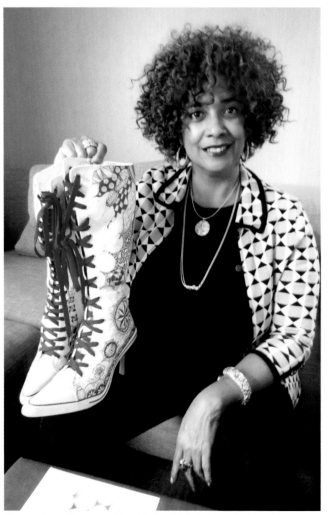

Sharon Lynn Payne, CZT, with her high-top tangled boots.

In less than a decade, the Zentangle method has become a worldwide phenomenon, attracting individuals of all ages and from all walks of life. There are many beauties in the Zentangle process:

The Zentangle method is for everyone. You don't have to be a trained artist to practice the Zentangle method; you don't even need to be able to draw. Similar to handwriting, it is a process that can be learned with practice. And similar to handwriting, each person's will be a little different and have its own signature look.

The Zentangle method provides the benefits of meditation. Whether you are working on a tile or just one tangle, the benefits of a slower heart rate, improved breathing, and a relaxed state of being can be accomplished. Furthermore, you can create beautiful art and obtain these benefits in an evening.

You can tangle on anything. You don't need expensive tools for this art form. Zentangle art only requires paper, pen, and pencil. But you also don't have to limit yourself to these items. If it stands still long enough, tangle on it! Almost any surface can be tangled to add distinctive design and express your creativity. Think purses, hats, shoes, shirts, sunglasses, and even cell phone cases. There's a world of surfaces waiting to become a canvas for Zentangle art. Just go for it and enjoy the compliments and rave reviews your art receives.

The Zentangle method builds friendship and family connections. The Zentangle method offers a beautiful way to connect with other people who share a passion for creativity. Whether you are a beginner or an experienced tangler, there is nothing more energizing than sitting at a table with other passionate Zentangle enthusiasts. Friendships form, ideas are shared, and minds are opened to new possibilities. Beyond that, it's always more fun to create art with a friend—and the more the merrier. Sharing the Zentangle experience in a group amplifies the creative energy, expands ideas, and multiplies the fun.

I personally like to make tangling a family affair. Because it can be done by individuals of all ages, tangling is a wonderful way to engage in

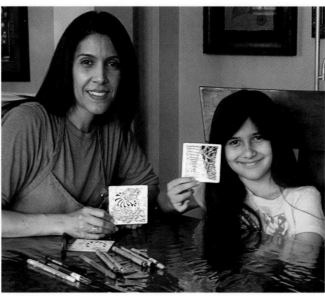

Sharon Lynn Payne, CZT, Carol Knight, CZT, Angie Vangalis, CZT, and Shawn Hayden, CZT, enjoy time together as they work to complete a floor cloth with Roc-lon Multi-Purpose cloth and large black Sakura Permapaque markers.

Cristie R. Campo, CZT, and her daughter Kaylei spend time together as they tangle on paper tiles.

some quality mother/daughter, or grandfather/granddaughter time. My grandchildren enjoy sitting together at the kitchen table as they tangle on T-shirts. My sister and I look forward to getting together to make tangled greeting cards, and even though Grandma's hand is a little shaky, her eyes light up when we tangle together.

There are no mistakes. The real beauty of the Zentangle method lies in the fact that there are no mistakes. No eraser is needed. Like every person, there are hundreds of variations, and each tangle is unique and beautiful. Life is a building process. All events and experiences are incorporated

into our learning process and into life patterns. Zentangle designs grow in the same manner. If a line grows in an unexpected place, tangle around it or inside of it. Make the new lines part of the structure.

To give the Zentangle method a try, take a class with your local CZT (Certified Zentangle Teacher). A teacher may invite new scenarios, provide an experience, give you support, and take you deeper into the process. Visit *zentangle.com* for a list of CZTs in your area so you can begin your journey with the Zentangle method. If you are interested in becoming a CZT, Rick and Maria lead certification seminars several times each year.

Zentangle and You

In the end, there is so much to say about the beauty of Zentangle, and I hope the art on these pages and the information about the artists who created it will give you an idea of the type of experience you can have using the Zentangle method.

In the end, the experience is what you make it, so get inspired by these creative art pieces, let go of your inhibitions about your artistic ability, and get out there and create your own beautiful Zentangle art!

Enjoy the journey.

Suzanne McNeill

—Suzanne McNeill, CZT

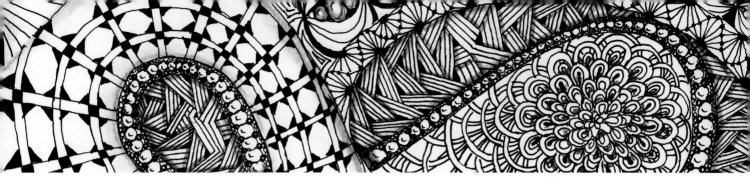

Inspiring Zentangle Artwork

The following pages are filled with simply beautiful tiles and spectacularly drawn designs of Zentangle artwork. This collection was created by tangle artists from around the world. Many of the pieces were drawn by individuals who thought they could not draw and are learning to enjoy the value and beauty of the Zentangle method.

Each piece displays its own beauty. Classic Zentangle pieces are striking with their simplicity of black and white patterns. Elaborate ZIAs contain color and images. Enjoy this collection and be inspired to admire and use these ideas as a springboard to jump into interpretations that are uniquely yours. Enjoy the process.

Zentangle art by Lesley Scott-Gillilan, CZT

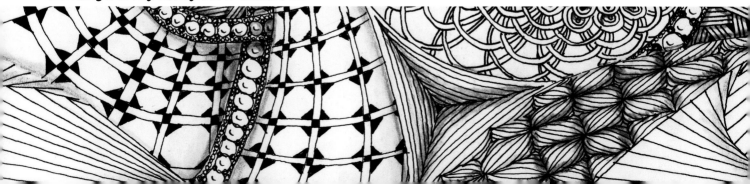

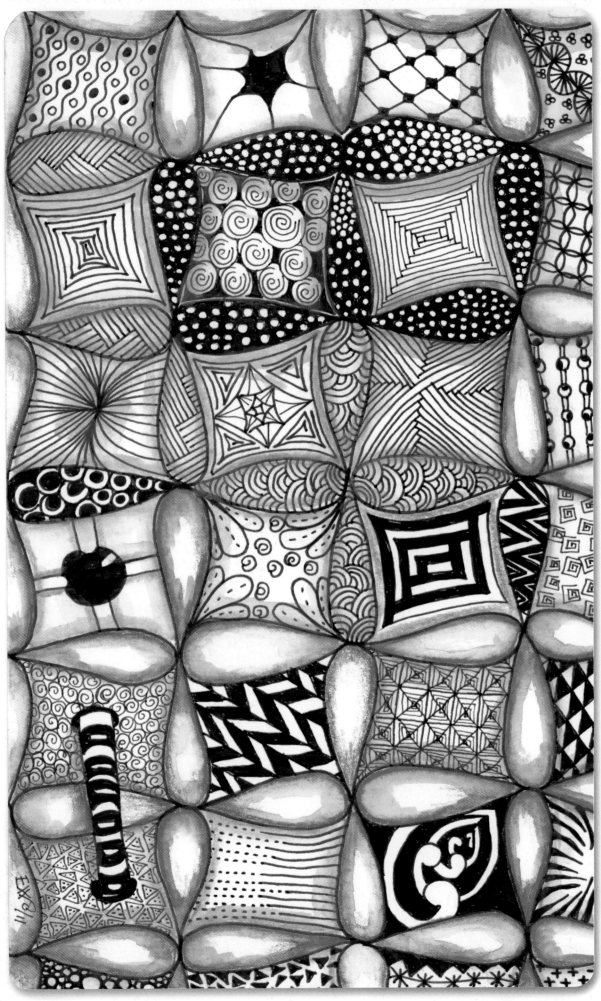

Tangled Sampler by Ellen Wolters

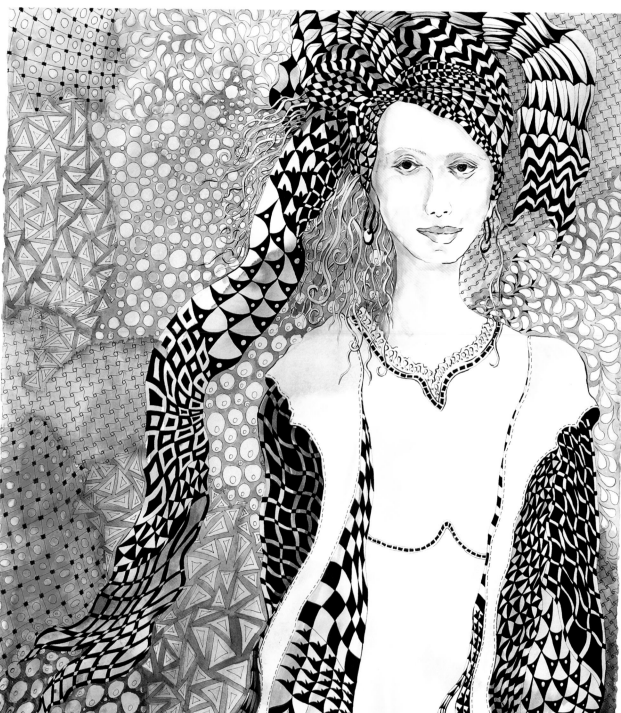

Celestial Beauty

Suzanne McNeill, CZT (TEXAS)

Welcome to my world of art and creativity! For me, art is a journey, not a destination. Taking time to try new concepts keeps me on my creative toes, pushing me to explore and experiment so that my art remains fresh. When I discovered the Zentangle method, I could hardly wait to take a workshop with the founders, Rick Roberts and Maria Thomas. Their generous spirits and kindness are contagious. The wonderful method of Zentangle opened up my art to a world of inspiration where anything is possible. Collaborating with Zentangle artists from around the world to put this book together was inspiring. I am grateful to have met and mentored so many artists and to publish their art. Best of all, many of these gifted designers have become my friends.

Suzanne McNeill

Sunshine Collection

Zen-sational Quilts

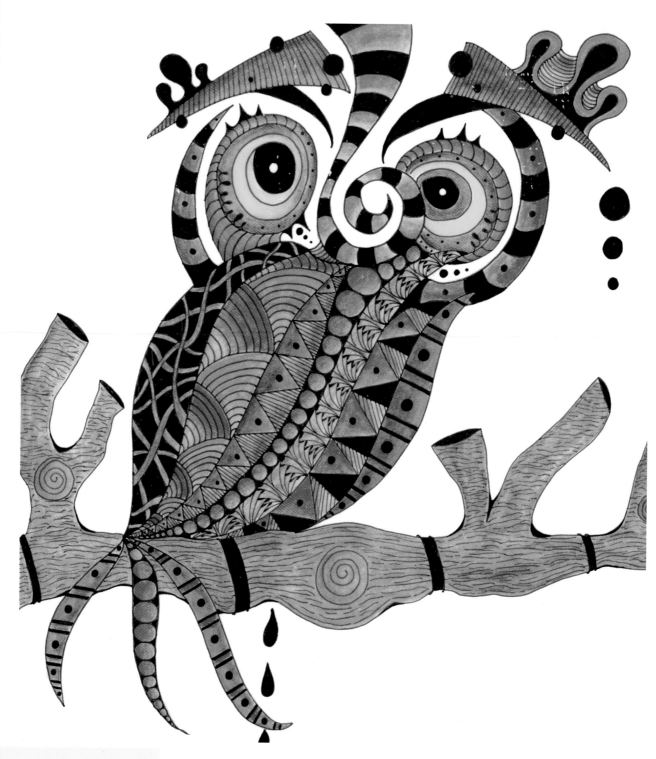

Who's Tangled

Cindy Shepard, CZT (TEXAS)

Like many others, I am an art addict...I love to have my hands in every technique and art material. Zentangle is an art form that can be incorporated into almost every type of art—painting, journaling, collage, and jewelry. My favorite thing about the Zentangle method is the minimal amount of materials required to practice it. This makes it a very accessible art form to learn and to teach. Zentangle is such a fun word.

Almost anyone who hears it is compelled to ask, "What is that?" When I begin explaining, they listen intently and want to find out more. I carry business cards with me everywhere I go. When people ask how to spell Zentangle, I just hand them my card. As a CZT, I believe my mission is to spread the word that "anyone can enjoy creating with the Zentangle method."

Cindy Shepard

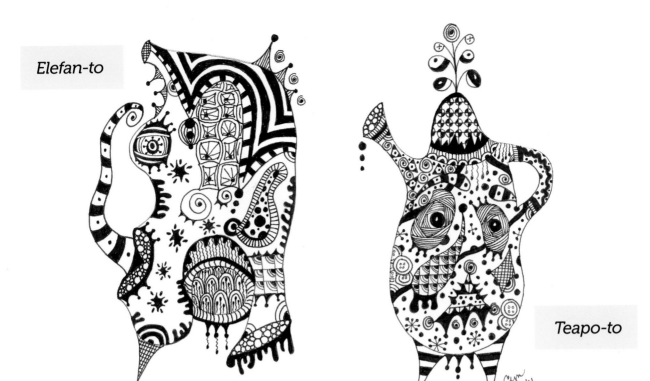

Elefan-to

Teapo-to

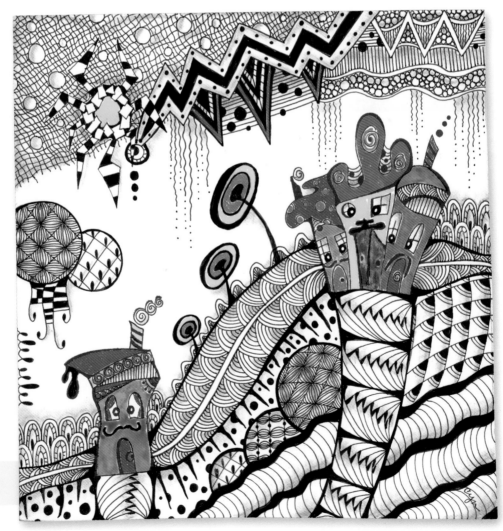

Quirky Houses

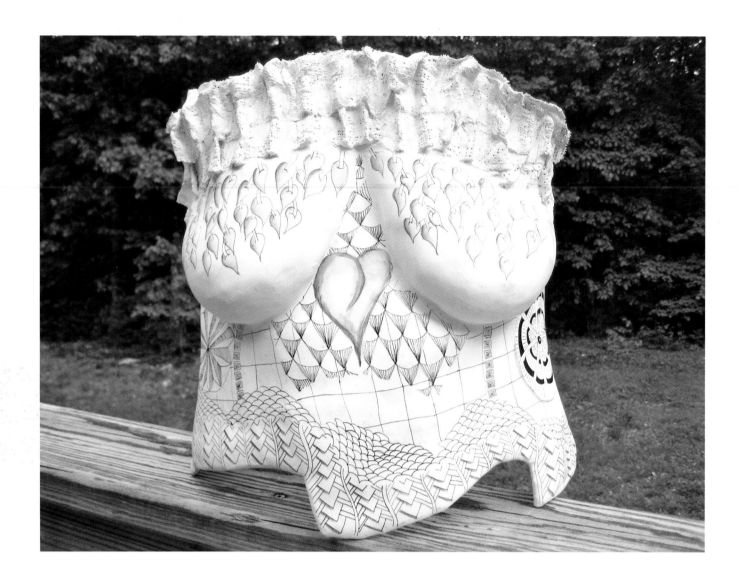

Bette Abdu, CZT (NEW HAMPSHIRE)
tangleclubhouse.com
Plaster, Micron pens, Inktense pencils and blocks. *Treasured Chest* was made for a fundraiser for breast cancer.

I found the Zentangle method in 2007. I encouraged Rick and Maria to start a Certified Zentangle Teacher Program and attended the first CZT classes. I am an enthusiastic teacher, run retreats for fellow CZTs, attended the Zentangle Master Class held by Rick and Maria, and have used Zentangle to participate in community fundraisers. I recently introduced Tangle Decals, high-quality tangles in vinyl, for application on glass windows.

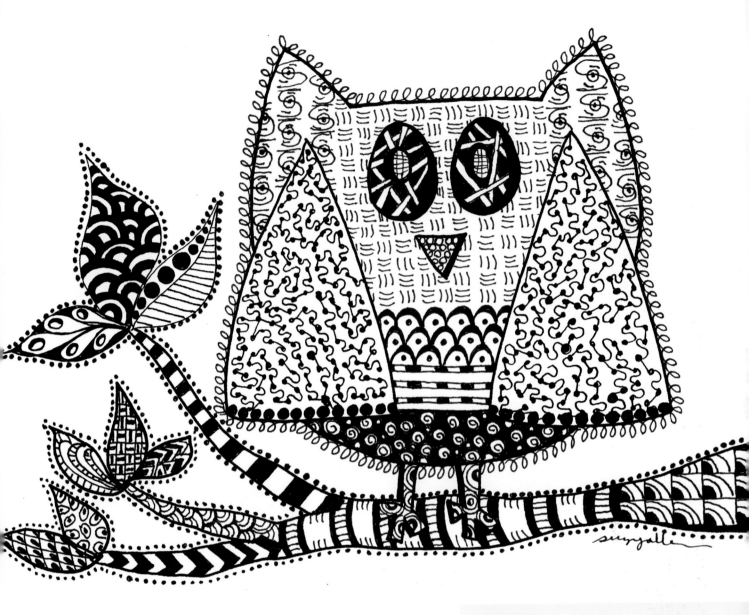

Wise Owl

Suzy Allen (LOUISIANA)

toddsuzy@bellsouth.net
Quality paper, Micron pens.

I am an artist, educator, and creator of many things. I love the feeling of having a small part in building a child's creativity. When I heard about the Zentangle method, I did a little research to learn the vocabulary and started teaching my students that it was much like doodling or drawing without thinking. In 2012, I attended a workshop given by CZT Suzanne McNeill.

It was there I realized just how wrong I was. Zentangle is not drawing without thinking; quite the opposite. It is a process of redirecting your thoughts, which is much more powerful. I believe that attending a workshop with a CZT is a necessity to fully understand and appreciate the Zentangle method.

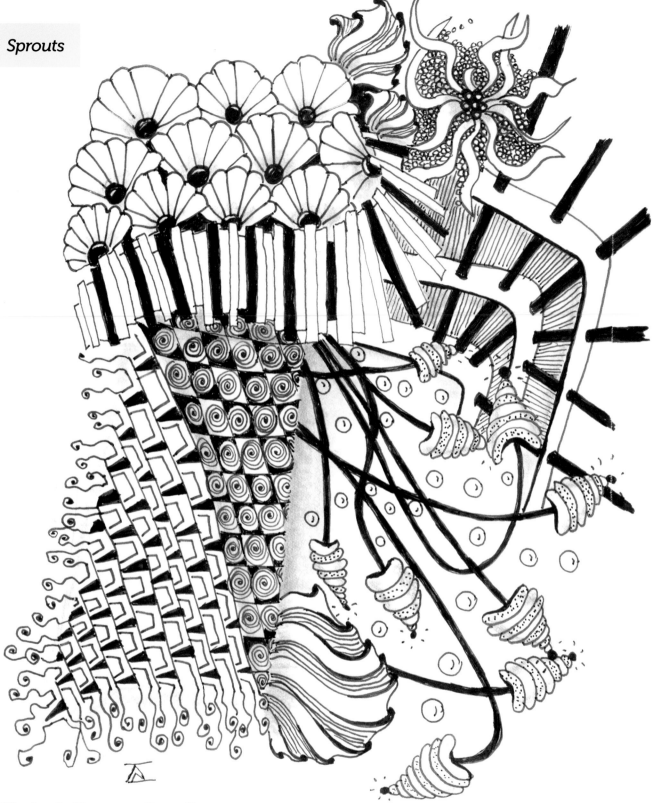

Kimberly Dragone Barcello, CZT (CONNECTICUT)
nowandzentangled@gmail.com
Quality paper, Micron pens.

I have been involved in the art world since childhood, when my artist father brought home different materials to support my interest in creative expression. I earned a BFA degree, but recently noticed a decrease in my passion and inspiration. While searching on *Amazon.com* for ideas, I kept seeing Zentangle books, and within weeks found myself in a workshop. It was the key that unlocked the door to a newfound sense of imagination.

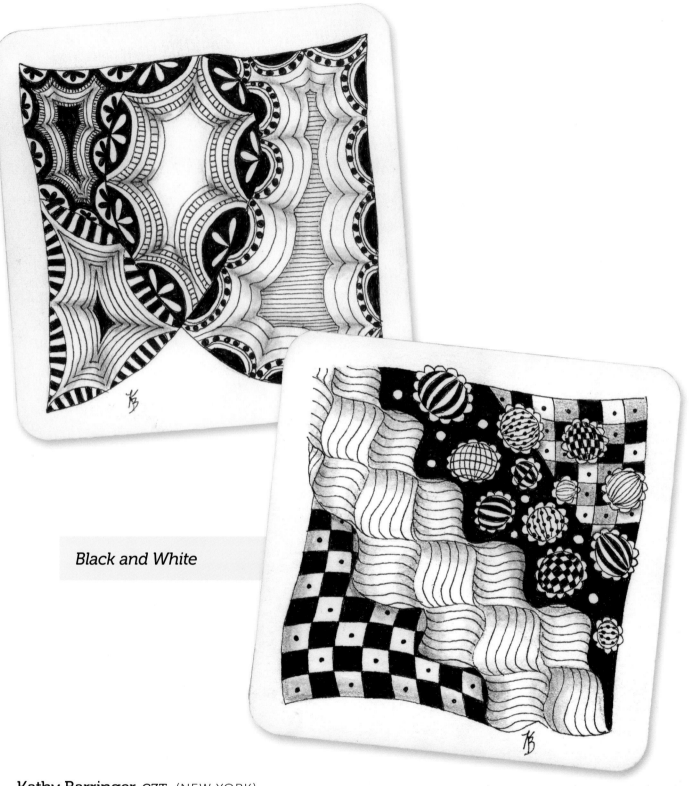

Kathy Barringer, CZT (NEW YORK)
tangledtopieces.com
Zentangle paper tiles, Micron pens, pencil.

Zentangle opened up a whole new world for me. I never thought of myself as an artist, but here I am, creating amazing things with paper and ink. It gives me a new confidence, not just in my art, but in other areas of my life. So, after retiring as a clinical social worker, I began a new venture teaching Zentangle classes. Teaching gives me so much pleasure, as I get to share this art form and have my students see what they can accomplish "one stroke at a time."

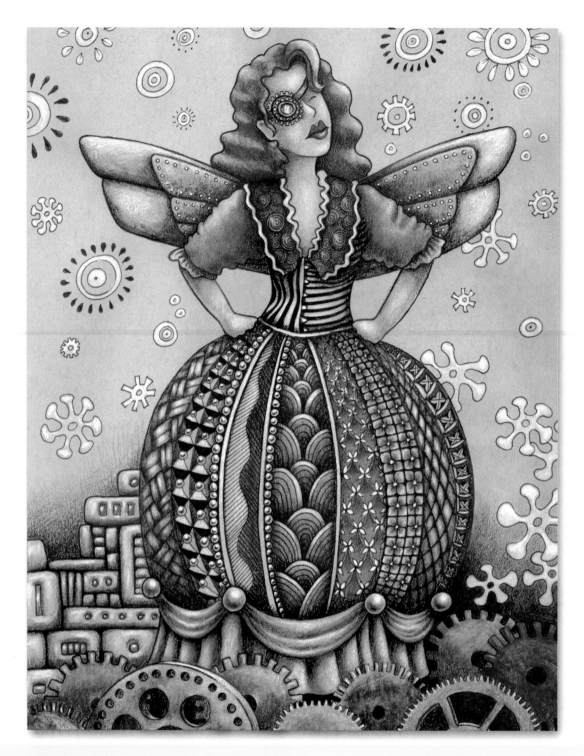

Steampunk Girl

Sandy Steen Bartholomew, CZT (NEW HAMPSHIRE)

sandysteenbartholomew.com
Strathmore toned paper, Micron pens, Inktense and Prismacolor pencils, waterbrush.

I have been drawing on things since I was a baby. All kinds of things—paper, walls, clothing, skin, driveways, windows, a gnu statue, and even an urn. I'm fascinated by other cultures who also do this—especially the ancient Egyptians and the Mehndi tattoos of India. I have been cursed by an insatiable curiosity and a frantic hunger to learn every artistic technique I see. When I learned the Zentangle method, it helped me focus my vision, calm down, and build my creative confidence. I am the author of several popular books on Zentangle, including *Yoga for Your Brain*™, *Totally Tangled*, *Tangled Fashionista*, *AlphaTangle*, and *Zentangle for Kidz!*, as well as a line of *Yoga for Your Brain*™ card decks. I still draw on everything.

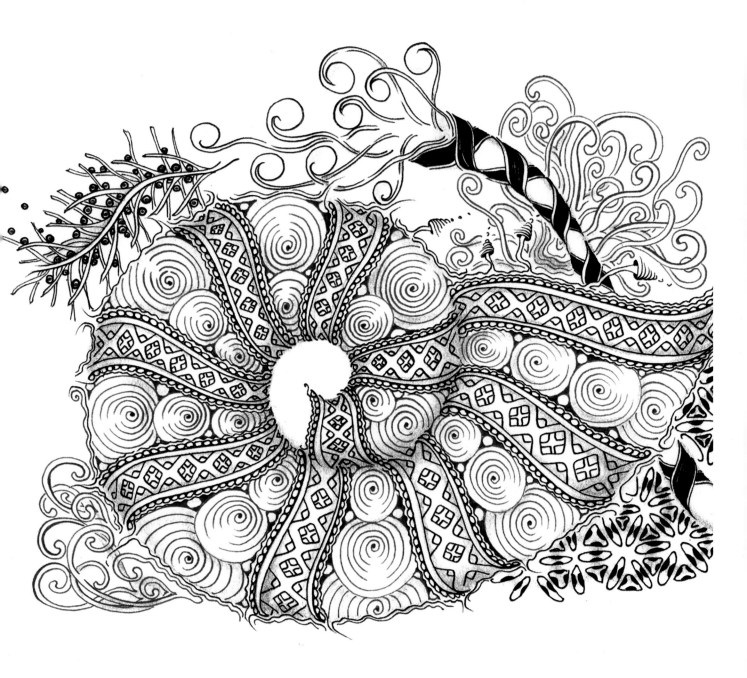

Michele Beauchamp, CZT (AUSTRALIA)

shellybeauch.blogspot.com
Stonehenge cotton paper, Micron pens in black and sepia.

Fortunately for me, the Zentangle method entered my life when I was able to take time each day to sit quietly and create what I call "little gems on paper." Learning the Zentangle method has felt "just right." It is a very forgiving art form where wobbly lines can be effective and wonky circles are fine. Mistakes are turned into opportunity, and there is a pleasant surprise when you finish. I like to think that perfection is not important and giving ourselves the freedom to be creative is essential to living well.

Morning Song

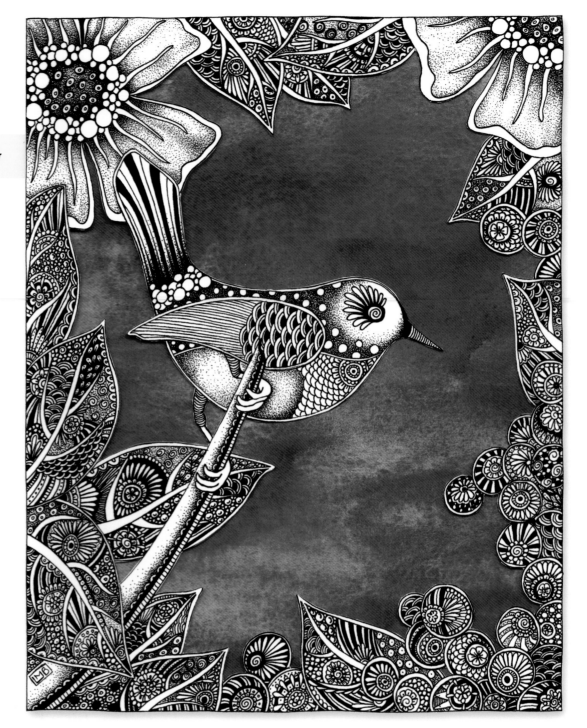

Lorrie M. Bennett (FLORIDA)
dzineafterhours.blogspot.com
Watercolor paper, pen and ink, watercolors, X-acto knife.

Even though my days are filled with every art medium I can get my hands on, I seem to always come back to pen and ink and using patterns in my artwork. I came across the Zentangle method by accident one day and found I loved the many new patterns it introduced me to. I knew I wanted to use some of these and still find ways to incorporate other media alongside the pen and ink that I can just never get enough of. I use watercolors and acrylics, cutting out little windows between layers so other layers peek through; the possibilities are endless. I love that the Zentangle-inspired portions of my pieces give me moments of meditation and relaxation, while the other portions allow me to be filled with artistic excitement and exhilaration. It's the best of all worlds for me as an artist.

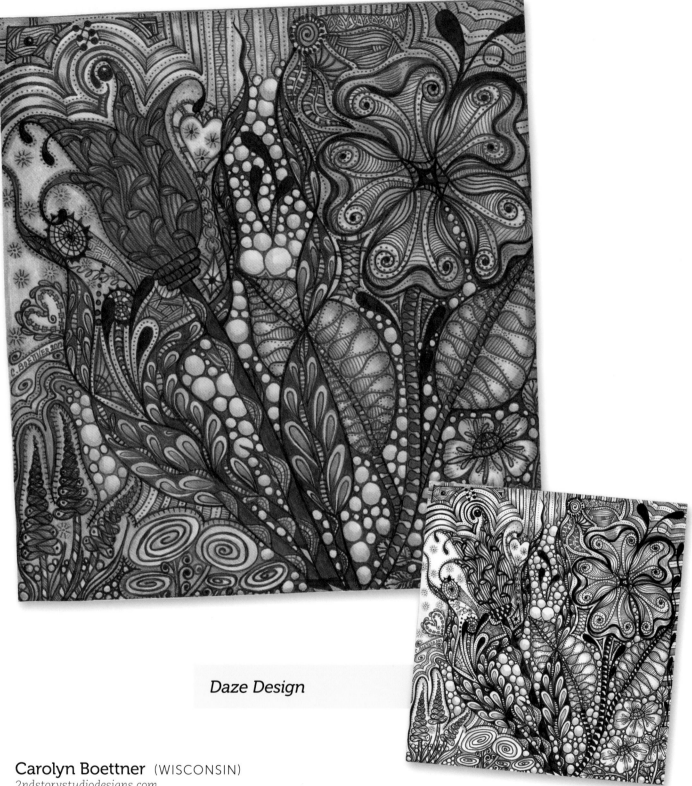

Daze Design

Carolyn Boettner (WISCONSIN)
2ndstorystudiodesigns.com
Quality paper, Micron pens, Copic markers, watercolor pencils.

I was a coloring book baby. I always knew I would share my art with others throughout my lifetime. When I discovered the Zentangle method, I was already doing ZIAs. I immediately fell in love with tangles and drawing them. I must now admit to being totally addicted to this art form. It has enriched my life and made it so much sweeter through the pure joy of tangling and meeting all of the wonderful friends I have made in the Zentangle community. I will be tangling for the rest of my life and loving it!

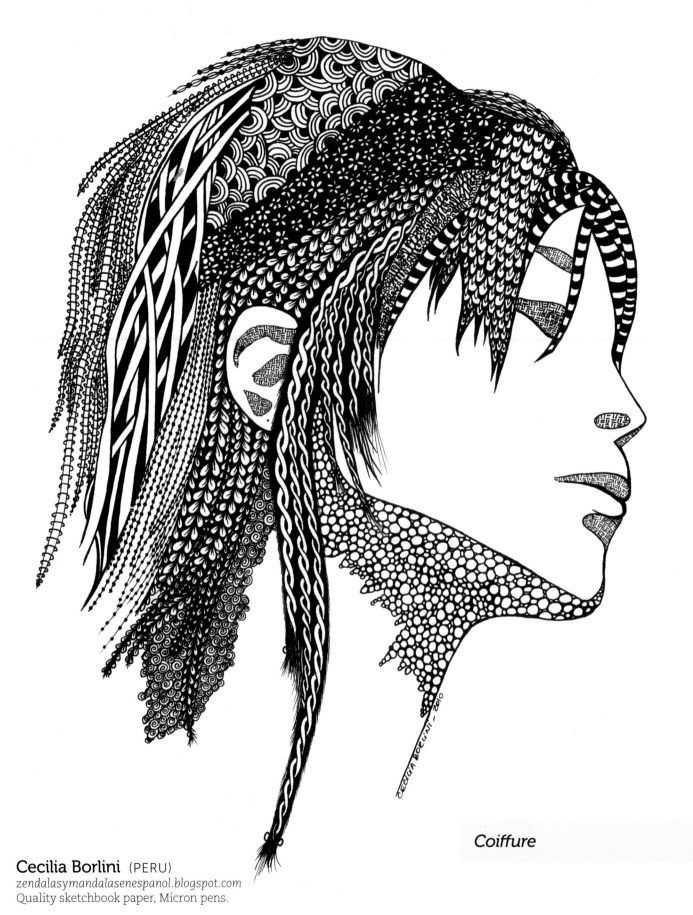

Coiffure

Cecilia Borlini (PERU)
zendalasymandalasenespanol.blogspot.com
Quality sketchbook paper, Micron pens.

I discovered the Zentangle method in a YouTube demonstration by Suzanne McNeill while looking for something else. It captivated me! I began to draw tangles, and, with many hours of practice, I have now drawn numerous art pieces. It is an art form that I love. I have drawn many pieces of Zentangle-inspired art.

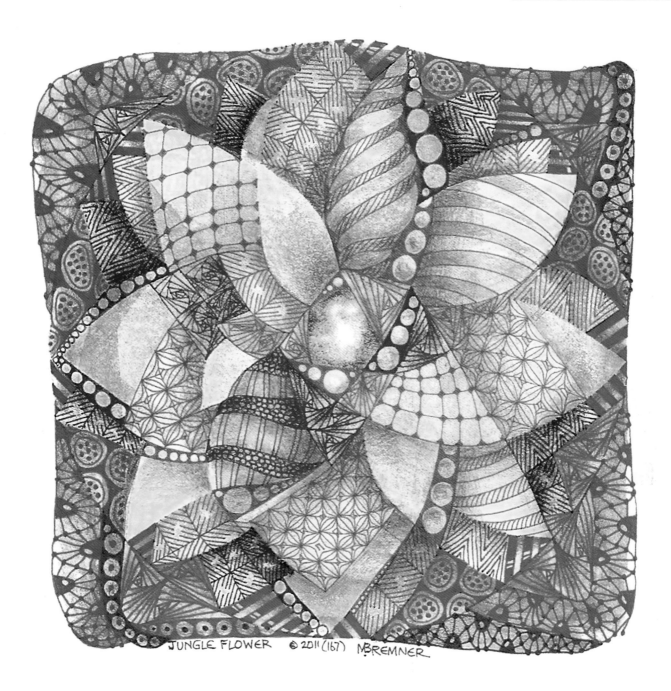

Margaret Bremner, CZT (CANADA)

enthusiasticartist.blogspot.com
Acid-free matboard, Archival pens in black and colors, colored pencils.

I have always loved tiny details and repeating patterns. I especially love mandala circles and houses. While I love the colors possible with paint, I really enjoy drawing more than painting. You can see how the Zentangle method immediately clicked with me! I only wish I had discovered it earlier!

Fangtooth or Ogrefish

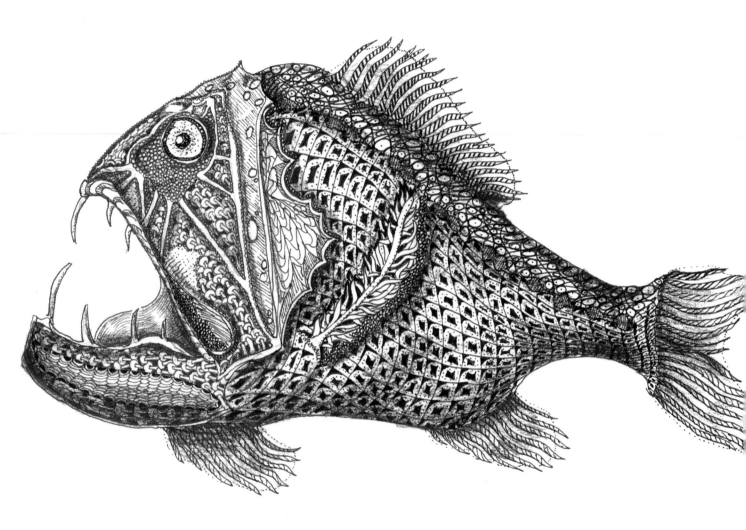

Christine Britos, MAE, CZT (NEW HAMPSHIRE)
expressivecoach.com
Quality paper, Micron pens, pencil.

My love of fish began with my adventures in Alaska. My experience with the Zentangle method began twenty years later when my mother signed me up for a Zentangle class. As I began to tangle and be more creative, I relaxed, let flow my creative impulses, let go my hidden agendas, and began opening up to the process of creating more. It was only natural for me to create tangled fish. I love seeing how tangles and fish meld together.

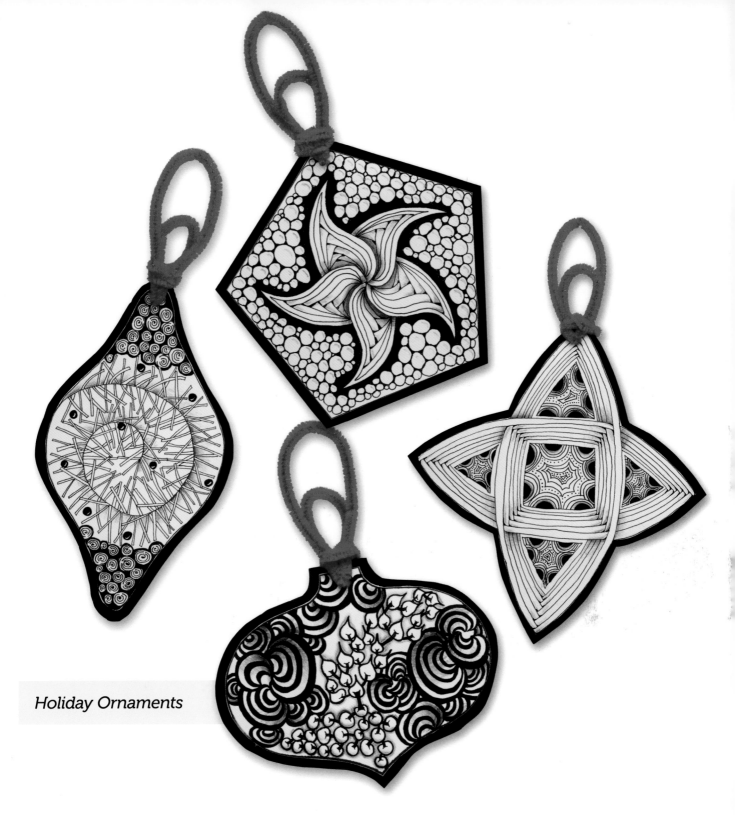

Holiday Ornaments

Amy Broady, CZT, and Caroline Broady, CZT (TENNESSEE)

tanglefish.blogspot.com
Vellum surface bristol paper, Micron pens, pencil, black cardstock, adhesive.

My mom, Amy, taught me how to tangle when I was twelve years old. I wasn't feeling well that day and only had the focus to watch and listen, but I was enchanted by how each and every individual stroke wove into the completed tile. I decided to make my first Zentangle piece using tempera paint and black poster board. I went over certain elements with tints of color to make them come to life. I went big, used paint, worked white-on-black, and even made up a new tangle. I love experimenting with new tangles, using unusual media, and punching in color. I especially love working with my mom and the support she gives me.

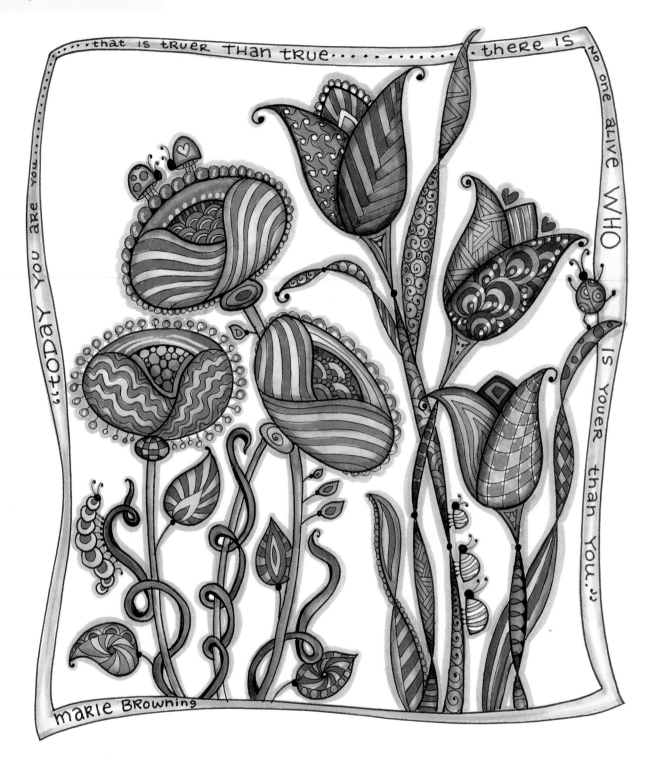

...that is truer than true... ...there is no one alive WHO is youer than you." "today you are you...

marie Browning

Marie Browning, CZT (CANADA)

marie@mariebrowning.com
Watercolor paper, Micron pens, Tombow Dual Brush Pens, Tombow Glue Pen.

I am a multi-talented artist and the author of *Time to Tangle with Colors*, the first book on coloring tangles. I live, garden, craft, and tangle in Brentwood Bay on Vancouver Island. I am also a Creative Consultant, assisting manufacturers in developing innovative products. I have taught classes, demonstrated at trade shows, and appeared on TV and in videos. I am currently the lead designer for American Tombow and was selected by Craft Trends trade publication as a Top Influential Industry Designer.

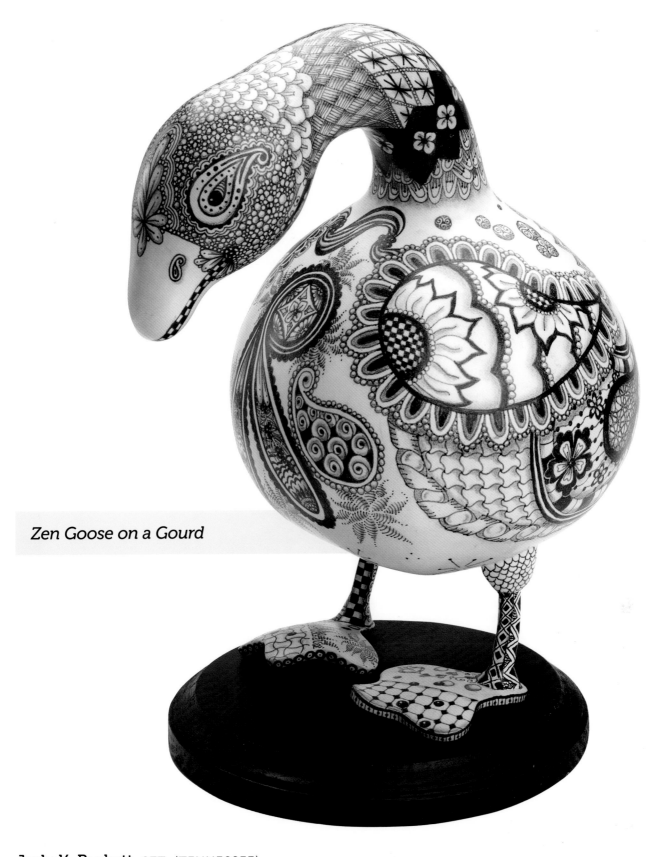

Zen Goose on a Gourd

Judy K. Burkett, CZT (TENNESSEE)
Goose-shaped gourd, permanent marker, white paint, pencil, clear sealer.

I love to create almost anything. I am an award-winning gourd artist and have received such honors as Best of Show and People's Choice. I teach at state gourd shows around the country, where I am known as "The Zentangle Lady," which is funny, because I am known as "The Gourd Lady" by my CZT peers.

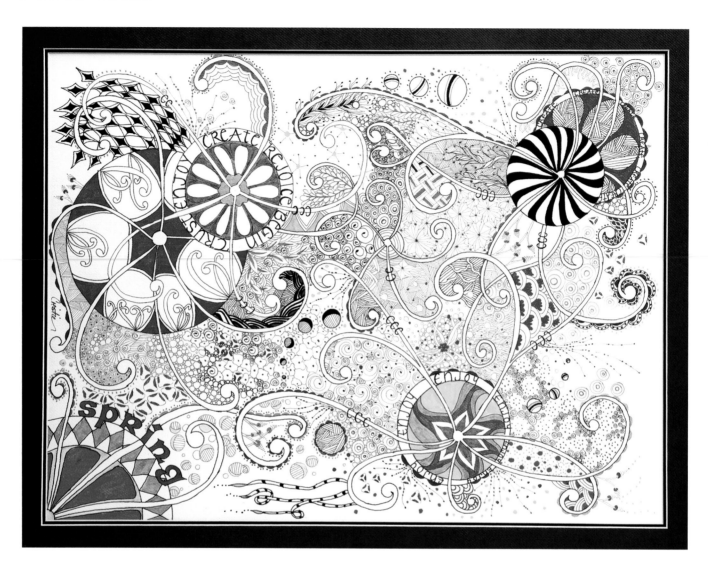

Cristie R. Campo, CZT (TEXAS)

oneofakindtangles.com
Professional illustration board, Micron pens, color gel pens.

When I was a child, my grandfather would take me for walks in the early mornings. We would sit under a shady tree to rest. Often he would pick up a stick and show me how to draw birds and trees in the soft ground. This caring gesture ignited my passion for art. The Zentangle method gives me the ability to relax and de-stress while I organize patterns, create art, and use harmonious colors to evoke mood and personality.

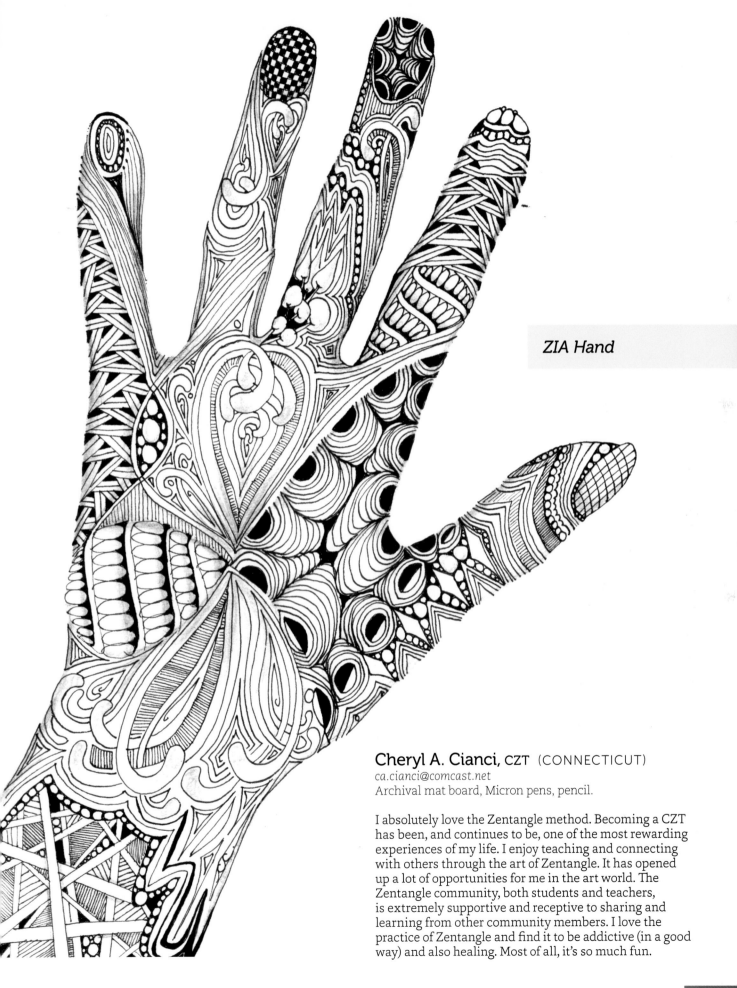

ZIA Hand

Cheryl A. Cianci, CZT (CONNECTICUT)
ca.cianci@comcast.net
Archival mat board, Micron pens, pencil.

I absolutely love the Zentangle method. Becoming a CZT has been, and continues to be, one of the most rewarding experiences of my life. I enjoy teaching and connecting with others through the art of Zentangle. It has opened up a lot of opportunities for me in the art world. The Zentangle community, both students and teachers, is extremely supportive and receptive to sharing and learning from other community members. I love the practice of Zentangle and find it to be addictive (in a good way) and also healing. Most of all, it's so much fun.

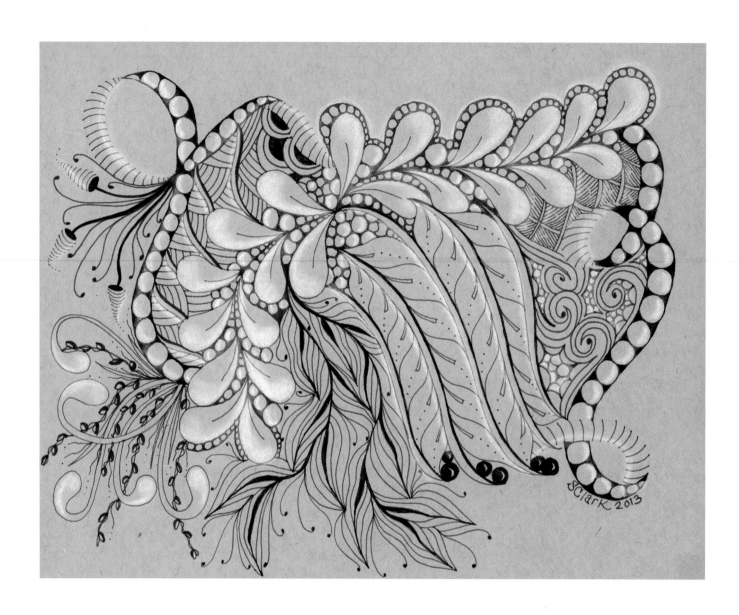

Nature's Gift

Sue Clark, CZT (COLORADO)

tangledinkart.blogspot.com
Strathmore toned tan paper, Micron pens in brown and sepia, white charcoal pencil.

I have had a love of art and drawing my entire life. Following a thirty-six year career with the federal government, I now love spending time as an artist, teacher, and blogger. I now operate my own art business, Tangled Ink Art. My other interests are traveling, hiking, art and crafts, and spending time with my husband and family. The Zentangle method has enriched my life in so many ways. I am very passionate about tangling and love to share it with others.

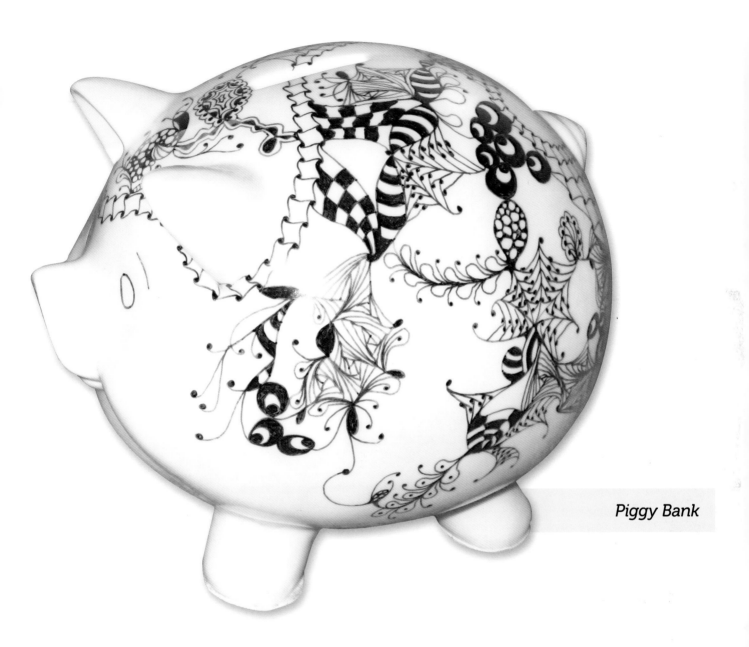

Piggy Bank

Linda R. Cobb, CZT (PENNSYLVANIA)
fallsdalestudios@yahoo.com
Ceramic piggy bank, Permapaque markers.

I love Zentangle because it is an art form for everyone! It has been such a wonderful challenge to tangle on wood and ceramics and to create small inspirational booklets with paper. I also love to tangle because it gave me a way to relieve my stress during treatments for cancer. The versatility of Zentangle continues to astound me.

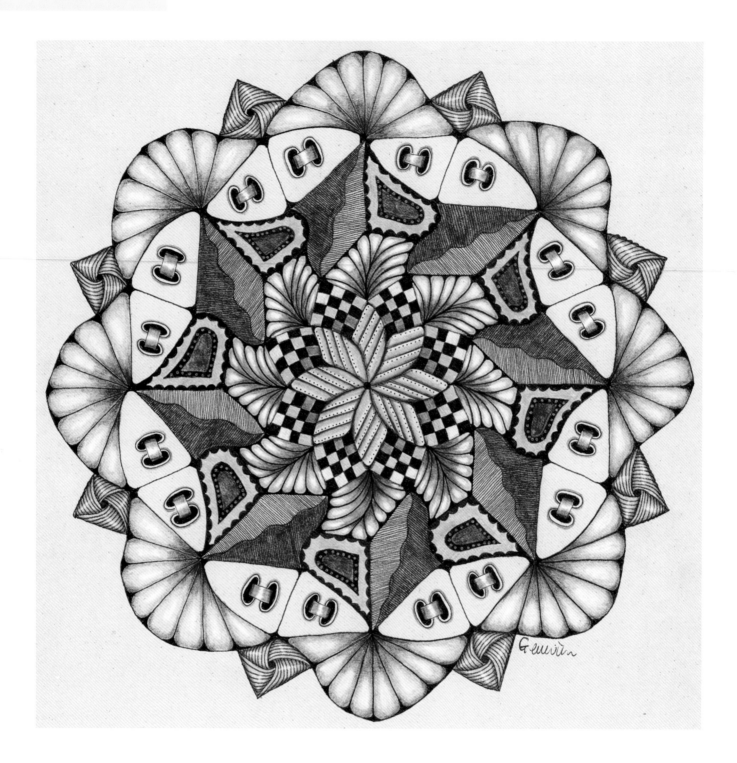

Geneviève Crabe, CZT (CANADA)

amarylliscreations.com
Quality paper, Micron pens, pencil, Prismacolor pencils in white, dark purple, and light purple.

I have been an artist for as long as I can remember. Over the years, I played with many art forms, but pen and ink has always been my favorite. When I discovered the Zentangle method, I knew that it was the art form for me.

I am also a math geek, and the geometry of mandalas appeals to me on that level. Zentangle and mandalas... a marriage made in heaven.

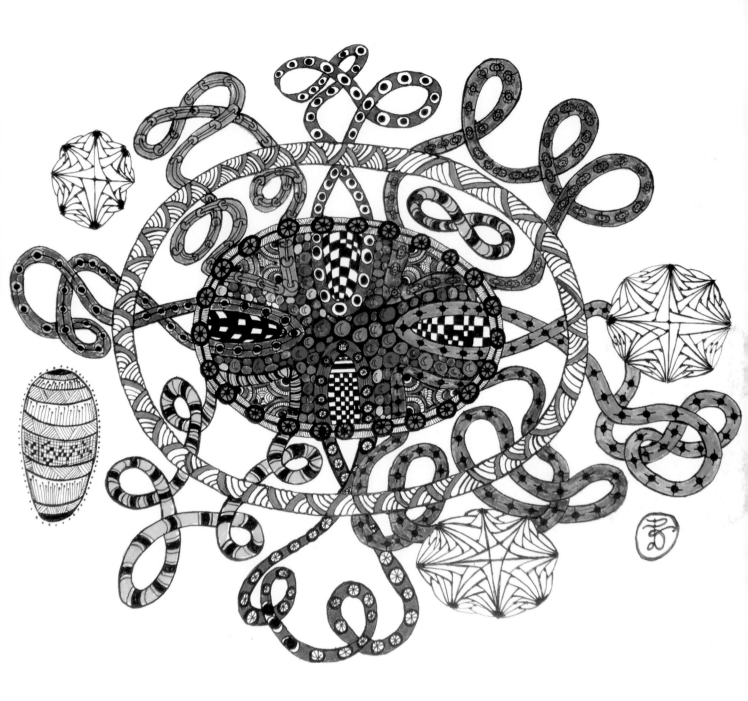

Panos Dervissis (GREECE)

pdevpan@gmail.com
Quality paper, Micron pens.

When I was a child, I started drawing as a way to express myself. I took drawing lessons in Athens, Greece. When I started practicing the Zentangle method, I found it was an amazing art form that helped me focus, relax, and amuse myself. Now I am inspired by everyday life to create original tangled art.

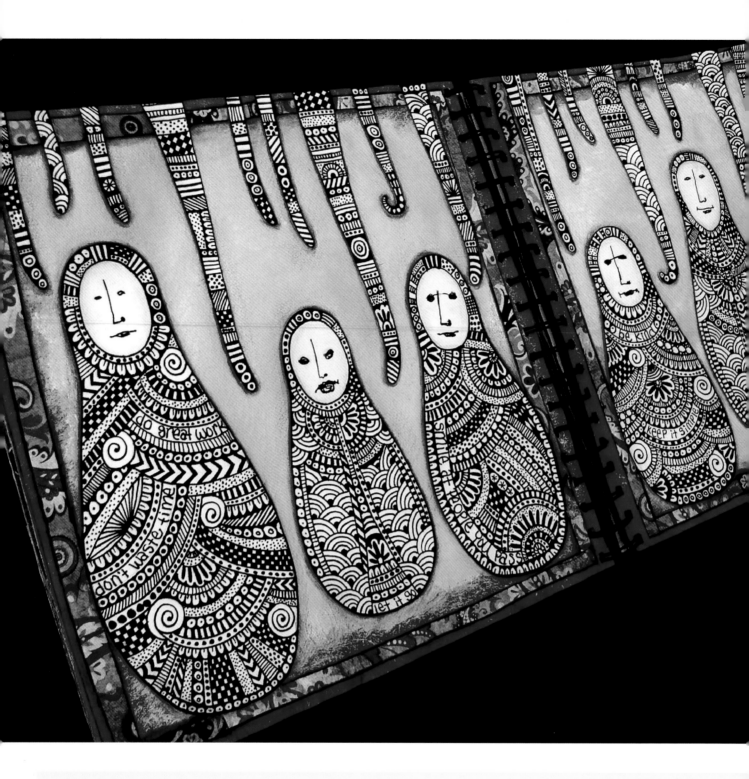

Zen Matryoshka

Ingrid Dijkers (MICHIGAN)

ingriddijkers.com
Quality papers, permanent markers, paints, watercolor pencils.

I have been involved in the arts my whole life in one way or another. My interests have migrated and merged from one art form to another during the years. For the past several years, my passion has been in journaling, where I often incorporate lettering and tangles.

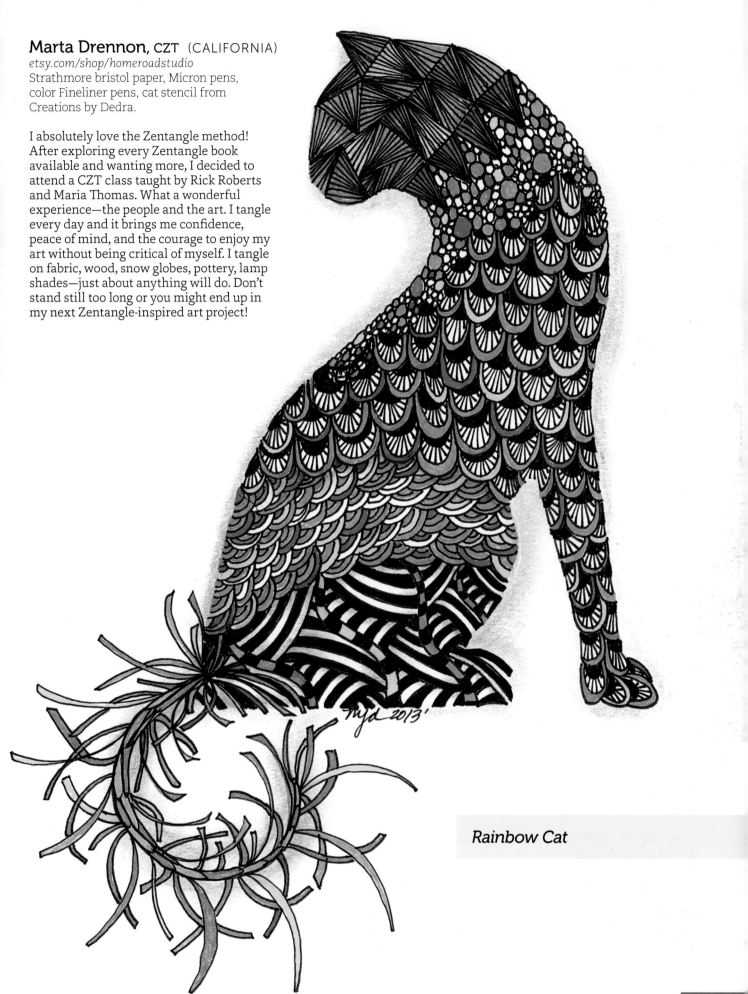

Marta Drennon, CZT (CALIFORNIA)
etsy.com/shop/homeroadstudio
Strathmore bristol paper, Micron pens,
color Fineliner pens, cat stencil from
Creations by Dedra.

I absolutely love the Zentangle method!
After exploring every Zentangle book
available and wanting more, I decided to
attend a CZT class taught by Rick Roberts
and Maria Thomas. What a wonderful
experience—the people and the art. I tangle
every day and it brings me confidence,
peace of mind, and the courage to enjoy my
art without being critical of myself. I tangle
on fabric, wood, snow globes, pottery, lamp
shades—just about anything will do. Don't
stand still too long or you might end up in
my next Zentangle-inspired art project!

Rainbow Cat

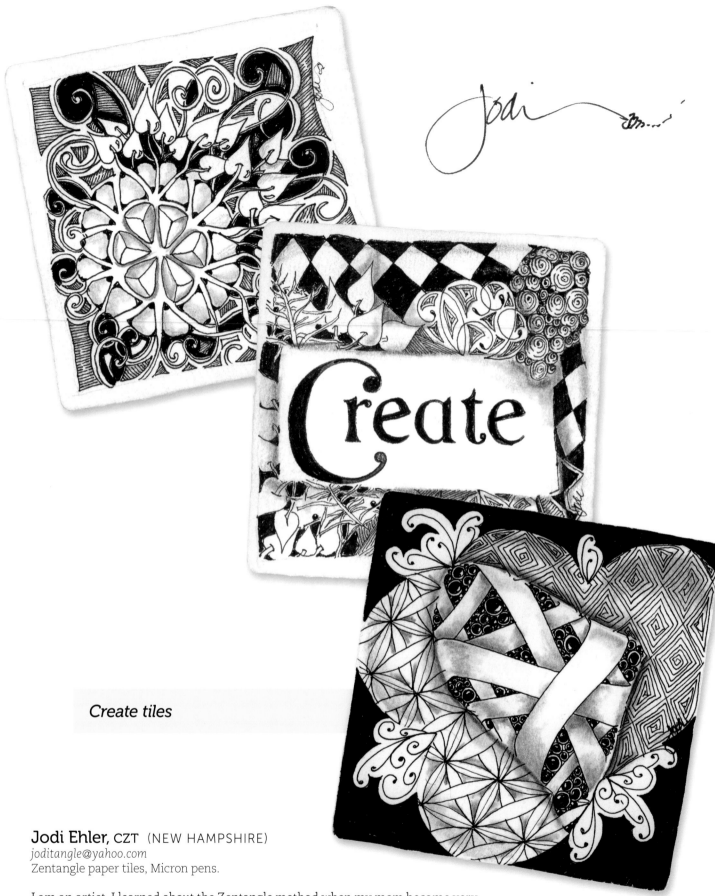

Create tiles

Jodi Ehler, CZT (NEW HAMPSHIRE)
joditangle@yahoo.com
Zentangle paper tiles, Micron pens.

I am an artist. I learned about the Zentangle method when my mom became very ill and had to be put in a nursing home. Being able to sit down and focus on something else was so comforting for me—I continue to teach the Zentangle method as a way of creating comfort and peace.

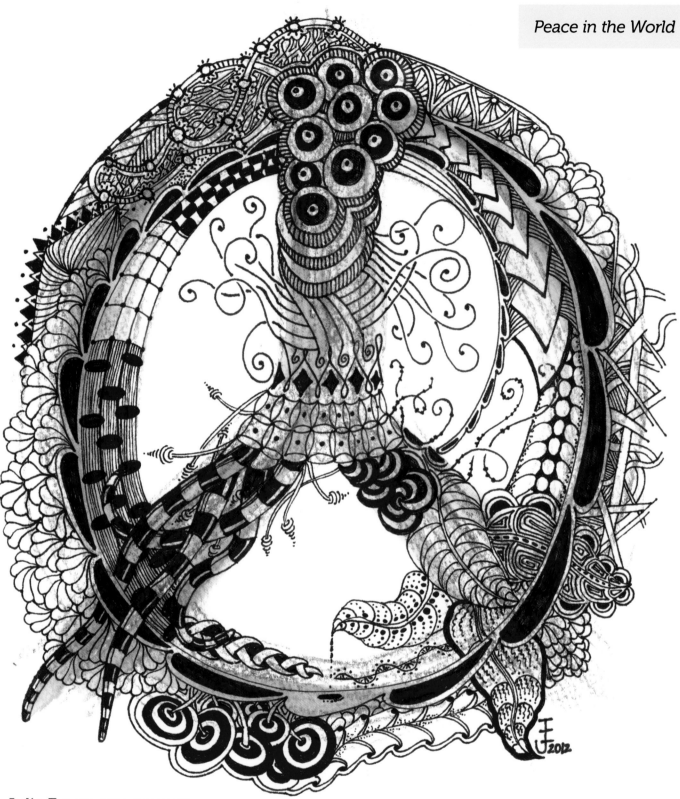

Julie Evans, CZT (HAWAII)

kalacreative.com/julieszenbliss
Watercolor paper, Sharpie marker in blue, Inktense pencils.

I've always been an artist—trying every craft, collecting every art supply. Then I discovered the Zentangle method in a class taught by "Big Island" CZTs Lois and Earl Stokes. I developed a whole-hearted appreciation for "less is more," using simple tools, and black and white patterns.

Removing all the extra stuff and getting to the heart of the process opened up creative pathways for me. I'm so grateful for the lessons that the art and practice of the Zentangle method have taught me, and I love sharing the process with others.

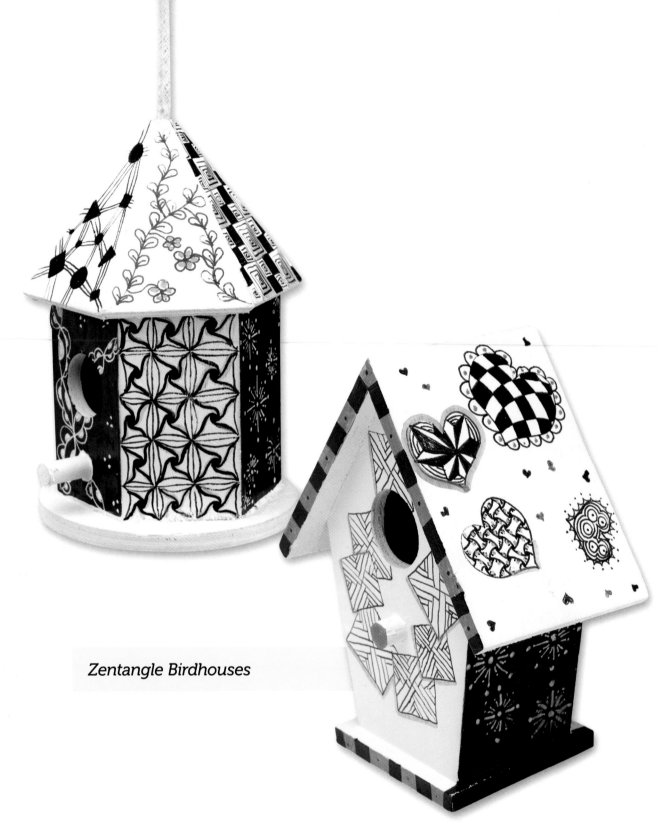

Zentangle Birdhouses

Cindy Fahs, CZT (PENNSYLVANIA)

Premade wooden birdhouses, black dual-ended Identi-Pen, Valspar flat white spray paint, colored Gelly Roll pens.

For me personally, the Zentangle method is all about relaxing and prayer—the finished piece is just an added bonus. I find joy in being able to present someone a "tangible" prayer or to look back at my finished pieces and reflect on what I was feeling or experiencing at the moment I created them. I like to feel in control, and when I tangle is the time I can just let go of everything and be free—no planning, no worries.

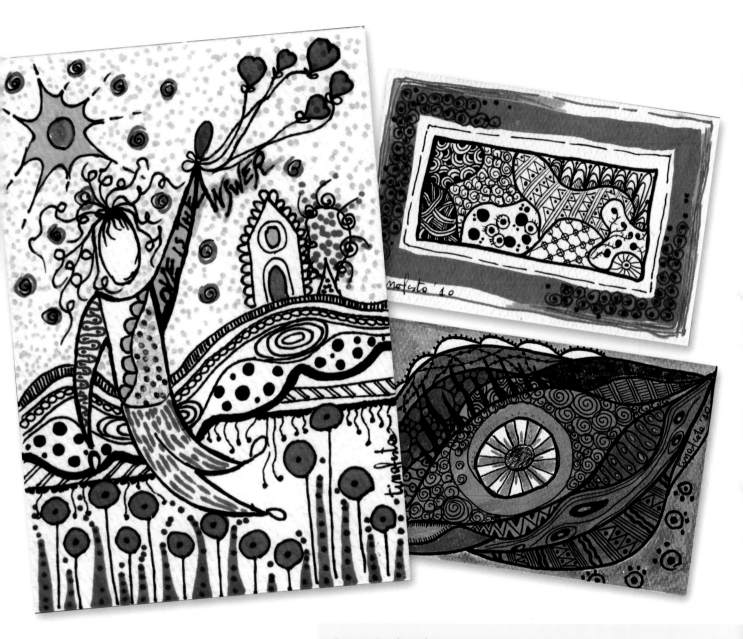

Love is the Answer

Tina Festa, CZT (ITALY)
scarabocchizen.blogspot.com
Quality paper, Micron pens, watercolor paints, paintbrush.

I discovered the Zentangle method during a period of loneliness and loss. The encounter with Zentangle has injected new life and energy in me. I am a teacher in preschool and lead workshops for children and adults.

I do not consider myself an artist; I am more interested in sharing creativity and finding new methods to help people awaken their creativity. I like combination art, using mixed materials and media.

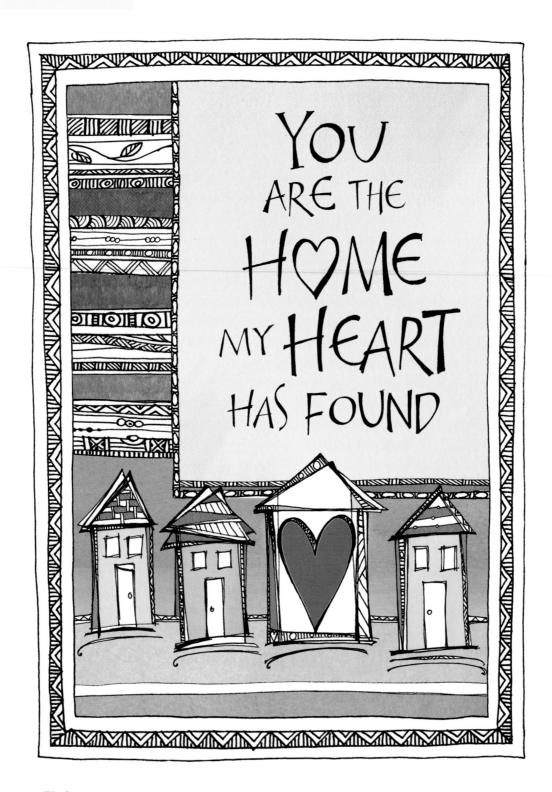

Joanne Fink (FLORIDA)

zenspirations.com
Strathmore drawing paper, Micron pens, colored digitally in Photoshop.

I have been a calligrapher for many years. I was inspired to start drawing when I discovered the Zentangle method. The interaction of ink on paper is exciting to me! My drawings are combined with the inspiring sentiments I write, and I call my new brand "Zenspirations." Getting into a Zen-like state when I draw is part of the pleasure.

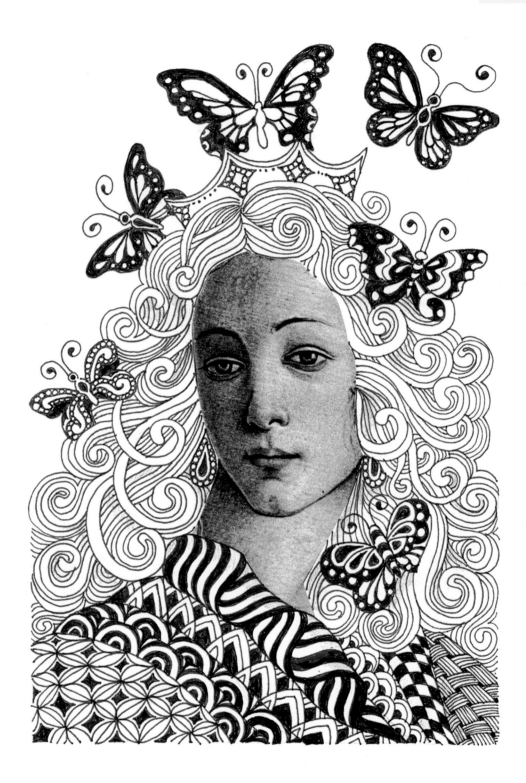

Barbara Finwall (CALIFORNIA)
banardesigns.blogspot.com
Quality paper, copy of a fine art print (copyright free), Micron pens.

I studied art at Chouinard Art Institute in Los Angeles, California. For the first half of my adult life, I worked as an Advertising Art Director. Then, I became co-owner of Banar Designs with my sister Nancy. We design and produce needlework kits and craft books. Suzanne McNeill introduced me to the Zentangle method, and I haven't stopped using it since. I love to tangle and paint in my studio, surrounded by avocado trees and a beautiful view.

Sweet River

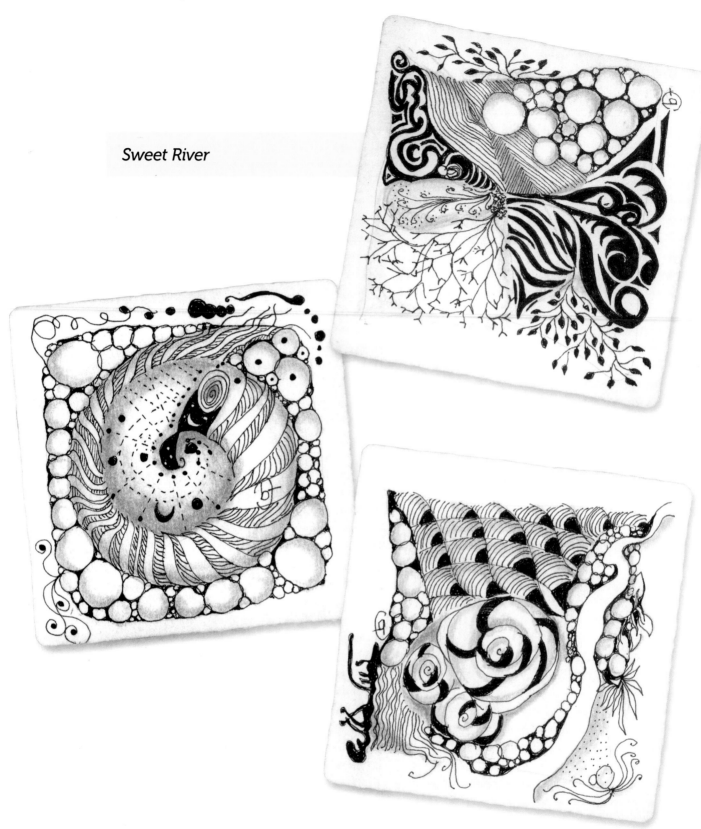

Bobbie Florida, CZT (TEXAS)
Zentangle paper tiles, Micron pens, pencil.

When my husband, Harvey, and I go out to eat, I take my little Zentangle box, and, while we are waiting, we do a Zentangle together. One of us will draw a string, and then we'll pass the art back and forth, adding whatever tangles strike us. We usually don't cross over into one another's patterns. If the service is really good, we finish our Zentangle at home and we have a little memento of our evening.

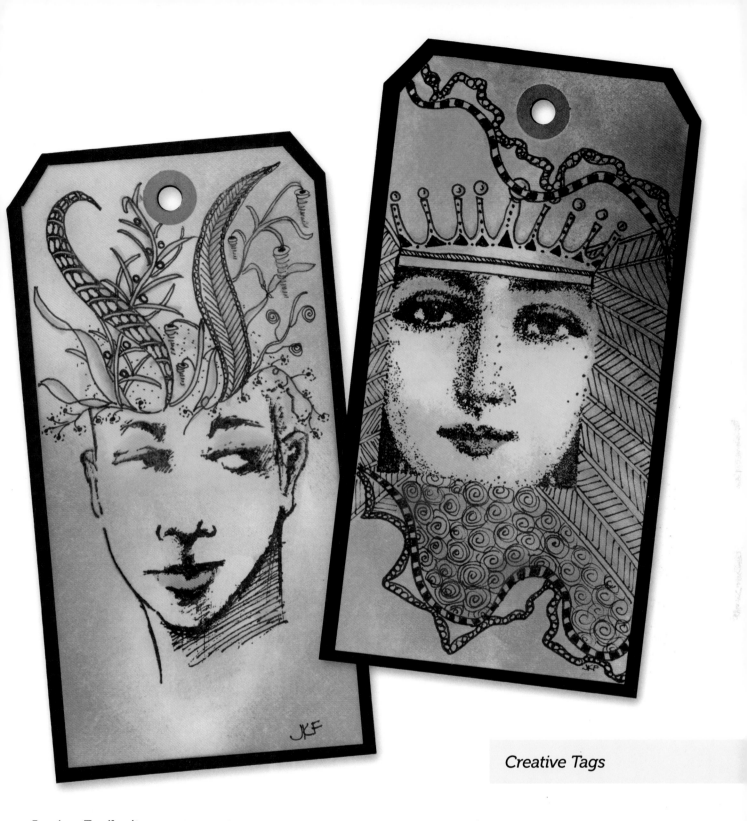

Janice Freiheit, CZT (TEXAS)

janicefreiheit@gmail.com

Cardstock tags, Micron pens, Ranger distress inks, rubber stamps from Invoke Arts and Stampers Anonymous.

I never thought I could actually draw anything until I found the Zentangle method. I saw an article about it in a magazine and became curious. I am a school librarian by trade, so I did my research and signed up for a class with CZT June Baty, and then went on to take a class with Maria Thomas and Rick Roberts. What a wonderful,

enlightening experience. I learned more about art in a few days than I thought possible. I also learned to keep the Zen in Zentangle and not be so critical of my own abilities. Combining my love of stamping with Zentangle seemed like a natural direction for me to go in.

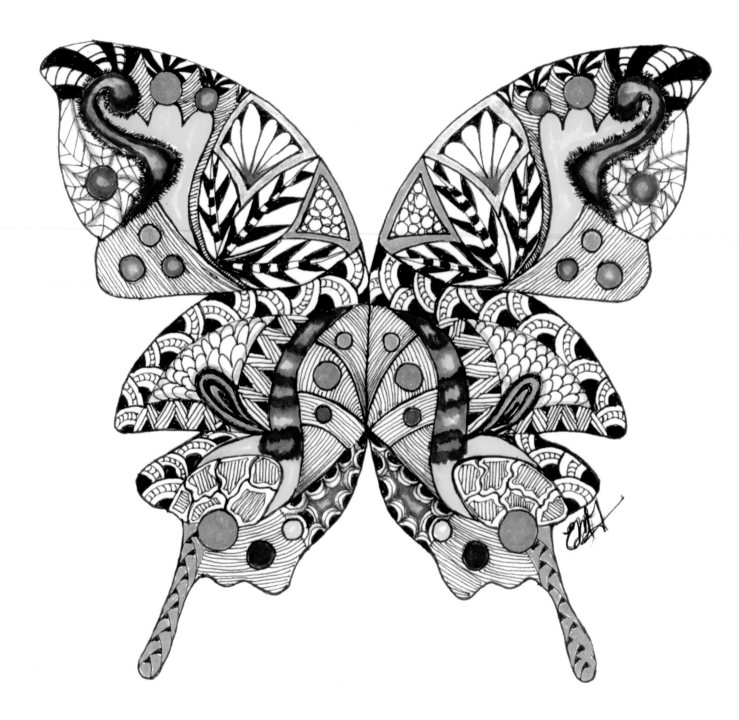

Estelle M. Goodnight, CZT (OHIO)

emgoodnight71@gmail.com
Watercolor paper, Micron pens, Tombow watercolor markers, Sakura Gelly Roll metallic pens, pencil.

I have always loved to do things with my hands. I sew, knit, crochet, paint, and do stained glass art and beading. When I overheard a conversation with the word "Zentangle" in it, my life changed. I took a class and was amazed at what I drew. I am a perfectionist, and tangling has helped me tremendously in learning NOT to be one. When I'm tangling, there is no sense of time. Teaching the Zentangle method has been so rewarding, because it has helped my students relax, focus, and be amazed by what they have drawn. I can't imagine my life without Zentangle.

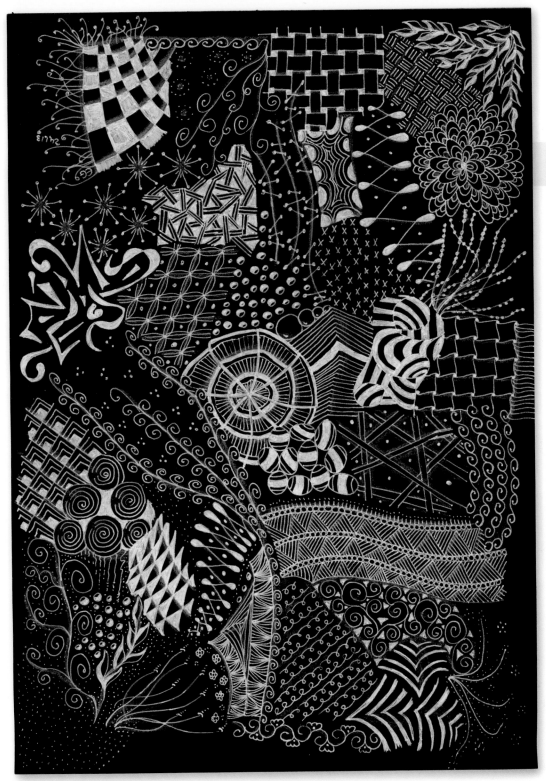

Ellen Gozeling, CZT (THE NETHERLANDS)
kunstkamer.info
Quality black paper, white Sakura Gelly Roll pen, white pencil.

I love the Zentangle method, because I can do it anywhere. Even on busy days, I can create for five minutes and feel relaxed and energized again. The piece shown here is one I made when I had an injury to my hand and could only hold a pen for five minutes a day. But five minutes a day for four weeks goes a long way toward creating something. I love sharing the Zentangle method and seeing how students using the same string and patterns all create something unique and personal.

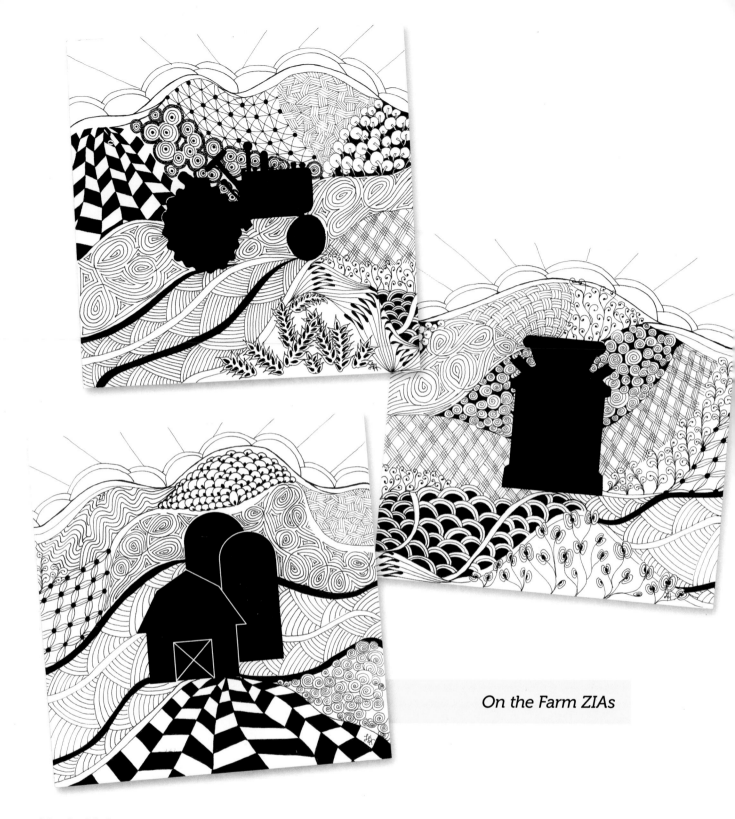

On the Farm ZIAs

Linda Halvorsen, CZT (PENNSYLVANIA)

bklynteecha@aol.com
Quality paper, Micron pens.

My Zentangle addiction began when a friend emailed information to me about Rick and Maria giving a Zentangle class near my home. Unfortunately, I could not attend, but my curiosity was sparked. I then drove four hours to attend a two-day Zentangle workshop in Massachusetts. I was immediately inspired by Rick and Maria and became hooked on Zentangle creations. I also attended the Zentangle Master Class held by Rick and Maria. The joy on the faces of students of all ages, particularly those who say "I really can't draw!", continues to inspire me to share this wonderful art form.

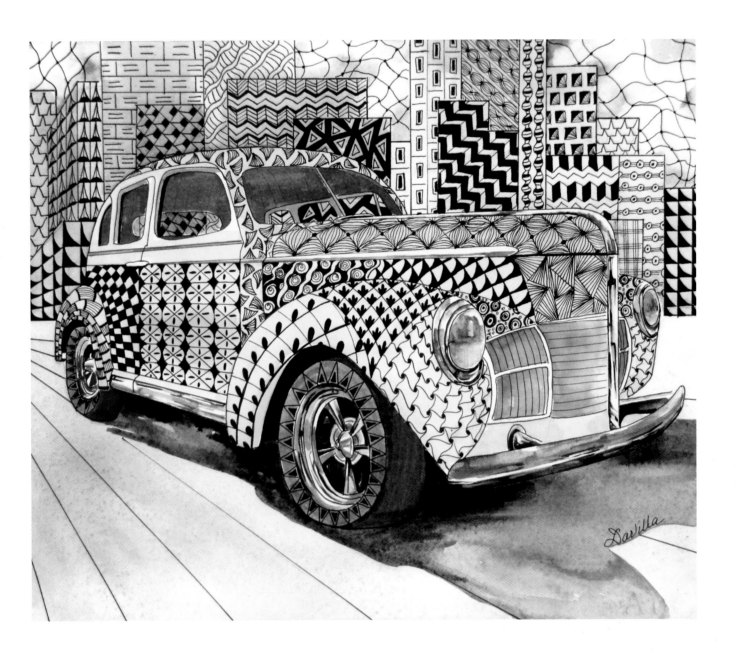

Davilla Harding (HAWAII)

artworksbydavilla.com
Arches HP (140 lb.) Watercolor paper, Micron pens.

I discovered the beauty of Zentangle at an art show in Texas when I saw a featured painting by Suzanne McNeill. I loved the beauty, energy, and movement of the designs and wondered how it was possible to make such intricate patterns. That painting stayed in my memory from that day forward. I had no idea the technique used to create the painting was called the Zentangle method. To my delight, I was able to attend a workshop given by Suzanne. Now in Hawaii, I continue to paint and tangle subjects with beauty and splendor.

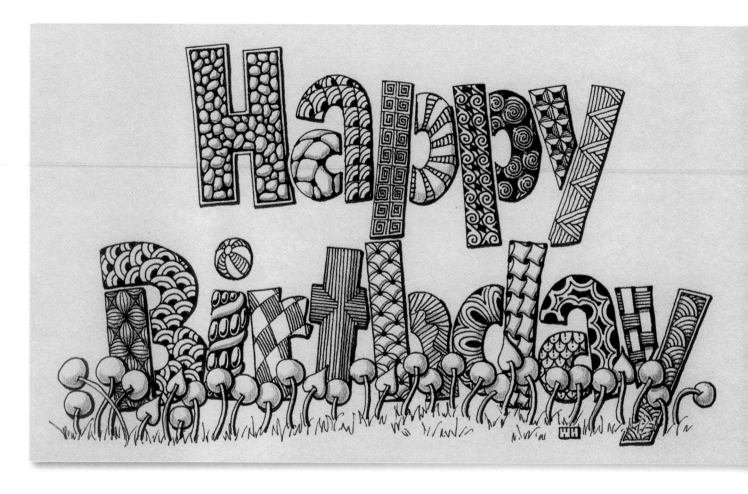

Wayne Harlow, CZT (CALIFORNIA)
Color cardstock, Micron pens, watercolor paints, pencil, stencil from Dreamweaver.

I graduated from college with a math/art double major and still did not know which I wanted to pursue for a career. My first job opportunity, however, was as a graphic artist, and that is what I have been ever since. I find the precision and structure of drawing patterns using the Zentangle method appeals to both my math and art sides. I found the Zentangle method after I saw the work of a friend of mine, who had tangled inside a stencil. My interest was piqued, and I spent the next year reading up on the art form via the Internet and learning as many tangles as I could. When it was clear that my interest wasn't just a passing fancy, I made the pilgrimage to study with Rick Roberts and Maria Thomas.

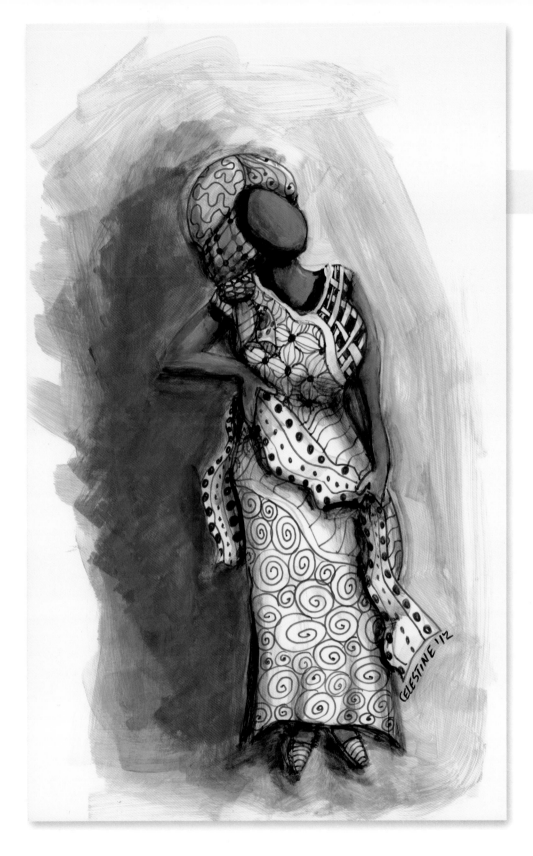

Celestine Hart, CZT (MICHIGAN)

celestinepaints.com/home
Archival illustration board, inking pen, pencil, acrylic paints.

I am an artist and painting teacher. I am an addicted crafter who enjoys knitting, crochet, and sewing, along with painting and the Zentangle method. Learning new artistic techniques is my favorite pastime.

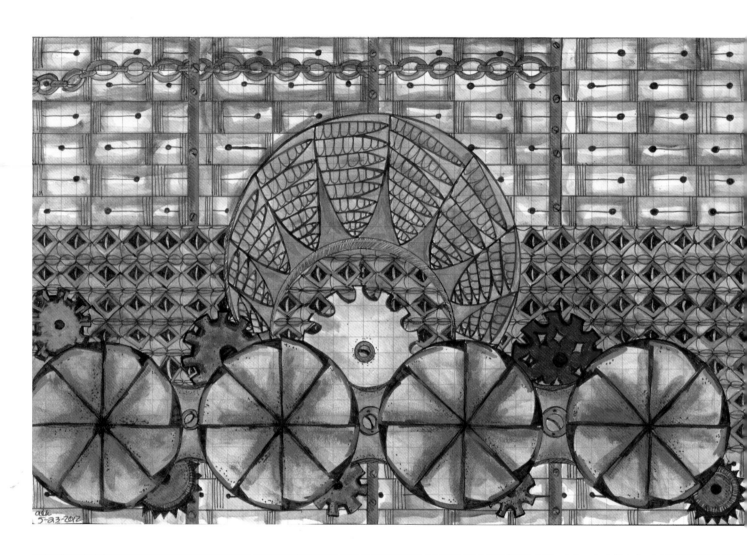

Steampunk Wall

Alice Hendon, CZT (FLORIDA)

thecreatorsleaf.blogspot.com
Quality paper, Micron pens, Inktense pencils, Zig metallic pens, metallic rub-ons.

I began my art journey after discovering that art journaling and the Zentangle method go together. Believing I could not draw, I fell in love with tangling and wanted to learn more. My interests in artistic themes include steampunk and organics. What I enjoy most is mixing Zentangle with bright, vivid color.

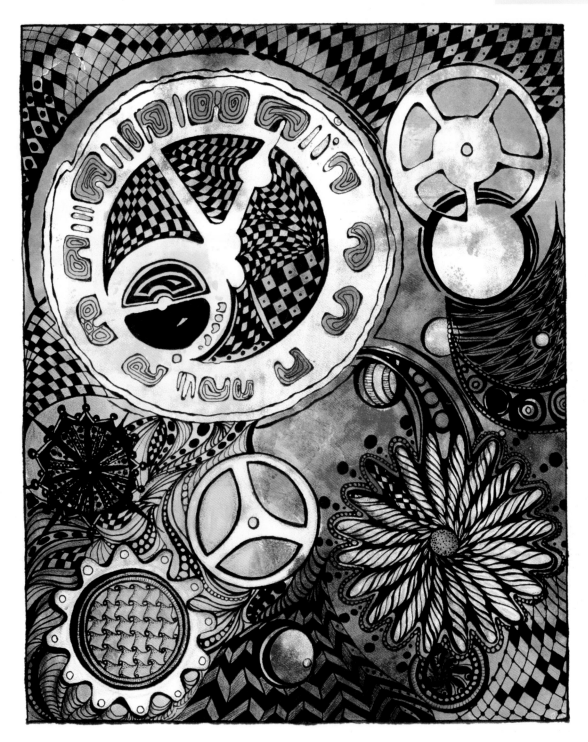

Sharla R. Hicks, CZT (CALIFORNIA)

sharlahicks.com
Quality paper, Micron pens, Permawriter, monoprint with Speedball printing ink.

It may shock many to know that I did not doodle in my younger years, and my drawing skills were, and still are, questionable, especially if realism is required. The gift of the Zentangle method has offered me a way to learn and to see. Okay, that sounds strange, but let me explain: I now know I am an artist who can draw the Zentangle way. Through daily tangle practice has come the discovery that I feel shape and form in my mind's eye, a quiet space where I create my own world of Zentangle-inspired art. Patterns pour out of my pen, turning lines and curves into geometric interpretations, botanicals, and zenscapes. The profound gift of tangling touches my soul in a way no other art form has, and I will be forever grateful to Rick and Maria.

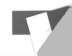

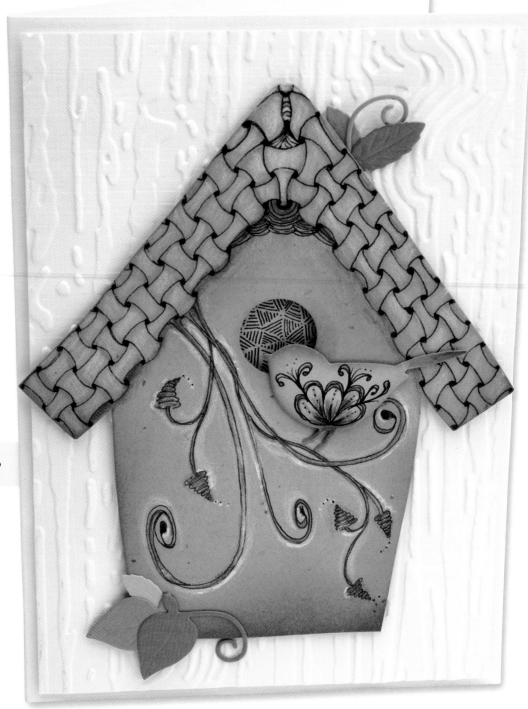

Bluebird at Home

Melissa Hoopes, CZT (NEW YORK)
stampassion.com
Cardstock, Micron pens, Prismacolor pencils.

My introduction to the Zentangle method was at a workshop with Rick and Maria—how lucky am I! I was hooked within fifteen minutes, and by the end of the workshop, I knew I wanted to learn more and teach the Zentangle method to others. To be able to facilitate the gift of drawing and to help others tap into the artist within them is beyond satisfying. Personally, the benefits of the Zentangle method, including calming the mind and spirit by picking up a pen and putting it to paper, have been substantial. Zentangle is a nourishing and multi-layered practice. Anyone can do it.

Donna Hornsby, CZT (TEXAS)

pegasuspapers.com
Watercolor paper, Micron pens.

Many know me as a horse and carriage driver; some know me as a catamaran sailor; others know me as a social media personality; and then there are those who know me for Zentangle. Tangling came into my life, and the journey has been nothing less than exciting and fulfilling. My favorite expression of this art form is creating Zentangle-inspired works using 6" x 18" (15 x 45.5cm) paper. While my day job is very demanding, I still find time to practice Zentangle and teach classes.

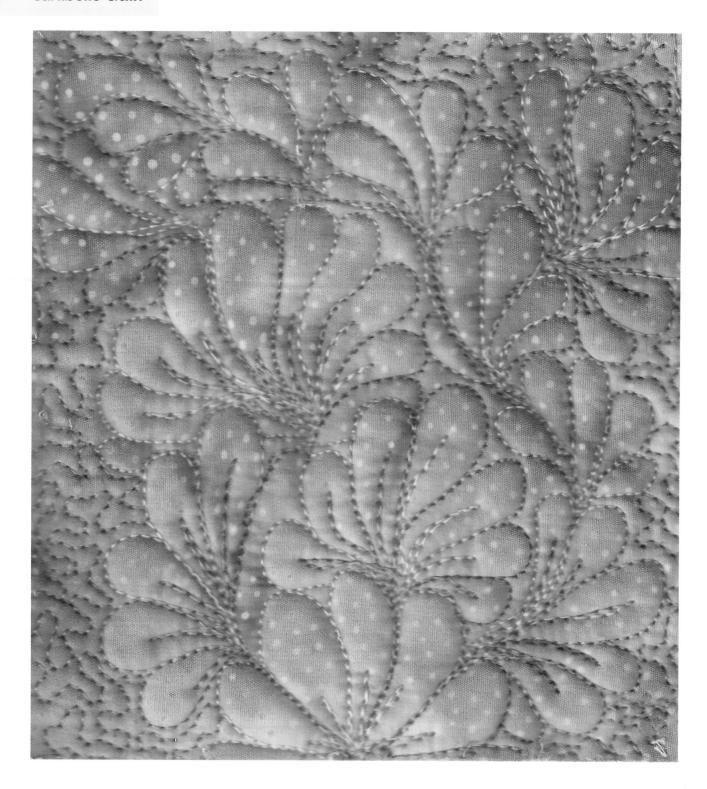

Elaine Huffman, CZT (MASSACHUSETTS)

sewtangled.blogspot.com
Batik fabric, cotton batting, cotton and rayon threads.

As a quilter, I am fascinated by patterns! Designs are everywhere, and I look for ways to incorporate the patterns I find into quilting. CZT Tricia Faraone's tangle *Sanibelle* is a natural for quilting. Many tangles are easily adapted to quilting and can be used in contemporary quilts, traditional quilts, and quilted art.

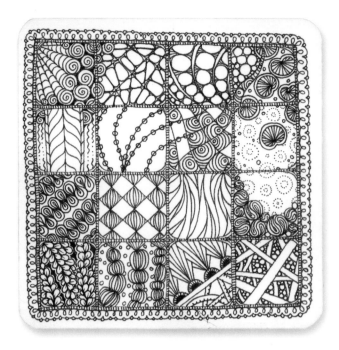

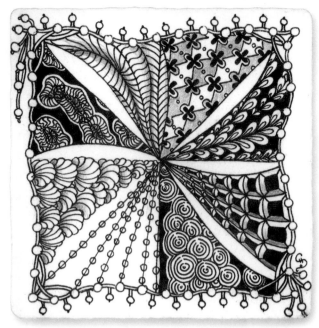

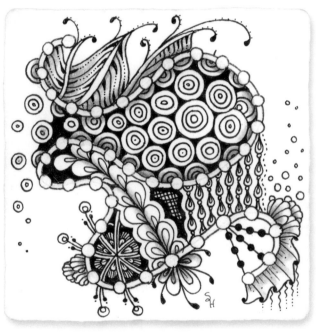

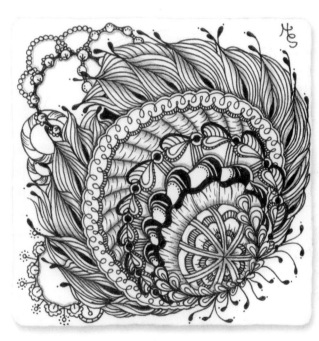

Samplers

Sandy Hunter, CZT (TEXAS)

tanglebucket.blogspot.com
Zentangle paper tiles, Micron pens.

There are so many things to love about the Zentangle method. I love the simplicity and accessibility of it, and the huge network of tanglers that share my enthusiasm. It is portable, can be social or solitary, takes very few materials, and doesn't require charging like many of the electronics we use every day. Every completed tangle turns out different than the last, and every blank tile holds potential. Zentangle is a great way to get people excited about art; especially those who say they "can't draw a straight line." I love witnessing that stunned moment of realization when it dawns on others that they can do more with a pen than they ever imagined.

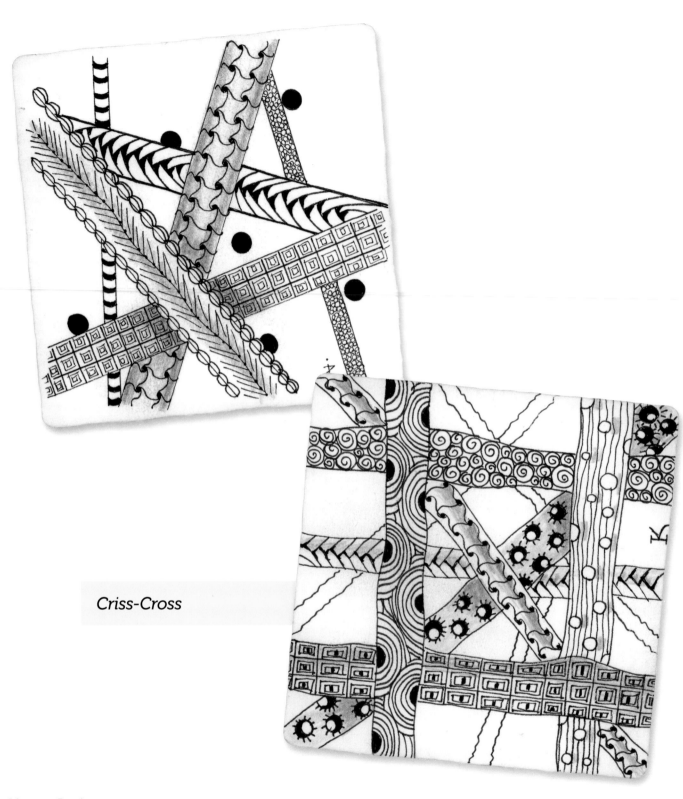

Criss-Cross

Karen Izzi, PhD, CZT (PENNSYLVANIA)
karenizzi.org
Zentangle paper tiles, Micron pens, pencil.

I am an artist and probably have been all my life. Because Zentangle is traditionally created using black pens on quality white paper—and to promote peace of mind—well, it was love at first sight! As I explored pens in my collection and tried different types of paper in my stash, I realized that tangling can be done anywhere, on any surface. I tangle on fabric, rocks, sticks, beads, and even on feet.

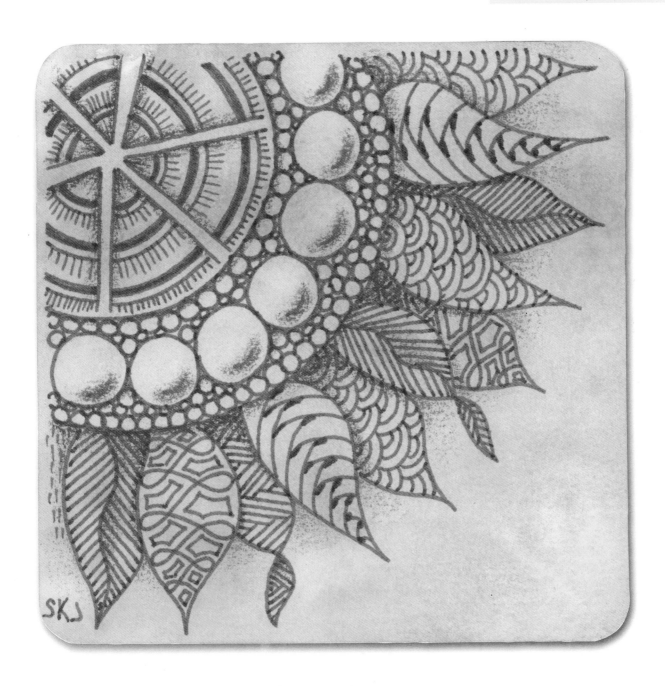

Sue Jacobs, CZT (ILLINOIS)

suejacobs.blogspot.com
Zentangle paper tile, Micron pens in sepia, Prismacolor pencils.

In college, I did cross stitch and Ukrainian Easter Eggs. As a young mom, I did papier-mâché and tried gourmet cooking. I became an accomplished decorative painter and muralist. I have many beautiful pieces, but also lots of UFOs—unfinished objects. When I discovered the Zentangle method, I realized I could use many of the techniques I learned through my different areas of study. By doing tangles on tiles of paper, I could get each one finished and have something to be proud of. I love to experiment with different ways to use color. Zentangle has become the perfect way for me to express my creative side.

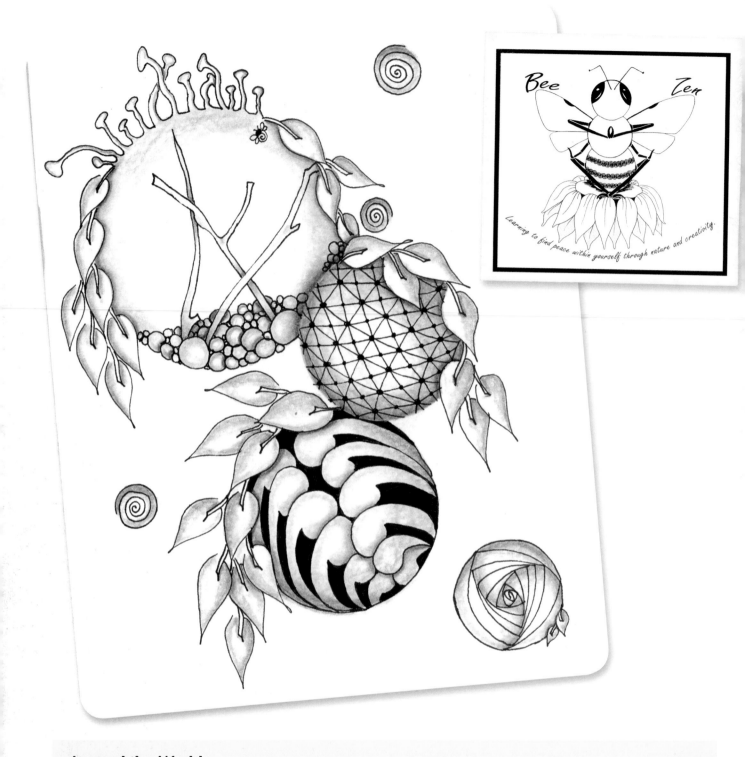

Around the World

Denyse Gower Jones, CZT (CONNECTICUT)

beezen.blogspot.com
Watercolor paper, Micron pens, Slicci gold pen, pencil.

When I first stumbled across Zentangle, I loved the look and have been an addict ever since! This isn't a passing hobby for me, and I am getting amazing benefits from it! This is an amazing art form in so many ways that it needs to be shared. Since discovering Zentangle, I have confidence in my artwork again, after abandoning art for almost twenty years—all because one teacher didn't like my abstract style! Thank you, Rick and Maria, for bringing passion back to my life.

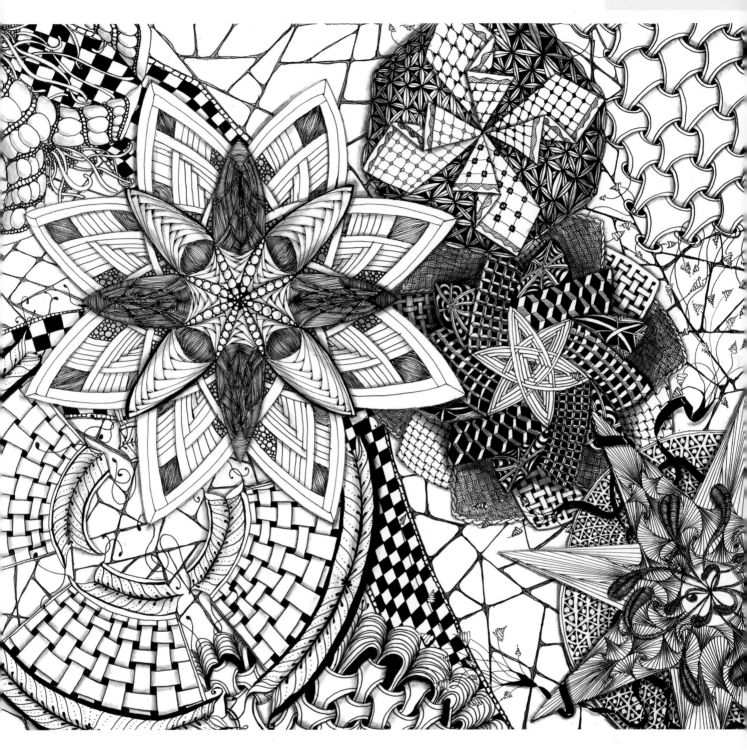

Kelley Kelly, CZT (CONNECTICUT)

thepathuntangled.com
Paris Paper for Pens, Micron pens, radiograph, pencil.

Once upon a time, ok, about forty-six years ago, a baby girl was born. This ornamental child, as she came to be referred to by her ever-so-practical parents, was (and is) a geek, loving books, music, and art. She grew and grew and went off to college to study (ack!) music and art and then photography. When she finally got a job as a paralegal and got married, her parents breathed an enormous sigh of relief. But always, always, she needed to sing and create and, to be honest, became very hard to live with when she couldn't. Fast forward to a house, a pilot's license, two jobs, a singing career, and three small children later, she discovered the Zentangle method and her soul breathed that same enormous sigh of relief.

Run Around

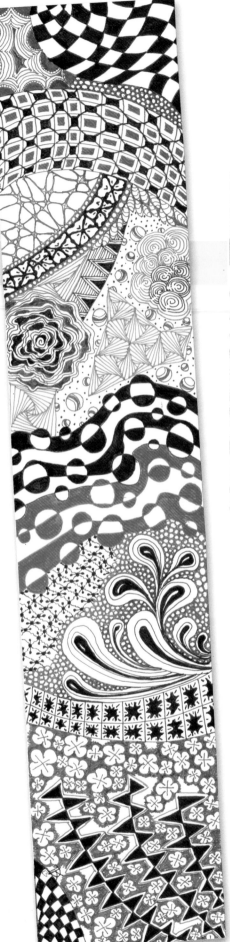

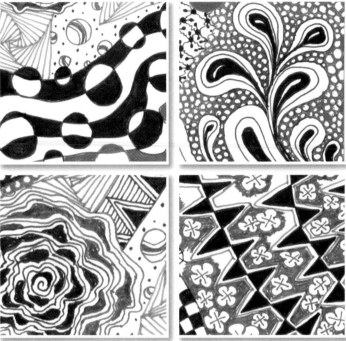

Denise Knobloch, PSS, CZT (CALIFORNIA)
uncoveringpathways.blogspot.com
Quality paper, Micron pens.

I came across the Zentangle method while looking at books that might inspire someone else to get back into their art. I found inspiration for myself as well. I soon realized that there are so many benefits of this mindful practice. I took classes and I started teaching the Zentangle method as a wellness tool in my work as a Personal Support Specialist. I have seen many positive changes in myself and others by learning this method. It is amazing and fun!

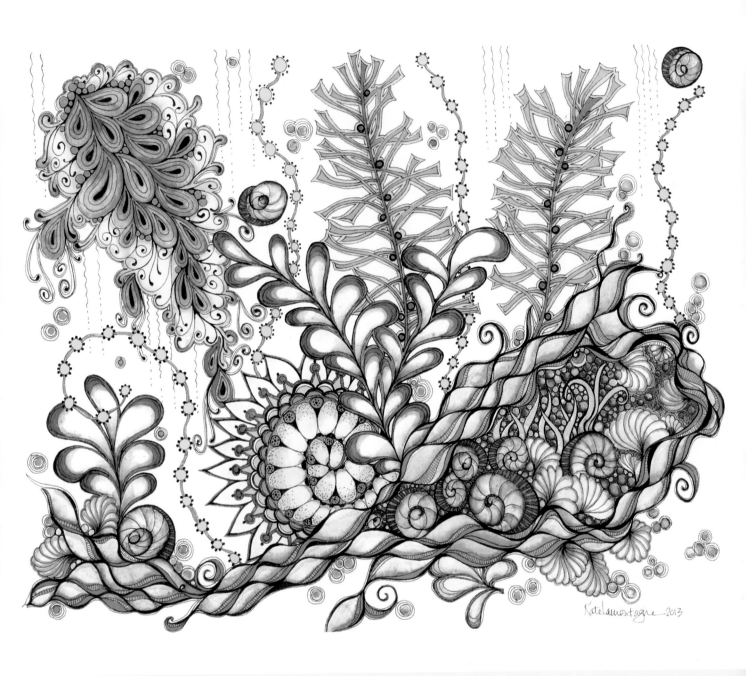

Under the Sea

Kate Lamontagne, CZT (MASSACHUSETTS)

kate@kamalaboutique.com
Quality color paper, Micron pens in black and colors, Tombow markers, Utrecht markers.

My creative life began with a "grown-up" sewing machine at age six. I studied fashion design and went back to study painting at mid-life. Self-employed, my daily work revolves around creativity. Through the Zentangle method, I am able to light the creative spark in people that don't know they have it in them! My tangle *Kurtinz* on page 174 is inspired by sheer striped drapes. For me, the beauty of this pattern is the hem that emerges out of the funnel-shaped spaces.

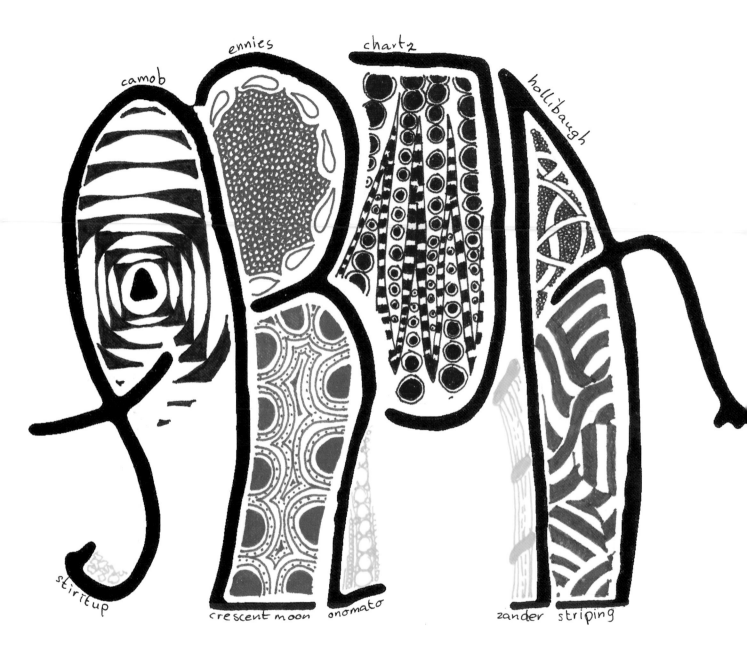

camob · ennies · chartz · hollibaugh · stiritup · crescent moon · onomato · zander striping

Arja de Lange-Huisman, CZT (THE NETHERLANDS)

elefantangle.blogspot.nl
Quality paper, permanent marker, Stabilo Fineliner pens in color.

I found the Zentangle method on the Internet while I was searching for Op-Art teaching materials for a workshop on my twelve-year wedding anniversary. I was "tangled" at once. The first weeks I tangled "inchies" while sitting near my children, waiting for them to fall asleep. One and a half years later, I attended a class with Rick and Maria, being the third person from the Netherlands to do so. My nights are now without interruption of thoughts…I sleep wonderfully from the moment I set aside the tangle I am working on before bed. I won't change that anymore.

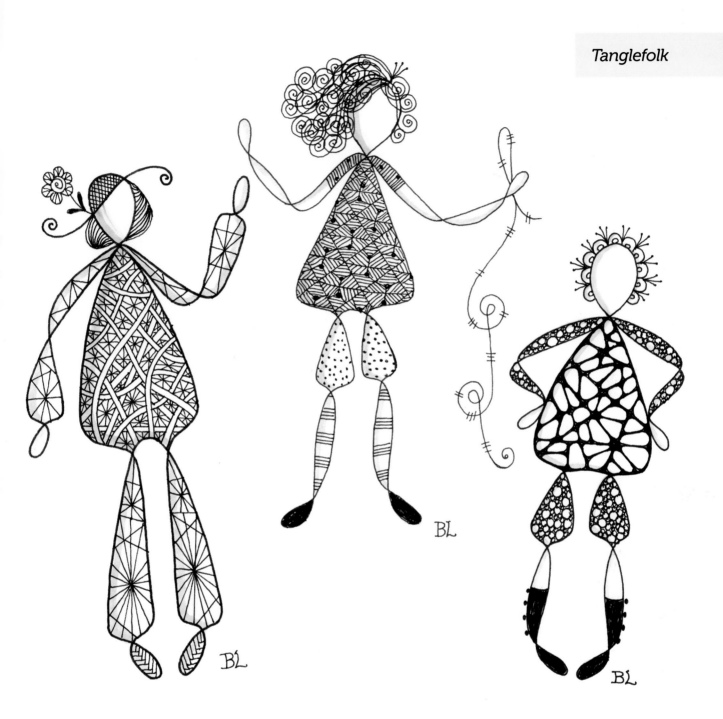

Billie Lauder, CZT (NEW MEXICO)

quiltmingo@aol.com
Quality paper, Micron pens, pencil, Prismacolor cool gray color pencils.

The Zentangle method has brought me pleasure and peace. I discovered it at a quilt show where I was teaching quiltmaking. At first, I did not understand the true value of Zentangle because all I saw was doodling. But NO! It is so much more. The process and thought involved in tangling relaxes you—grabs you. It helped me get through the grief of my brother's death. Anyone can do it and be so proud of what they have done. I travel with my pens and tiles and tangle whenever I can. Tangling in shapes developed into "Tanglefolk." The characters evolved into fun human shapes. I think of their body shapes as the string and tangle inside the shapes.

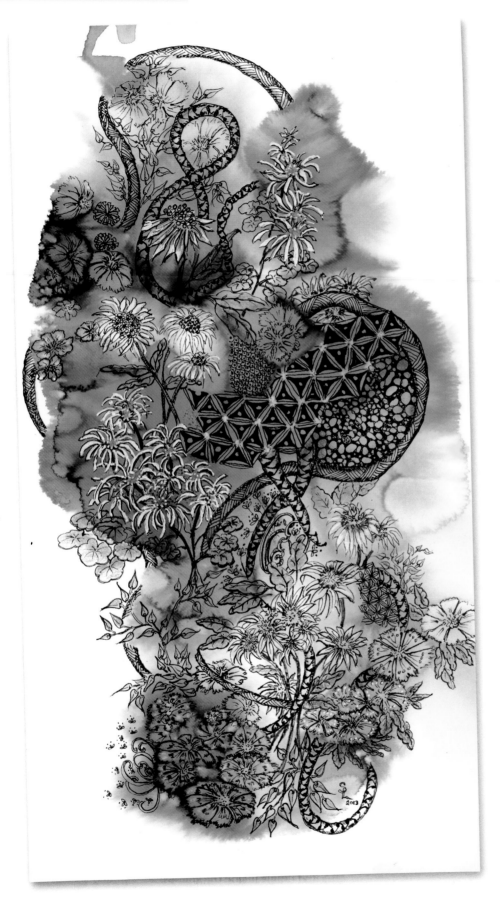

Susan Lazaruk, CZT
(CANADA)
lesla@telus.net
Watercolor paper, Micron pens,
food coloring, water, kosher salt.

I have taught art for fifteen years
to both adults and children. Art
became a passion—learning,
studying formally, and exploring
different techniques. Sharing this
with others has been very exciting.
The Zentangle method became a
new fascination and passion that
I now share and teach. Integrating
other art techniques and media
with tangling has extended my
exploration and adventure to
new heights. My students love
Zentangle! They can't wait to get
started and enjoy sharing their
creations and their own tangle
patterns with great enthusiasm.

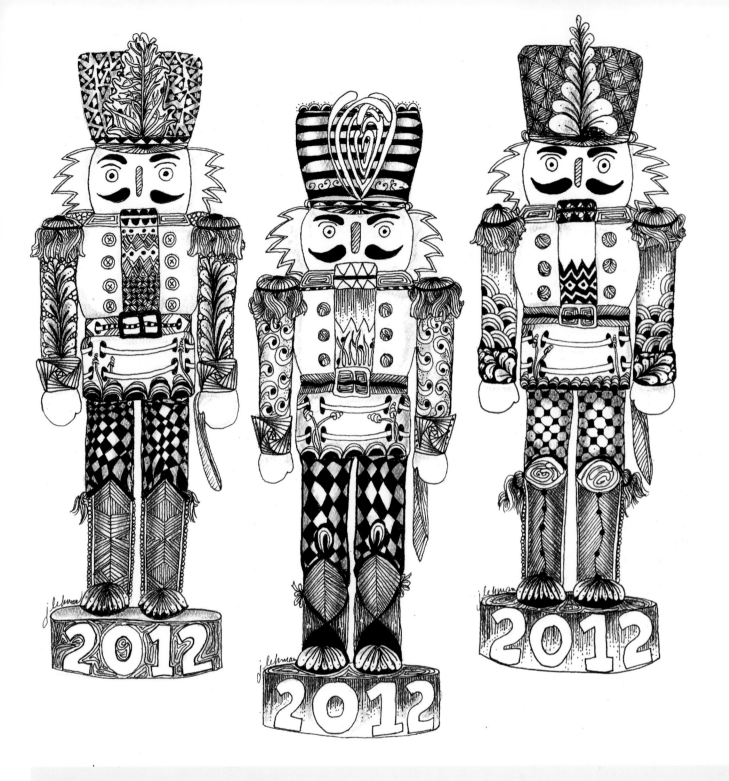

Nutcrackers

Judy Lehman, CZT (TEXAS)
btangled.com
Quality drawing paper, Micron pens.

I am an experienced designer, art educator, and fiber artist who tours and teaches nationally. I incorporate the art of Zentangle in all areas of my teaching and design career. I teach the value of the focused, repetitive tangles. I encourage students to tap into forgotten skills, while building self-confidence and becoming instant artists! Known as an enthusiastic color and design specialist, I try to bring an aesthetic flair to all that I create.

Inch by Inch

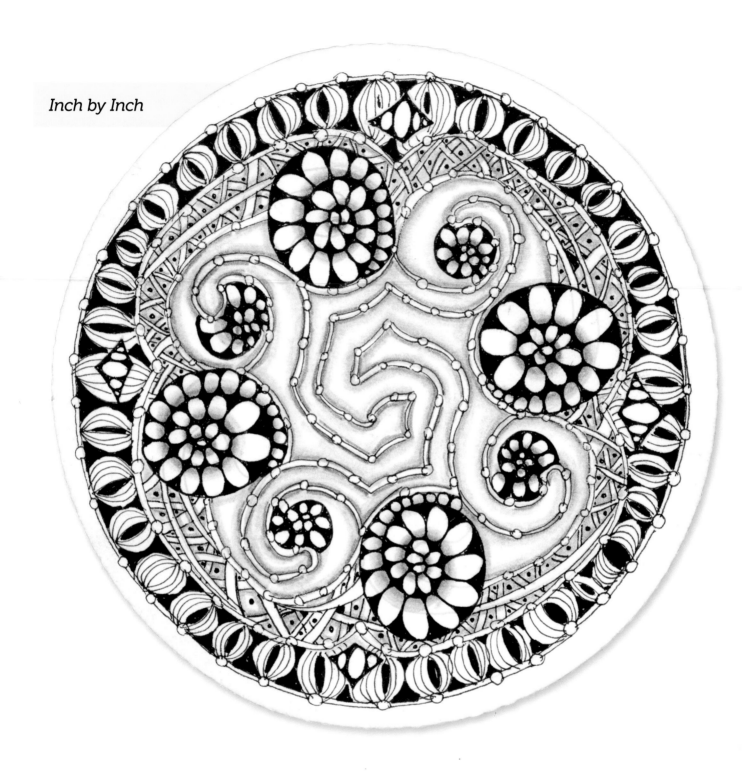

Cris Letourneau, CZT (OHIO)

tangledupinart.com
Zendala paper tile, Micron pens, pencil.

I've done all kinds of art since I was a child, but it had always been a hobby until I discovered the Zentangle method. I was immediately hooked and became a Certified Zentangle Teacher four months later. Since then, I have discovered a love of teaching and helping others develop their creativity and discover (or rediscover) their own inner artist. I have published my first book dedicated to shading tangle patterns, *Made in the Shade*.

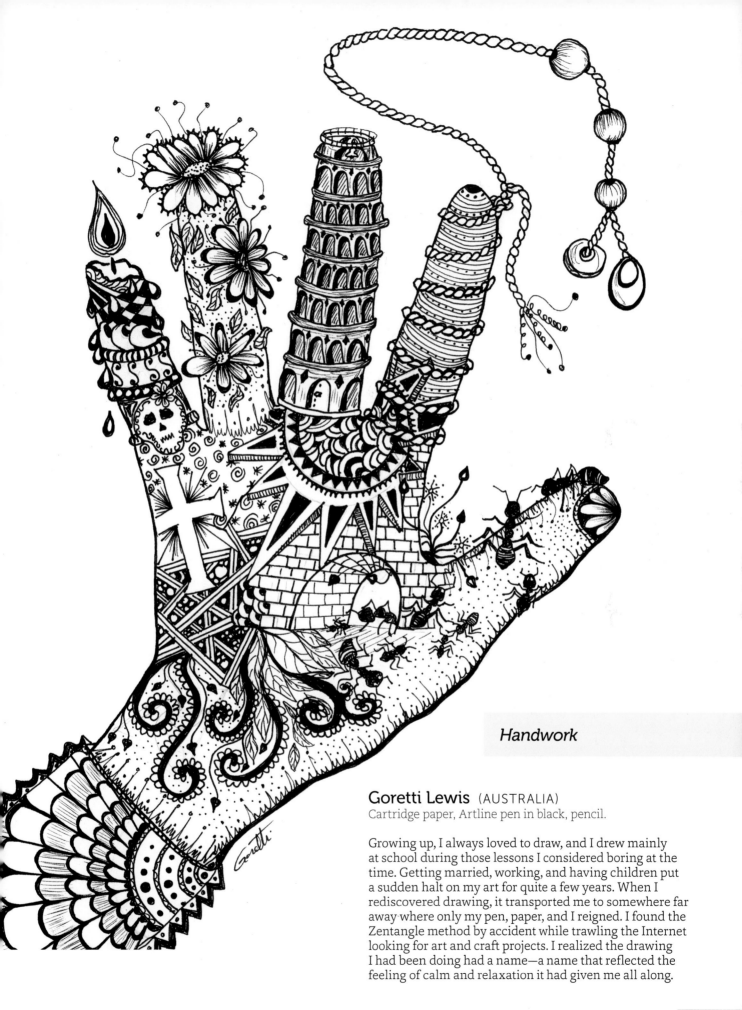

Goretti Lewis (AUSTRALIA)
Cartridge paper, Artline pen in black, pencil.

Growing up, I always loved to draw, and I drew mainly at school during those lessons I considered boring at the time. Getting married, working, and having children put a sudden halt on my art for quite a few years. When I rediscovered drawing, it transported me to somewhere far away where only my pen, paper, and I reigned. I found the Zentangle method by accident while trawling the Internet looking for art and craft projects. I realized the drawing I had been doing had a name—a name that reflected the feeling of calm and relaxation it had given me all along.

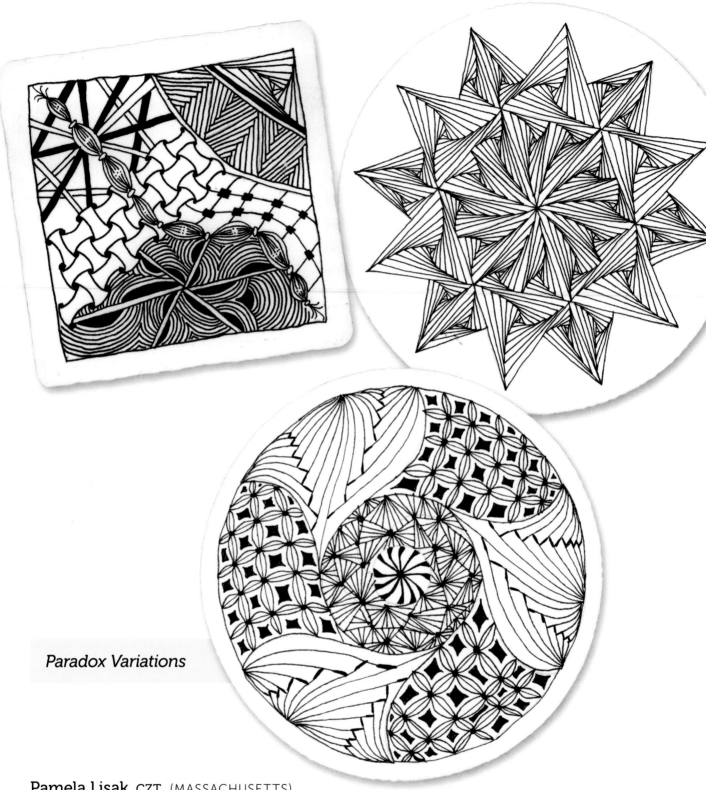

Paradox Variations

Pamela Lisak, CZT (MASSACHUSETTS)
pamee@charter.net
Zentangle paper tiles, Zendala paper tiles, Micron pens.

I live in Whitinsville, Massachusetts, where the art form of Zentangle began. My very first tile is dated 2004. Once I learned to tangle, I could not stop. It is relaxing, fun, and brings such joy to others. My favorite memory of tangling is of a time when a total stranger asked me about the Zentangle T-shirt I was wearing. I told him about the Zentangle method and he asked to see my work. He liked one of my tiles so much that he photographed and framed it—it is four feet (1.2m) square! It now resides in his studio (he is a musician). A new friendship was made!

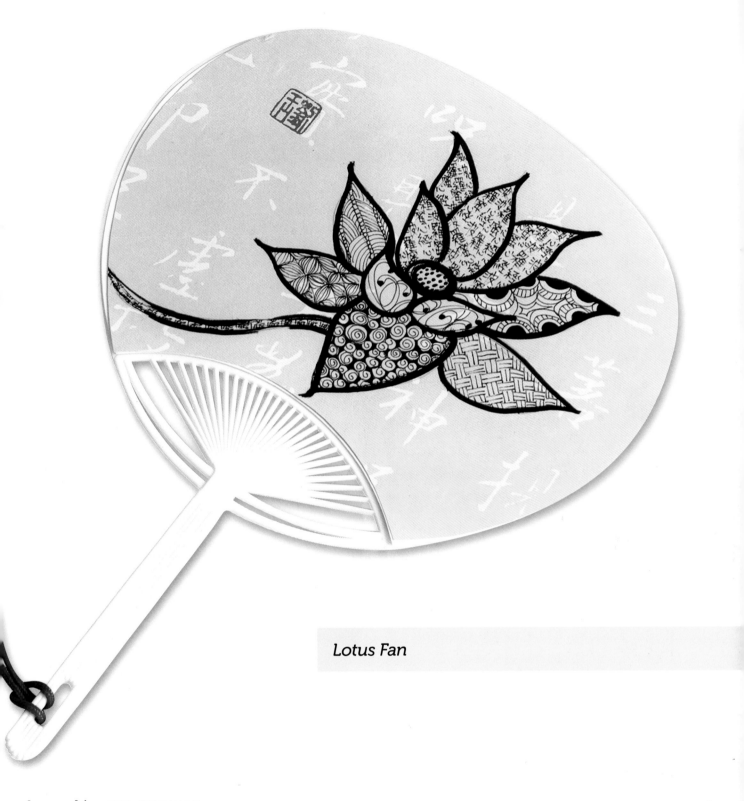

Lotus Fan

Laura Liu, CZT (TAIWAN)
tw.myblog.yahoo.com/noeraser-zentangle
Kodomo scrapbook paper, Micron pens, Sakura brush pen, fan frame.

Zentangle is an art that I love. Tangling is healing to me and helps me stay in a calm and enjoyable world. I attended a workshop with Rick Roberts and Maria Thomas and am the first Certified Zentangle Teacher in Taiwan.

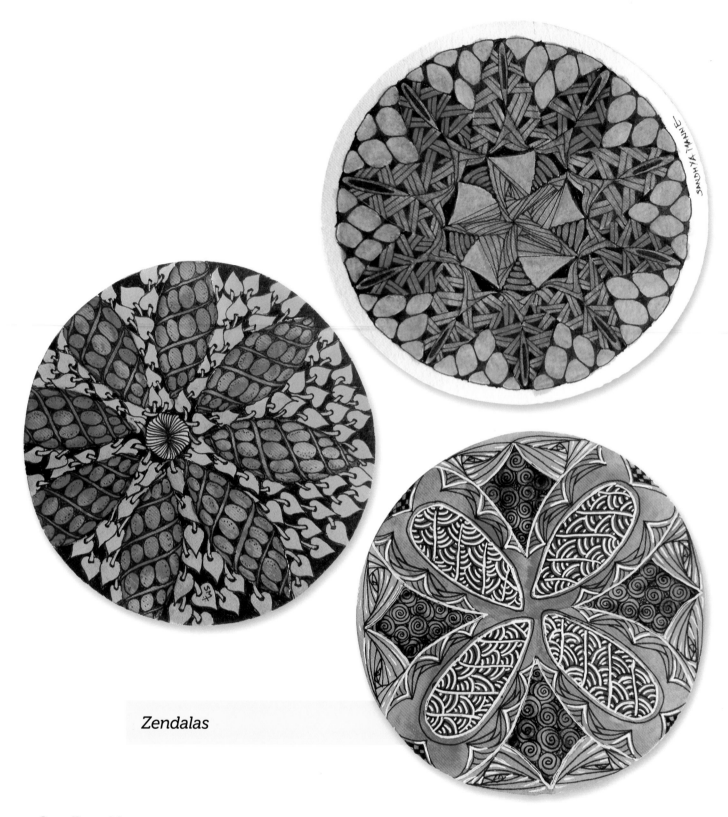

Zendalas

Sandhya Manne, CZT (INDIA)

zentempletangles.com
Zendala paper tiles, Micron pens, watercolors, brush.

I have always been an artist as part of my culture in India. I grew up making patterns in the form of Kolams on the floor and Henna drawings on hands. So, it is no surprise that I took to Zentangle. Practicing and teaching the Zentangle method has helped me calm down. I am no longer anxious. I have begun to trust the universe and believe that everything will turn out beautiful at the end. It is all about "one stroke at a time."

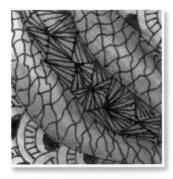

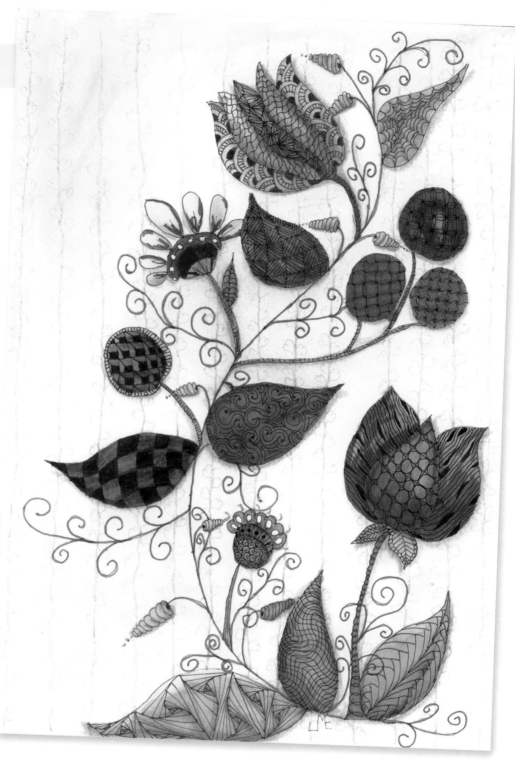

Judith McCabe, CZT (PENNSYLVANIA)

judithmccabeczt.com
Quality paper, Micron pens, Tombow and Koi watercolor pens, Sakura Gelly Roll Stardust pens, pencil.

Although I have always been creative and hold an MFA, I still rarely refer to myself as an artist. The amazing thing about Zentangle to me is that from the time I heard Rick and Maria talk about the simplicity of design, the need to know simple strokes and focus on the time and place you are in, I was hooked. I have felt my confidence grow; I try not to compare myself to others and take joy in the process of creating. It has not always been easy, and there are times when my inability to create something perfect makes me frustrated, but part of the beauty of Zentangle is that I keep going back. Whether I am working on my own or teaching others, I return again and again to the basics and the desire to create. Be inspired by what you see on these pages, but don't be intimidated. Bring your own thoughts and desires to this process and simply pick up a pen and start.

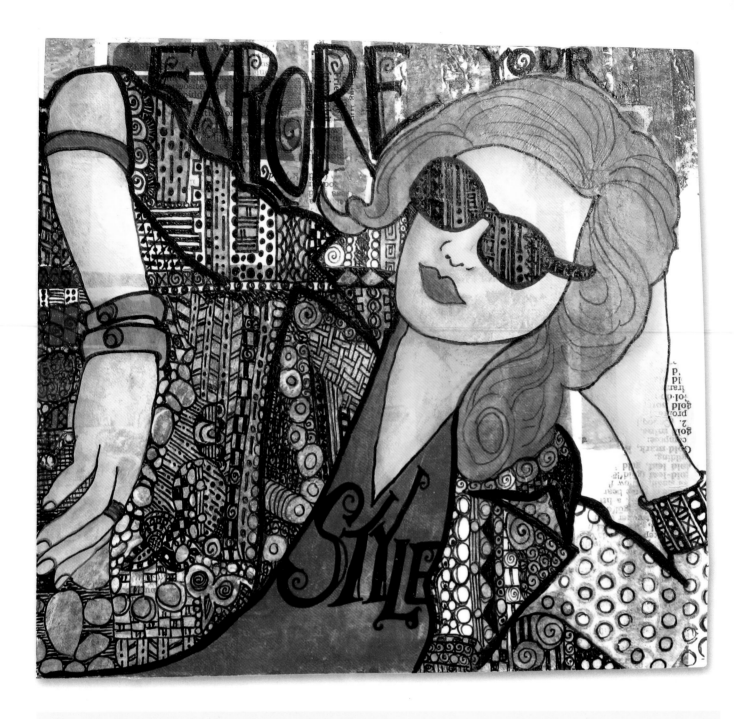

Explore Your Style

Kari McKnight-Holbrook (OHIO)
backporchartessa.blogspot.com
Watercolor paper (140 lb.), Pitt artist pens, acrylic paints, stamped papers, gel medium.

I love Zentangle! I find it very therapeutic, as well as a great tool to loosen up if I am sort of blocked in the studio. I have entire notebooks filled with tangles that have gone off the beaten track. When I began tangling inside my own drawings I found JOY! Also known as The Backporch Artessa, I am an award-winning artist, photographer, instructor, and author and have my own stamp line. I delight in sharing my love for art with students, watching them bloom in their artistic journeys. I try to keep my classes engaging and lighthearted and design them with the student's pleasure and success in mind. I like to guide projects and techniques while allowing for artistic self-discovery and individualization.

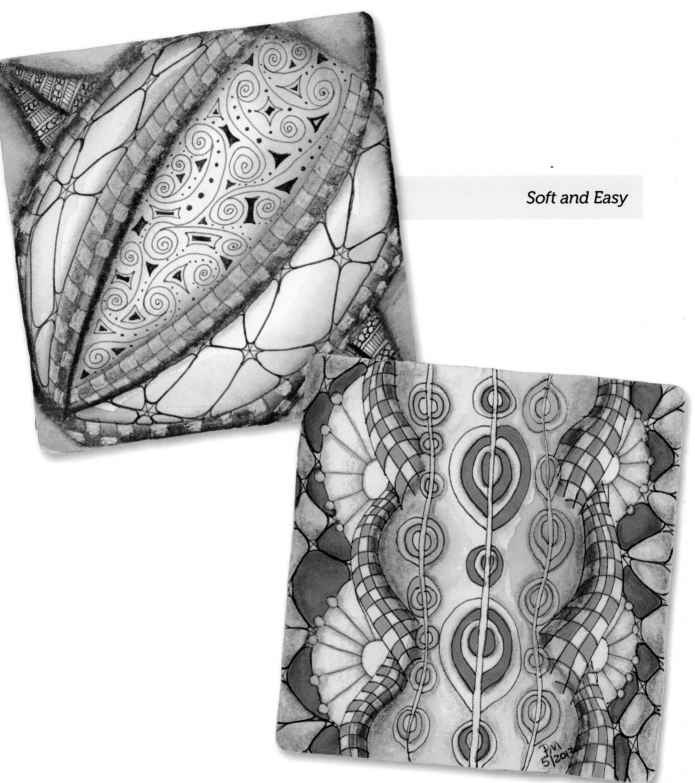

Patricia A. Meijer, CZT (MARYLAND)

ptrish40-zekesden.blogspot.com
Zentangle paper tiles, Micron pens in black and sepia, watercolor crayons,
Prismacolor marker, white gel pen, colored pencils.

I am a full-time special education teacher who has always been interested in art. The Zentangle method is a way for me to relax at the end of a busy day. The size of the tiles, the immediate feedback from the feel of the ink on the paper, and the beauty of the finished tiles is quite reinforcing, and I became addicted immediately. I love color, so I quickly began to explore using color with my tangled projects. I started a Zentangle-Inspired Art group on Yahoo, which I moderate. The ZIA group has been a wonderful avenue for sharing and exploring my love of Zentangle and ZIA art.

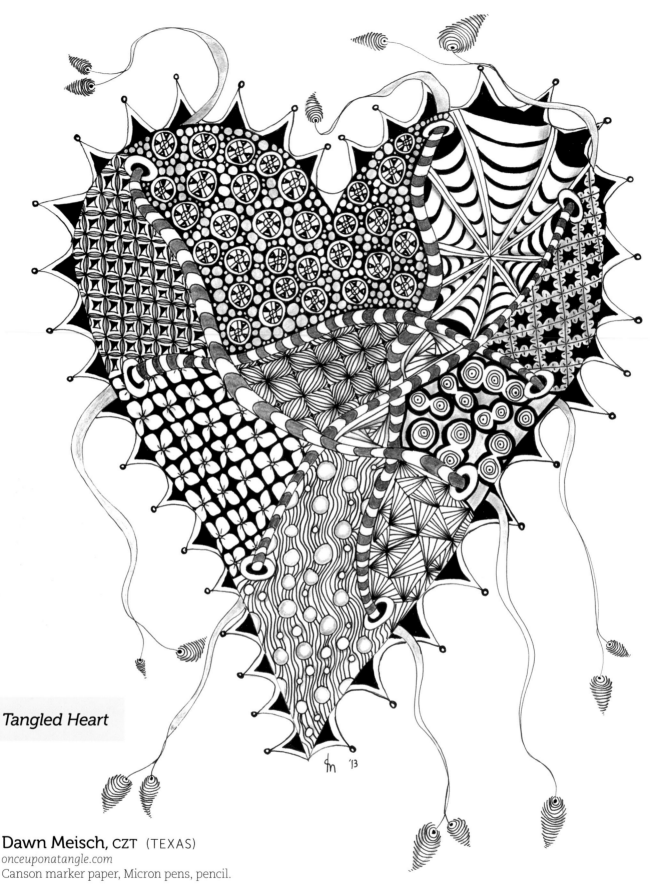

Tangled Heart

Dawn Meisch, CZT (TEXAS)

onceuponatangle.com
Canson marker paper, Micron pens, pencil.

I have always been an artist—specifically a bookmaker. After having a child, I needed an artistic outlet that took much less time. I ordered a Zentangle kit from *zentangle.com* and was instantly enamored. Tangling has helped me gain artistic confidence and has improved my drawing abilities. I enjoy sharing my passion for the Zentangle method with others.

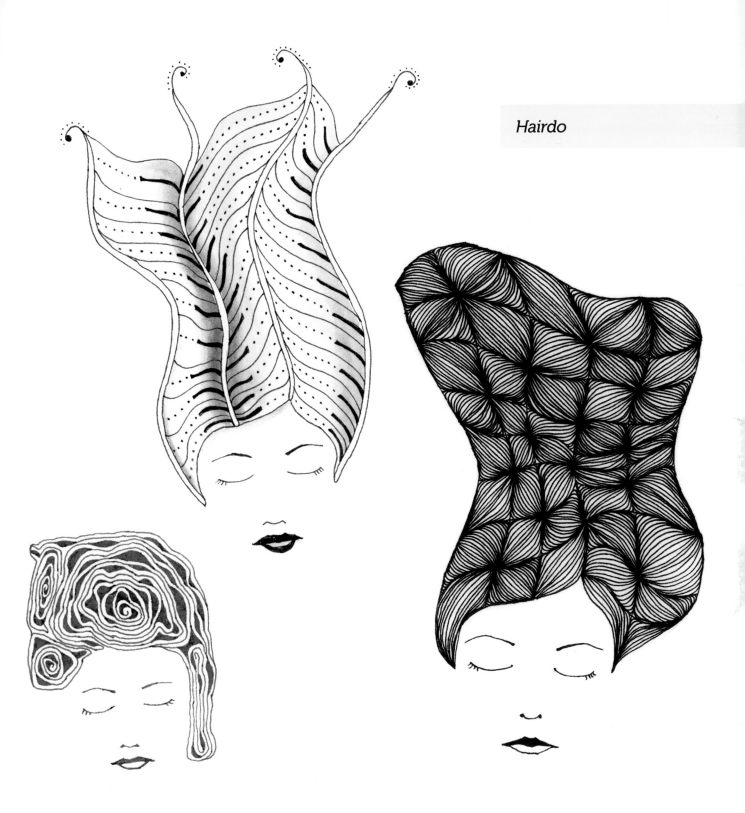

Grace Mendez, CZT (CALIFORNIA)

gracemendez.com
Watercolor paper (CP, 140 lb.), Micron pens, Sakura Koi watercolors.

The Zentangle method removed the limiting belief I had about drawing. Earning my art degree in Installation Art meant I was able to graduate with the minimum requirements in drawing courses. Now, I love to draw. I have even moved from abstract compositions to whimsical illustrations incorporating tangle patterns. Zentangle opened up these possibilities. To me, that is the beauty of Zentangle. It took me beyond my own expectations in surprising ways.

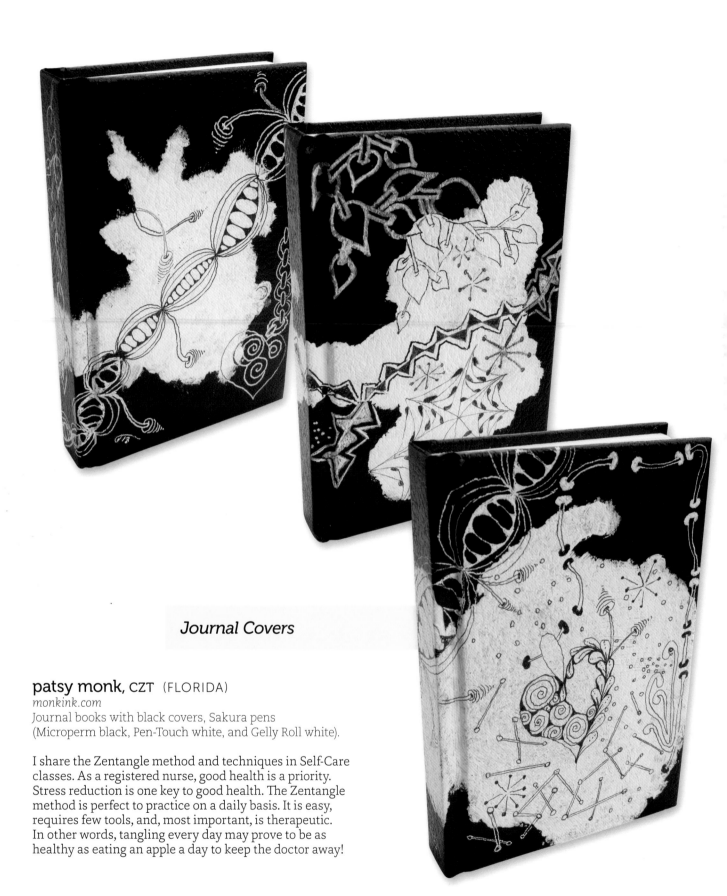

Journal Covers

patsy monk, CZT (FLORIDA)
monkink.com
Journal books with black covers, Sakura pens
(Microperm black, Pen-Touch white, and Gelly Roll white).

I share the Zentangle method and techniques in Self-Care classes. As a registered nurse, good health is a priority. Stress reduction is one key to good health. The Zentangle method is perfect to practice on a daily basis. It is easy, requires few tools, and, most important, is therapeutic. In other words, tangling every day may prove to be as healthy as eating an apple a day to keep the doctor away!

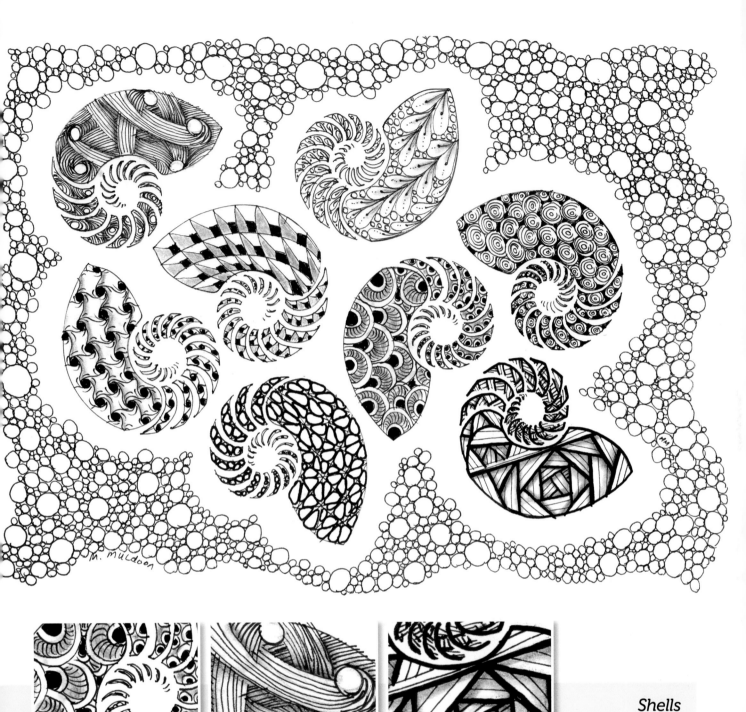

Shells

Magdalena Muldoon (TEXAS)
mercartusa.com
Quality paper, Micron pens, pencil, Mercart paper stump #1.

I have been teaching traditional metal embossing for eighteen years, and when I saw some Zentangle projects, they reminded me a lot of the textures, tangles, and backgrounds I used in my metal art. I immediately saw the similarities and fell in love with this new approach.

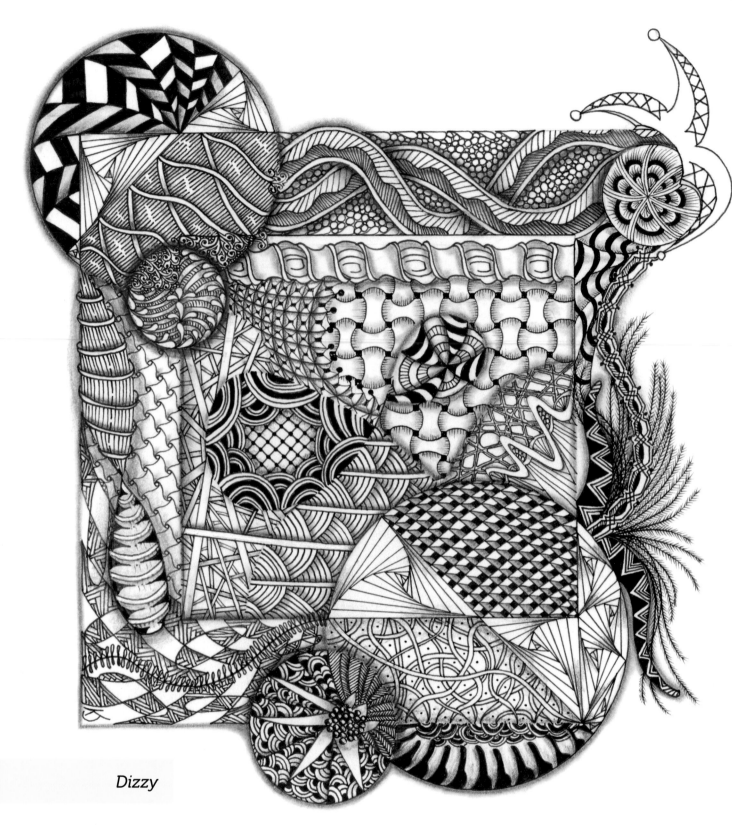

Dizzy

Kit Murdoch, CZT (AUSTRALIA)

kit@tangledtasmania.com.au
Quality paper, Micron pens, pencil, tortillon paper stump.

From a background in graphic design, I began my artistic journey with calligraphy, Chinese brush painting, and photography. When I discovered the Zentangle method, it felt like coming home. I love the quiet beauty of creating tangles and carry my sketchbook with me everywhere.

I love teaching the meditative aspect of this amazing art form and its potential for unlocking the creative processes. I'm currently writing my first novel and living the artistic life I've long dreamed of on the beautiful island state of Tasmania.

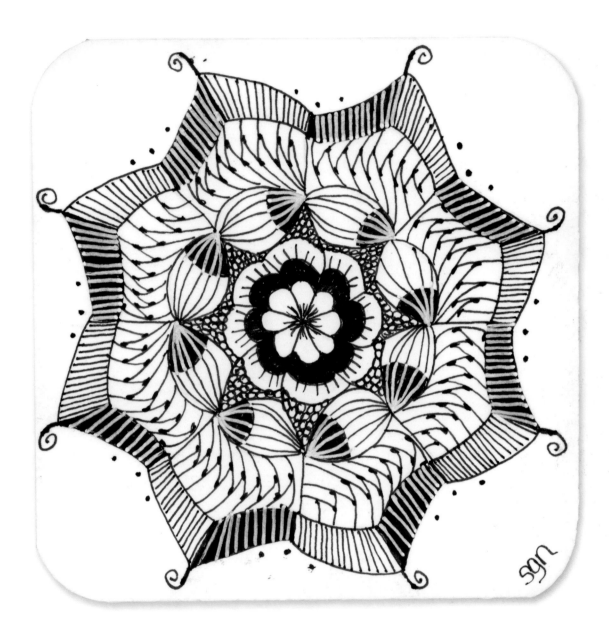

Susan G. Nutting, CZT (NEW HAMPSHIRE)

youcantangletoo.blogspot.com
Watercolor paper, Micron pens, Sakura Gelly Roll pen in white.

I was first drawn to the Zentangle method because of its promise that I could create beautiful works of art through easy-to-draw, repetitive patterns—and I could! And I still do! But tangling has taught me so much more. Through staying in the moment, concentrating on one stoke at a time, and using mistakes as opportunities, I have learned to slow down and live life to its fullest, using Zentangle along the way.

Zensplosions Banner

Daniele J. O'Brien, CZT (MICHIGAN)
dobriendesign.blogspot.com
Cotton sateen fabric, Micron pens, pencil,
fusible interfacing, metal aluminum
wire, thread.

I am a CZT, graphic designer, and children's
book illustrator. Since childhood, I was
always the "artist" in my family, but lost
my connection to the drawing process as
technology, life, and work responsibilities
took over. Finding the Zentangle method
not only renewed my love of drawing, but
also rekindled my artistic fire in all areas.
About four years ago, on one of our art days,
my friend Jeanne taught me to "Smile, Relax,
and Breathe" with the Zentangle method.
From that moment, I was hooked. It became,
and still is, my passion. My sisters and niece
gave me the gift of a workshop with Rick
and Maria for my birthday. It was the most
wonderful gift ever! Tangling has been a
fabulous ride, and I look forward to all the
wonderful things Zentangle brings into
my life.

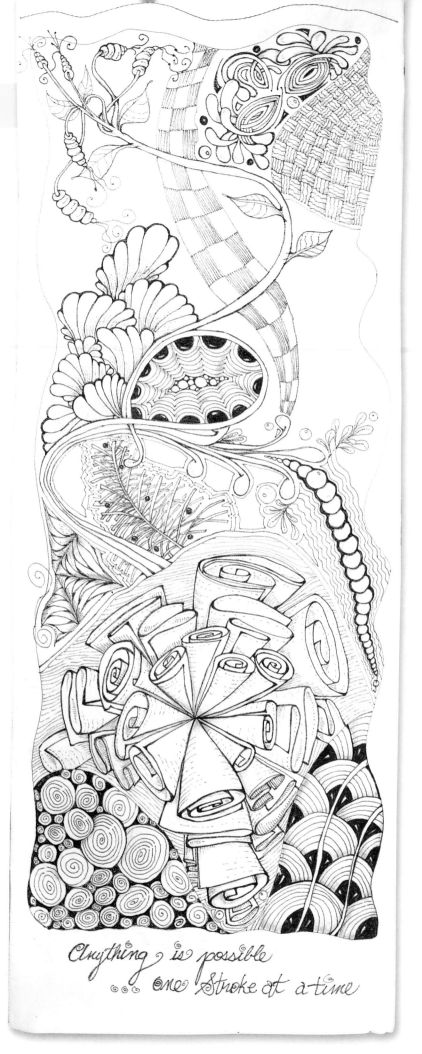

*Anything is possible
... one stroke at a time*

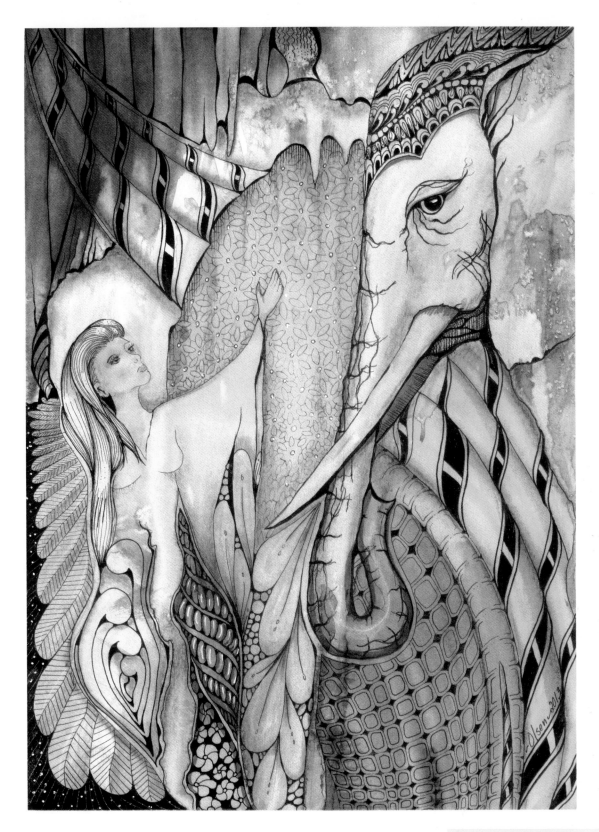

Susan Olsen, CZT (OHIO)

flickr.com/photos/suzen_art
Watercolor paper, Micron pens, pencil, Winsor & Newton watercolors.

Art isn't something I DO, it is creative energy that is channeled through me. I don't remember when I began to draw or paint, because that desire had always been with me, but I did have a wonderful high school teacher who encouraged me to pursue the arts. Now, after many years of working forty hours a week and raising a family, I am encouraged by my family and friends. When I was introduced to the Zentangle method, I found a creative channel that was exciting and new, yet felt comfortable and familiar! Tangling feels like home!

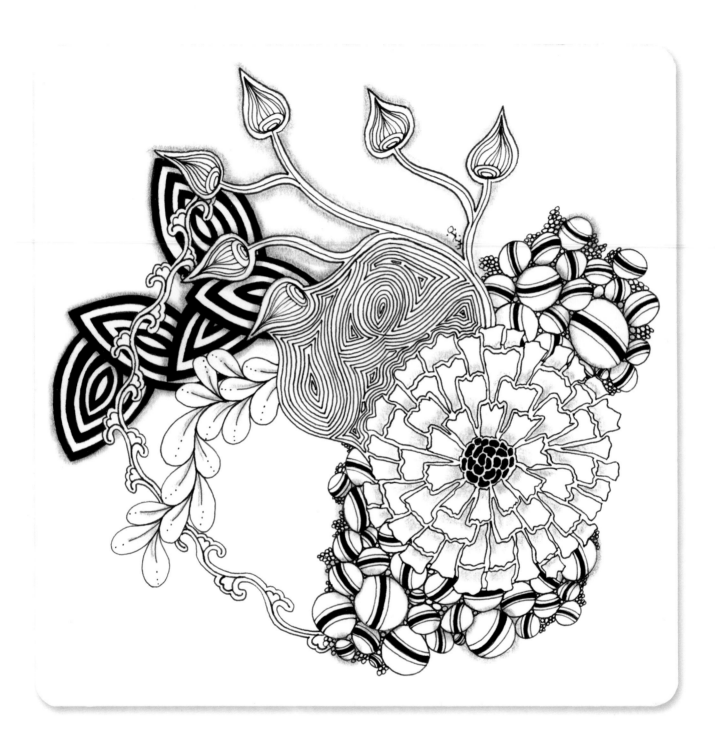

Erin Koetz Olson, CZT (CALIFORNIA)

thebrightowl.com
Quality paper, Micron pens.

I am a paramedic living in the beautiful wine country of northern California. I stumbled upon the Zentangle method while searching for quilling classes on the Internet and have been hooked ever since. I am host of the Zendala Dare, a weekly challenge on my website.

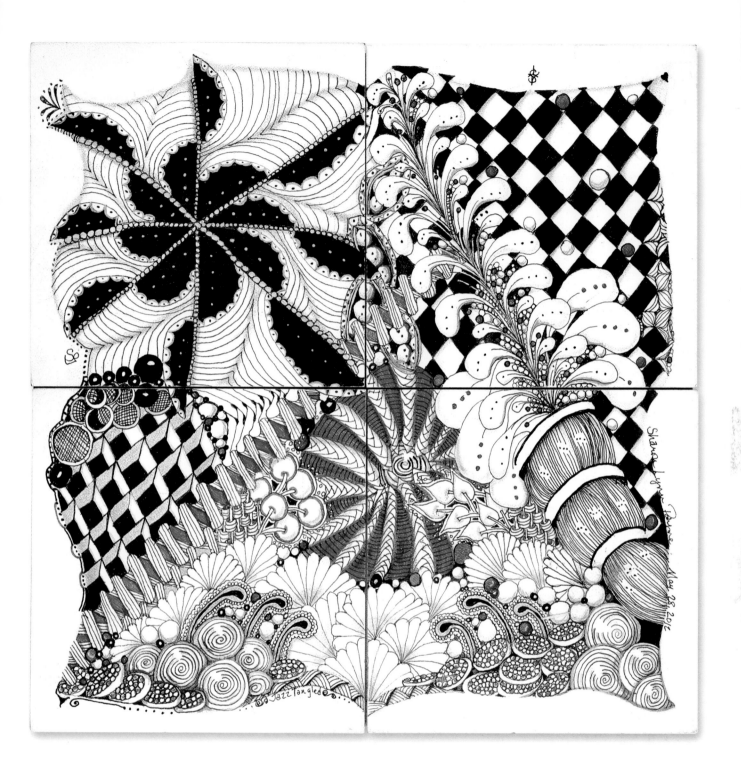

Black, White, and Red All Over

Sharon Lynn Payne, CZT (NORTH CAROLINA)

jazztangled.blogspot.com
Ampersand Aquabord, Sakura IDenti-Pens and Gelly Roll pens, pencil.

I started using the Zentangle method after seeing a post about it on Facebook. I took a class from CZT Suzanne McNeill at the Art of the Carolinas show and was excited by Suzanne's acceptance of my work. Immediately, I started using tangles in my silver jewelry and tangled my tall boots—and everything else. It's been a wonderful adventure!

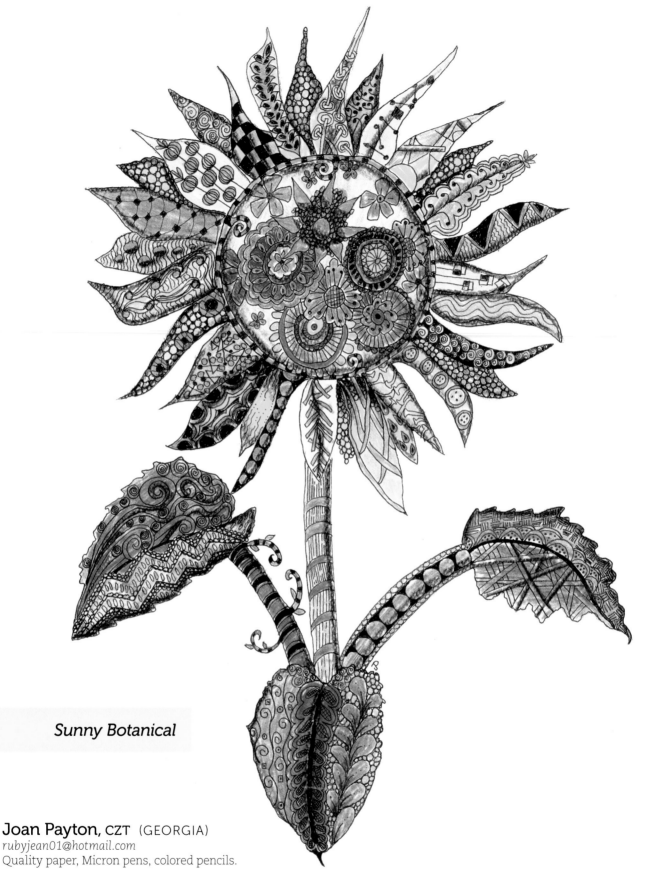

Sunny Botanical

Joan Payton, CZT (GEORGIA)
rubyjean01@hotmail.com
Quality paper, Micron pens, colored pencils.

I have been creating most of my life, from making jewelry to fiber arts. I am a primitive rug hooker and have been in several rug hooking books, most recently *Hooked Rugs of the Deep South*. I am a Certified Zentangle Teacher. Jeannie Mahood and I have taught more than four hundred students, from Nova Scotia to Mexico. I love the excitement Zentangle brings to my students' lives, taking them from "I'm not an artist...I can't draw" to "Wow, look at what I can do!"

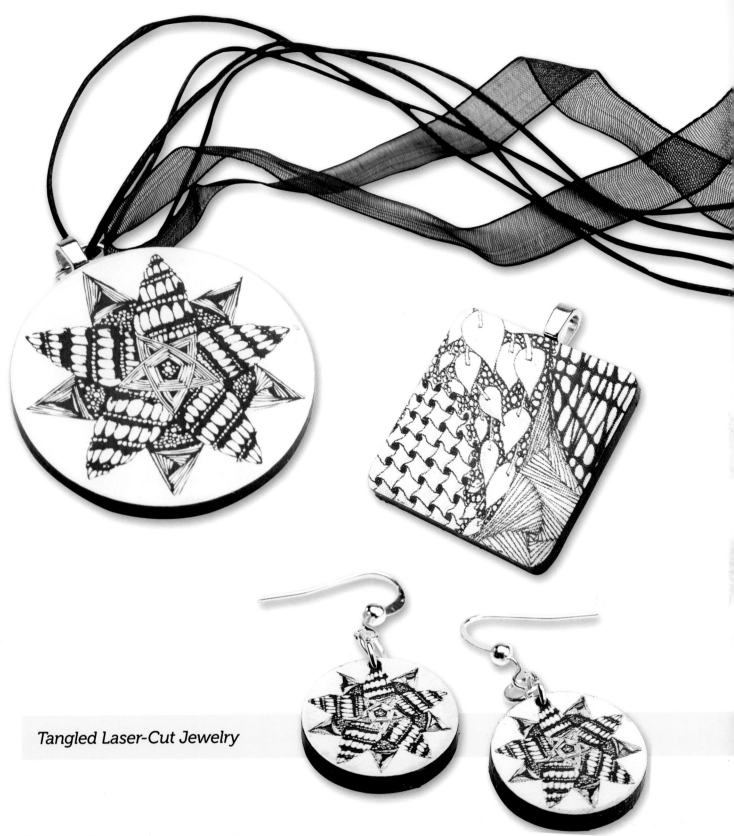

Tangled Laser-Cut Jewelry

Jennifer Perruzzi, CZT (MAINE)

acadialasercreations.com
Laser-able plastic, wood, laser cutting machine, jewelry findings.

I have been crafting and card making for fifteen years and eventually discovered the Zentangle method. I have incorporated tangling into my laser engraving business, cutting shapes and words from Fabriano Tiepolo paper and cardstock. I engrave designs on a variety of plastics and materials for jewelry and other uses.

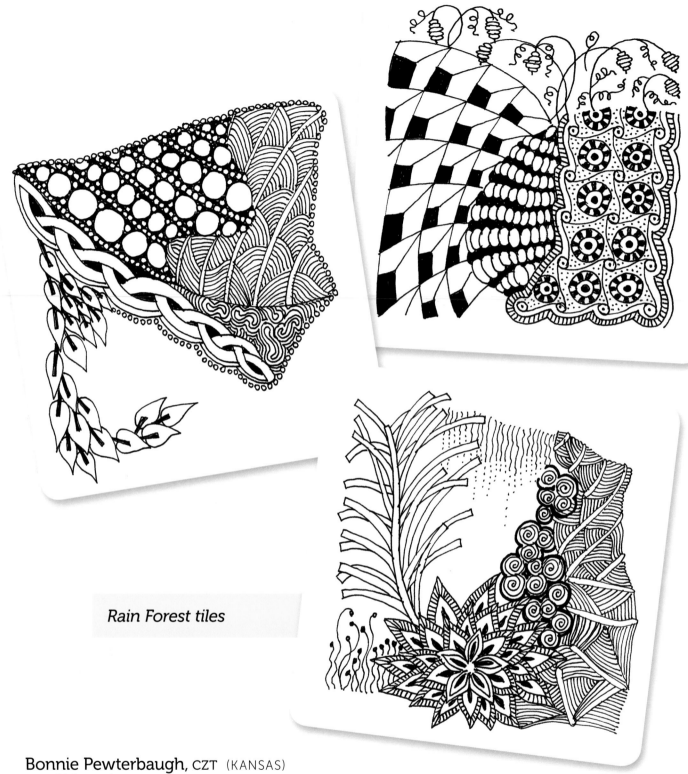

Rain Forest tiles

Bonnie Pewterbaugh, CZT (KANSAS)

emeraldcitytangles.com
Zentangle paper tiles, Micron pens, pencil.

I have been involved in the arts since my childhood. My father, Samuel Glanzman, is a comic book artist, and my uncle Louis Glanzman is a fine arts illustrator (both well known in their fields). My grandmother Florence copied masters in oil. Growing up, my family helped to cultivate my love of art. With my children grown, I rediscovered the time to once again release my inner artist. The moment I found the Zentangle method, I fell in love. Tangling was the perfect mix of creativity, enjoyment, and tranquility that I was looking for, and I couldn't wait to share it with others. I love teaching the Zentangle method. I have taught more than two hundred students in the Kansas area—they are my tangling babies!

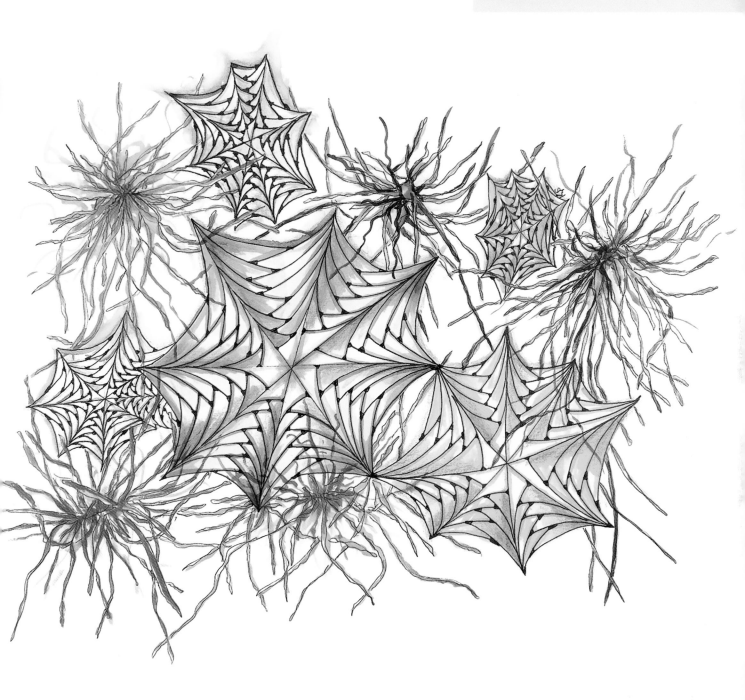

Karen Polkinghorne, CZT (AUSTRALIA)

karenpolkinghorne@iinet.net.au
Watercolor paper, Micron pens, Koh-I-Noor Brilliant watercolors.

I live in Perth, Western Australia, and traveled to the United States to take a workshop with Rick and Maria. I have always been interested in various arts and crafts, but for me, discovering the Zentangle method was an awakening of the soul. I see so much more through new eyes and appreciate the benefits of this amazing journey. Thank you to Rick and Maria and all the CZTs who share so willingly.

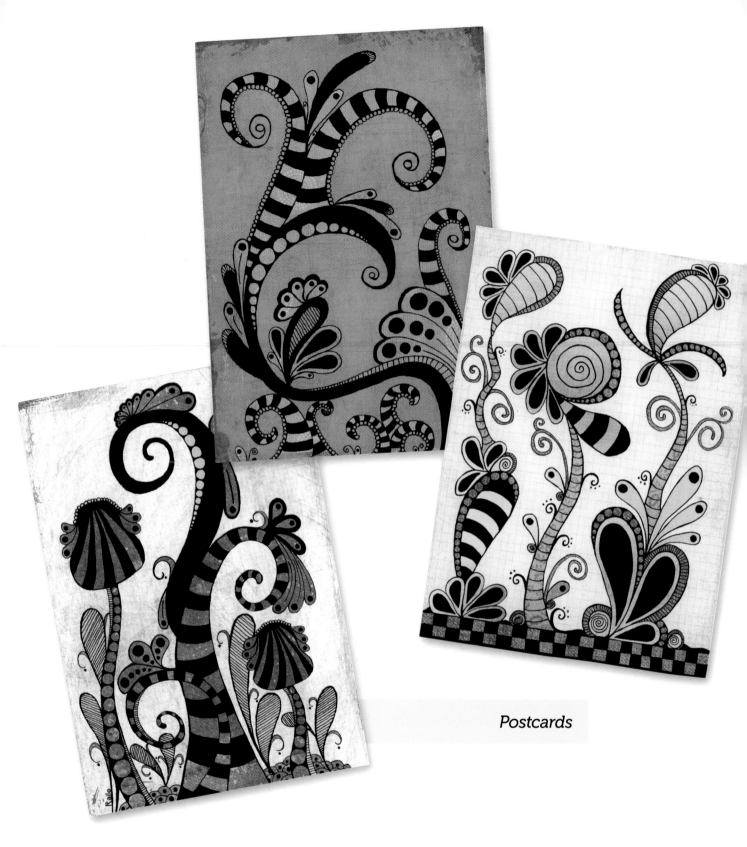

Postcards

Penny Raile, CZT (CALIFORNIA)

tangletangletangle.com
Quality paper, Micron pens, colored digitally in Photoshop.

Many years ago I started tangling. My family was worried about me when they saw me at the dinner table with my paper and pens. Yes, I was obsessed, but to me it was a healthy obsession. I especially noticed the difference when I flew on airplanes. Never one to enjoy flying, I found myself looking forward to getting on a plane and spending time tangling. Zentangle is a permanent part of my life now.

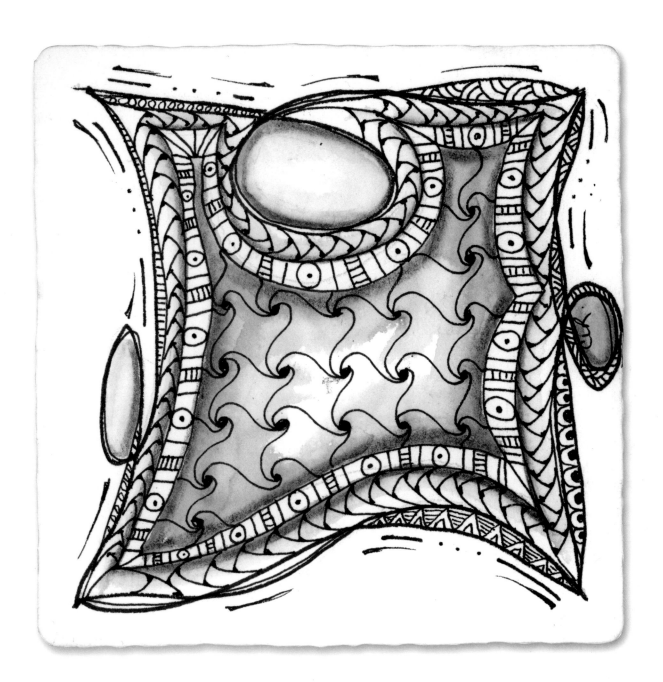

Chari-Lynn Reithmeier, CZT (CANADA)

charilynn.com
Zentangle paper tile, Micron pens, Derwent Graphitint pencil.

I am a trained artist who was introduced to the Zentangle method by a friend. I love the simplicity of the lines and the beauty of a completed tile. I use tangling as part of my creative process and as a warm-up exercise. I love to share the practice and principles of the Zentangle method with students of all ages!

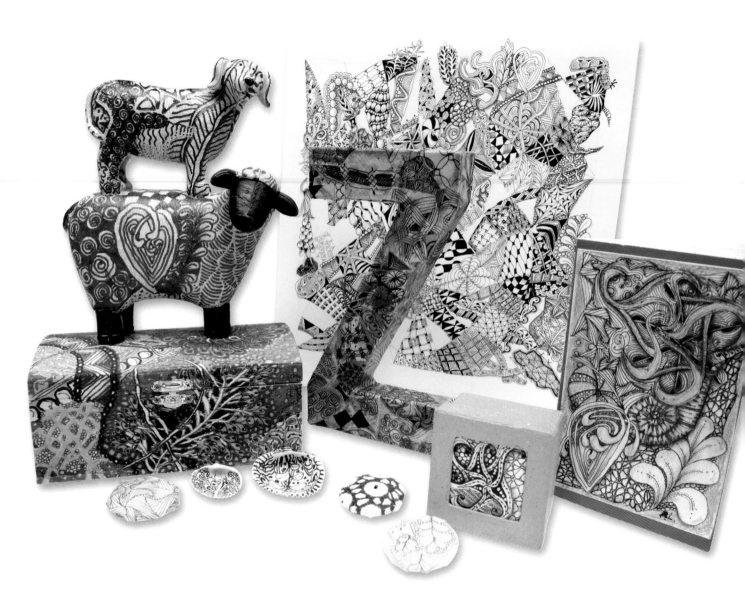

Dr. Lesley Roberts, CZT (UNITED KINGDOM)
lesley@theartsoflife.co.uk
Canvas, Micron pens, Permapaque markers, acrylic paints, assorted supplies.

I want to share a story about one of my students. Ten-year-old Daniel often has difficulty focusing on tasks for a length of time. Tangling has greatly improved his attention span. Learning patience and mindfulness has also helped him in other subjects at school. Daniel now takes his supplies everywhere! His mom recommends the Zentangle method to all parents, as she feels its positive impact, especially on focus and self confidence.

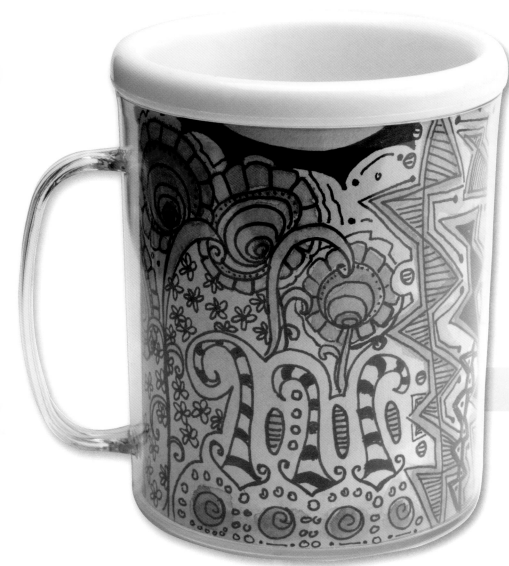

Cup with Tangled Insert

Michelle Robinson, CZT (TEXAS)

michellerobinson.biz
Watercolor paper, Micron pens, Tombow color markers, cup with insert.

There are no mistakes in Zentangle, only opportunities to create. So it was not by accident that Zentangle found me through an article by CZT Sandy Steen Bartholomew in the pages of my favorite craft magazine *Cloth Paper Scissors*. I fell in love with Zentangle immediately. When I had kidney stones and shingles in the same six-week period, I tangled every day for pain management.

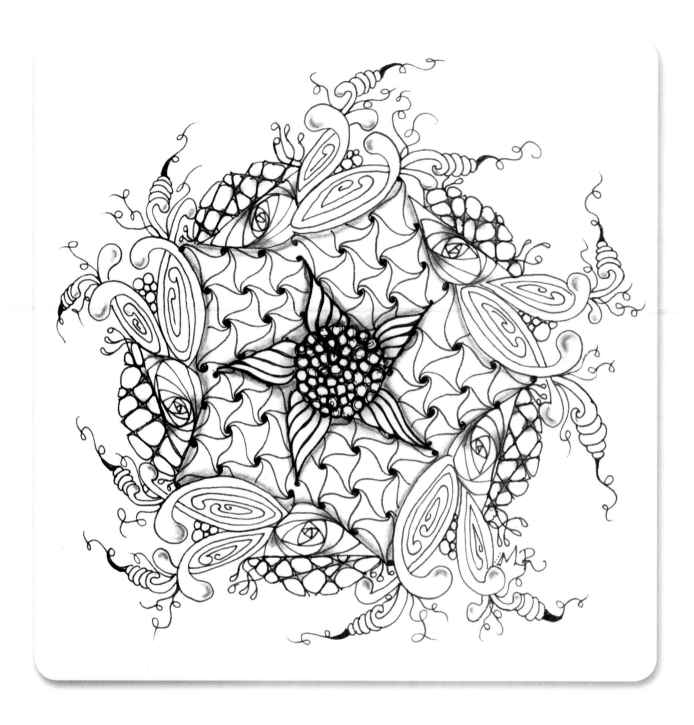

Loop de Loop

Michelle Rodgers, CZT (OHIO)
rodgersart.blogspot.com
Zentangle paper tile, Micron pens, pencil.

The Zentangle method has been a perfect way to bring creativity into my art classroom. As I was teaching my students, I found that I was doing more tangles in my own art. Sharing Zentangle with friends has enriched all of our art. Tangles have brought new life to my pottery also. For more than ten years I created leaf pottery, but was looking for something new. With Zentangle, I enjoy creating art again!

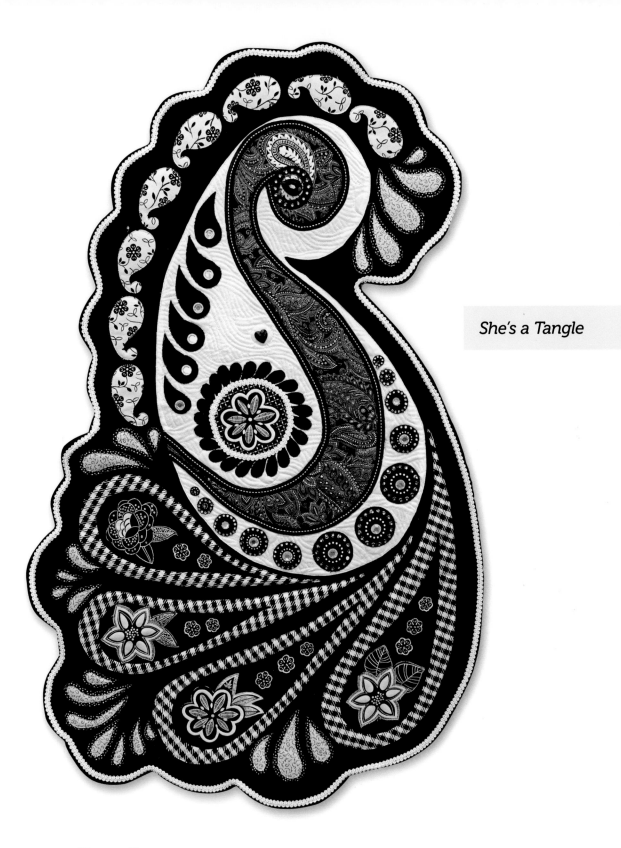

She's a Tangle

Karen Rogers (ARIZONA)

quiltedinspirations.net
Fabric, thread, trim, ribbons, buttons, crystals.

Give me beautiful things to gaze upon, new techniques to explore, and creative challenges, and I'm off designing a new quilt. The first time I experienced Zentangle was when I was surfing the web and came across Suzanne McNeill's blog (*blog.suzannemcneill.com*). As a quilt designer, I knew I had to create a tangled quilt. So, in my twenty-first year of quilting, designing, teaching, and sharing, I get to Zentangle with quilts.

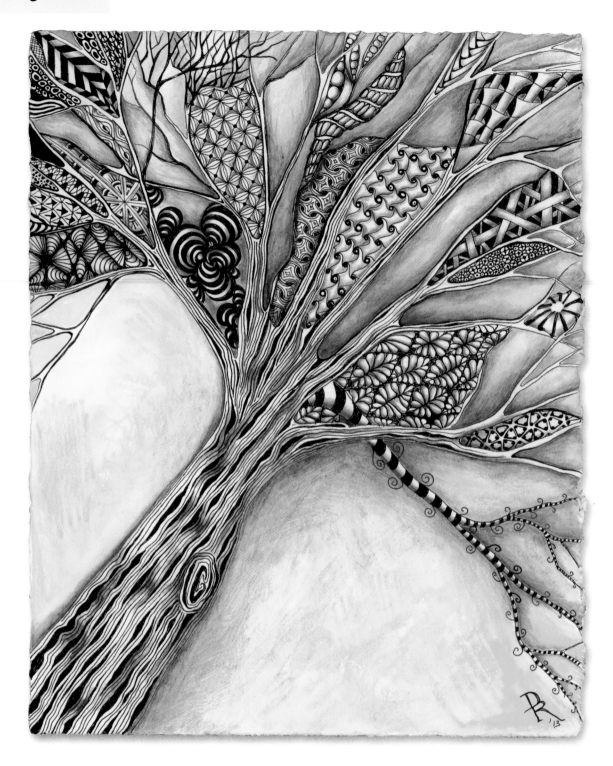

Denise Rudd, CZT (NEW MEXICO)
artteachertangler.com
Quality paper, Micron pens, pencil, Caran d'Ache Neocolor crayons.

I discovered the Zentangle method when what I thought at the time was a funny word came up on Google. I was immediately hooked. What I did not know was that tangling would play a part in my recovery from a form of depression. During therapy, I realized that I already had a tool to shift my focus from my worries to something beautiful and constructive. I began a daily practice of the Zentangle method to take my mind to a more peaceful place. With a toddler, it's hard to keep up that daily practice, but my daughter has a mother who has recovered from a debilitating condition and can enjoy every second with her.

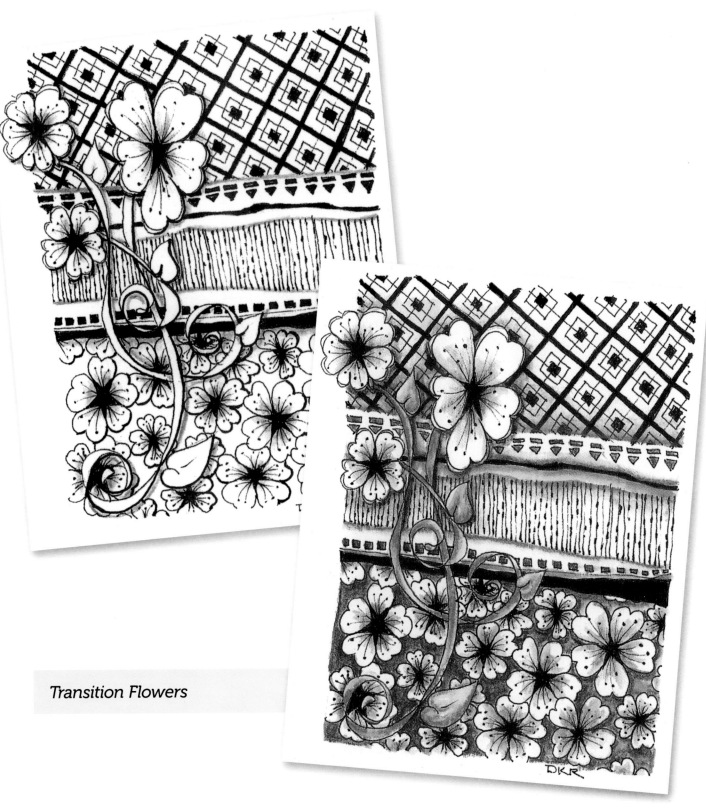

Transition Flowers

Diane K. Ryan, CZT (NEW HAMPSHIRE)
dianeryan36@comcast.net
Quality paper, Micron pens, pencil, watercolors, brush.

I spend a lot of time with my family in Wyoming. It is one of the most inspiring art areas I have found. I try to add a little creativity in everything I do. I feel like the word CREATIVITY is my second name. I work in many different artistic media and love including tangle patterns in my artwork. I also love teaching the Zentangle method and feel like I'm awakening creativity in others. It's so uplifting for me to see how excited my students get.

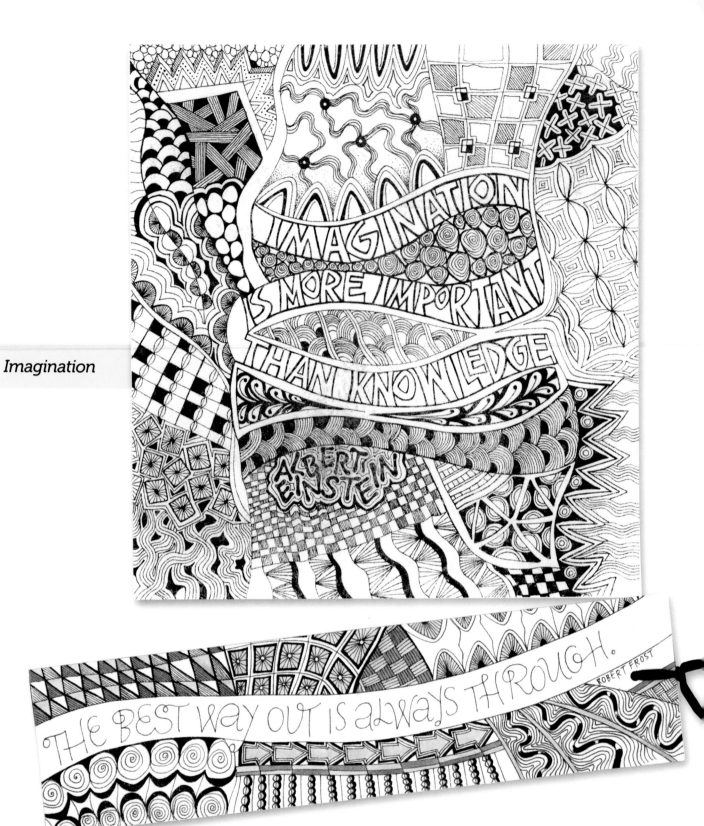

Imagination

C. C. Sadler, CZT (CALIFORNIA)

letteringandtangling.squarespace.com
Quality paper, Micron pens, Tombow brush markers, Sakura Koi brush markers.

The Zentangle method is helping people reconnect with things barely remembered from drawing as a child by allowing them to shore up self-esteem and develop new drawing skills. I love teaching people how to solve design problems. The beauty of Zentangle is also about watching the amazing things people are doing worldwide. There is a deep connection and sense of community.

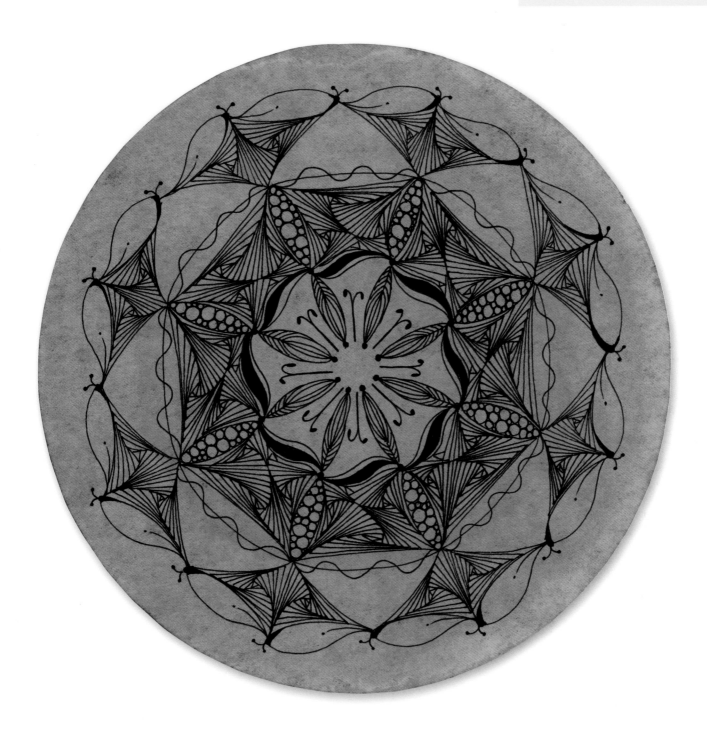

Izumi Sato, CZT (CALIFORNIA)
izumisato.com
Recycled coffee filter, Micron pens.

I have been a Japanese narrator for more than thirty years, but I was always interested in art. I became the first Japanese individual to take a Zentangle workshop from Rick and Maria. I teach the Zentangle method in San Diego and Los Angeles, California. My exciting future plan is to spread the Zentangle method throughout Japan. Tangling has been a self-healing method for making my life more peaceful and thankful!

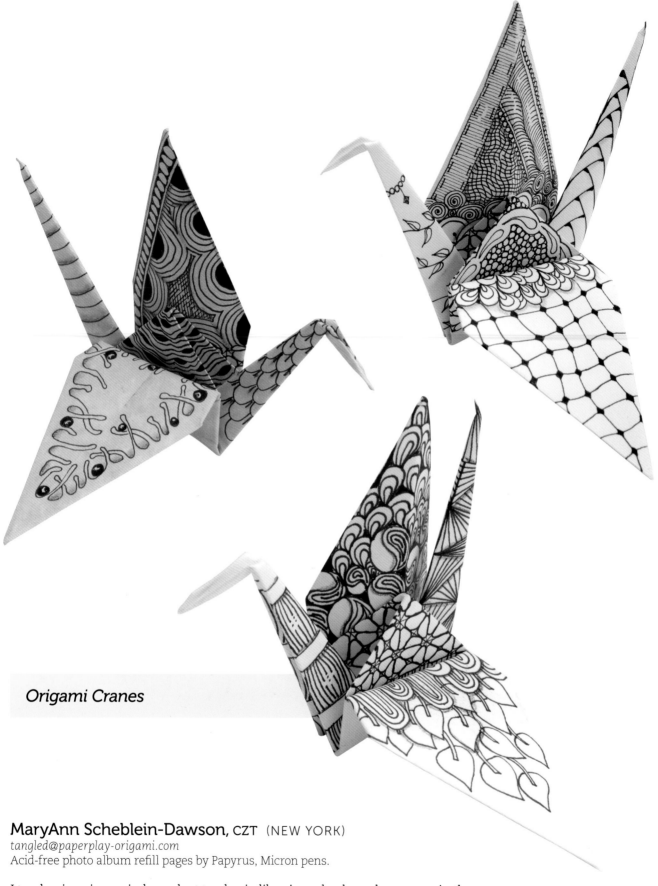

Origami Cranes

MaryAnn Scheblein-Dawson, CZT (NEW YORK)

tangled@paperplay-origami.com
Acid-free photo album refill pages by Papyrus, Micron pens.

I teach origami as an independent teacher in libraries, schools, and museums in the metropolitan New York area. Combining the two art forms of Zentangle and origami seemed to be a natural progression and has added much joy to both practices. I especially enjoy adding my own special tangles to the origami models I fold for gifts, making them truly one-of-a-kind pieces of art.

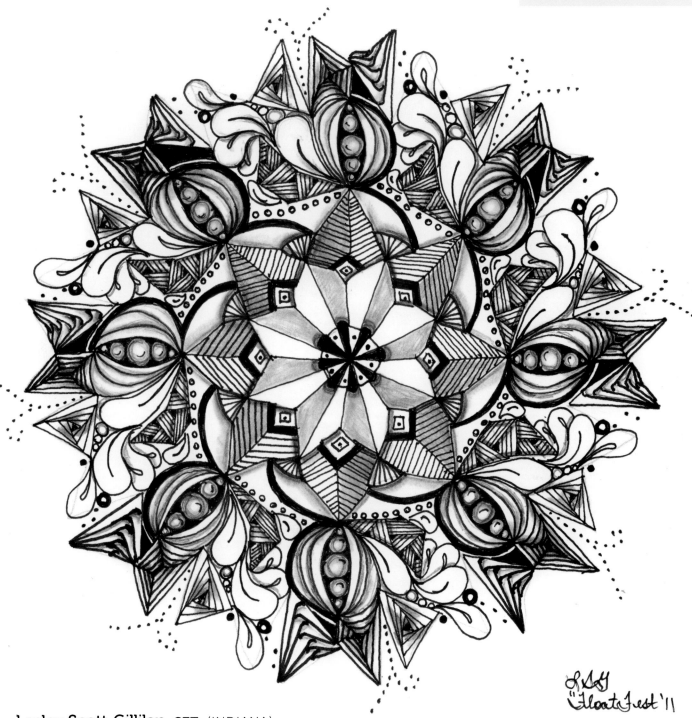

Lesley Scott-Gillilan, CZT (INDIANA)
wattatangledweb.blogspot.com
Strathmore bristol vellum paper, Micron pens, pencil.

I have always been an artist. As far back as I can remember, I've drawn or painted or played with clay. By the time I received formal training in college, I was working almost exclusively in three dimensions. I loved sculpting on a large scale and creating heavily textured woven pieces. I just accepted the fact that I was a 3-D artist. My sister Peggy introduced me to Zentangle. As I learned the Zentangle method, I discovered that the 3-D artist in me could be satisfied working in just two dimensions. Most of all, I have re-discovered the sheer joy and unrestrained creativity that drew me to art as a kid.

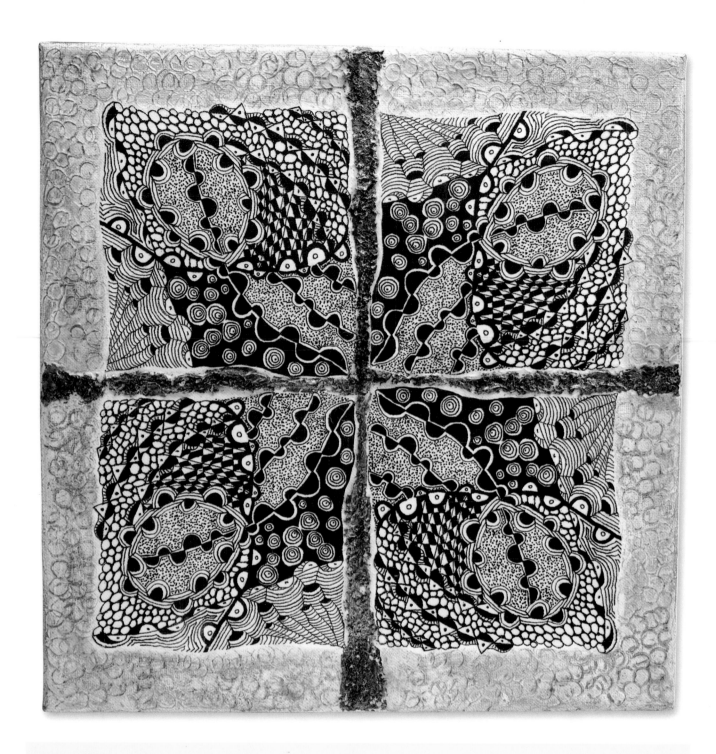

One Thing Leads to Another

Judith R. Shamp, CZT (TEXAS)
narrative-threads.com
Quality paper, Micron pens, stretched canvas, photo transfer paper, gel medium, copper foil.

I take great joy in guiding art students to become comfortable with asking "what if" questions. My attempts to provoke thinking outside the box are triggered when asking "I wonder...," "Let's imagine another way to do...," "Is there a different way to look at this?" I continually learn that the Zentangle method opens doors to engage and empower creative thinking—at least that's my experience along this bumpy road of complex, paradoxical, contradictory, and truly mysterious human experience. In a broader sense, I am learning that in most cases almost anything is doable—one mark, one step, one smile, one connection at a time.

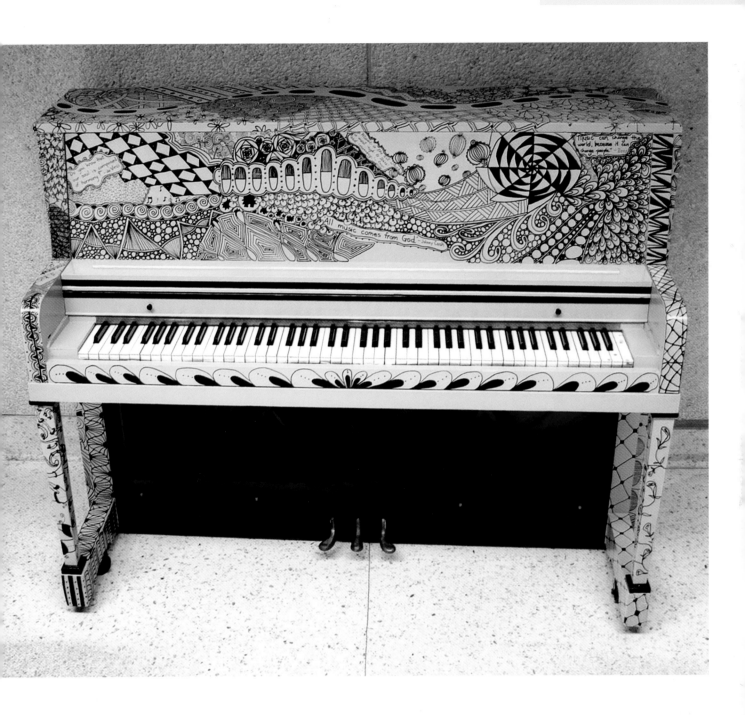

Lisa Skeen, CZT (NORTH CAROLINA)

Oil-based paint pen, acrylic house paint, polyacrylic sealer.

I earned my BFA at the University of North Carolina at Greensboro and have since been working as a studio artist and educator. Currently employed as an elementary art teacher, I enjoy working in many different media, including clay, paper, fibers, paint, and Zentangle. I love this piano and could hardly wait to draw tangles all over the surface.

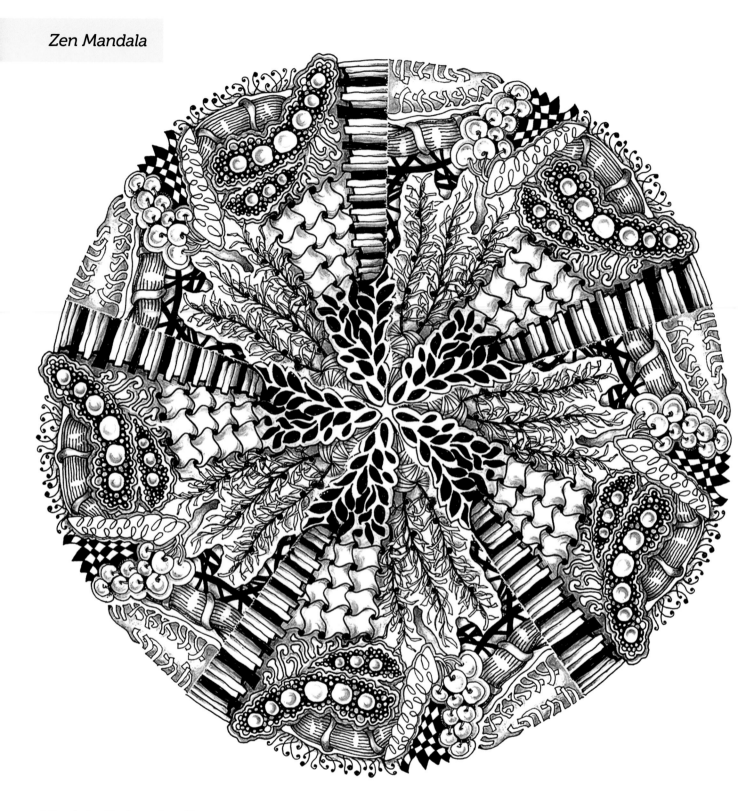

Virginia Dejewska Slawson, CZT (MAINE)

mandala@midcoast.com
Quality paper, Micron pens, pencil.

Throughout my life as an artist, no matter the medium or palette, it is light—with its negative and positive space—that defines my art. With the simple concepts of light/darkness, line/no line, filled space/empty space, and swelled form/lack of form, universal language takes shape. Amazing and satisfying, primal and visceral, intellectual thought—both simple and complex—all becomes communication.

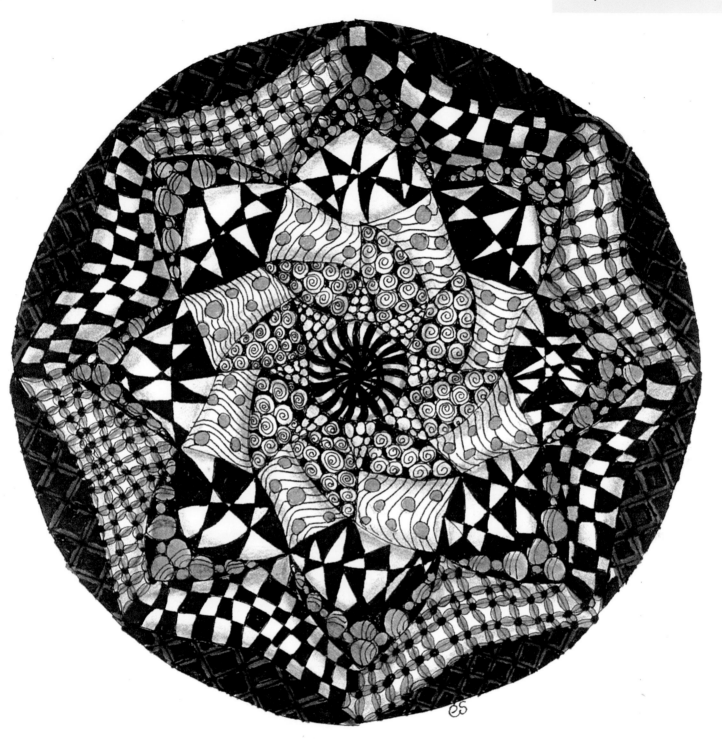

Elizabeth Smith, CZT (CALIFORNIA)
elizsmith564@yahoo.com
Quality paper, Micron pens, pencil, watercolors, brushes.

Finding the Zentangle method was a life changer for me. During that first class I took with CZT Denise Rudd, I found myself astonished with what happened while drawing on that tile. It made flat paper take on depth, and I was never the same again! It has become my art form of choice, and I find myself intrigued with what is possible every time I pick up my pen. Tangling also quiets me.

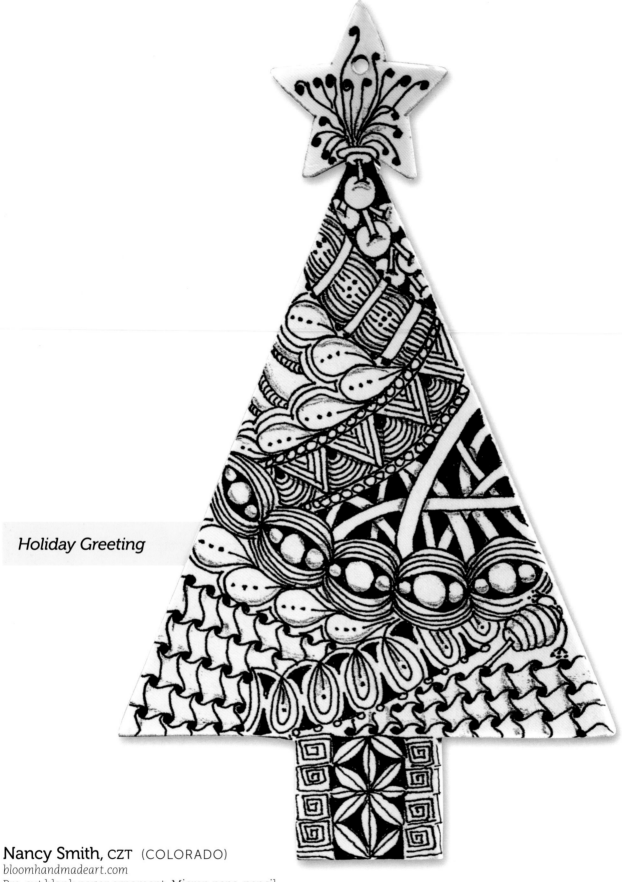

Holiday Greeting

Nancy Smith, CZT (COLORADO)
bloomhandmadeart.com
Pre-cut blank paper ornament, Micron pens, pencil.

I am coauthor of many quilting books. I am a former owner of the Great American Quilt Factory in Colorado. I love teaching the Zentangle method. Tangling has truly become my passion. I draw daily and it helps me stay centered.

Susan Smith, CZT (MASSACHUSETTS)

susan.smith3821@gmail.com
Quality paper, Micron pens, Tombow markers, Inktense pencils.

As a calligrapher for many years, the art of Zentangle has been a welcome addition to
my artistic endeavors. My first workshop with Maria and Rick provided me with infinite
hours of creativity. Most exciting for me has been sharing this art by teaching it to others
and branching out from the Zentangle tiles to larger, more colorful pieces and truly
feeling good about my art.

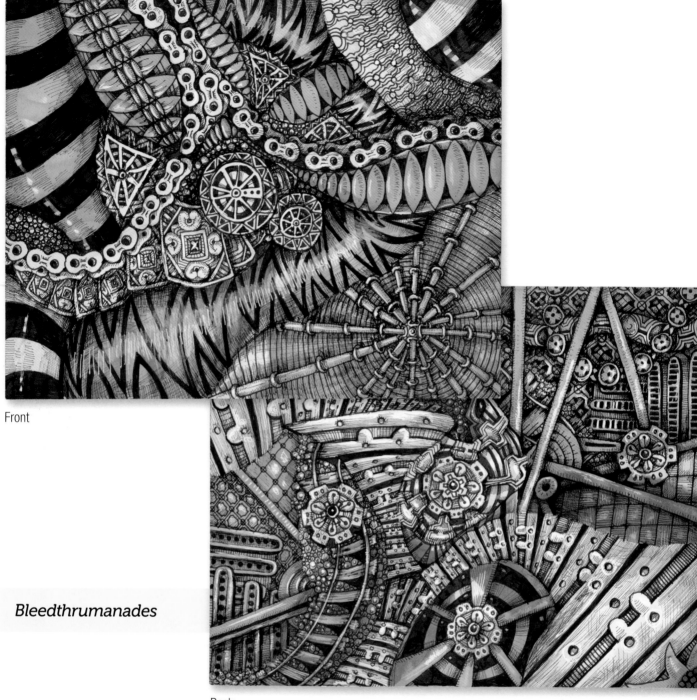

Front

Bleedthrumanades

Back

Sandra K. Strait (OREGON)

lifeimitatesdoodles.blogspot.com
Rhoda ivory vellum paper, Micron pens, Copic markers. The name of my art piece, *Bleedthrumanades*, references the phrase "Got lemons? Make lemonade." Got marker bleed thru? Make bleedthrumanades!

I have been drawing since I was able to hold a pen in my hand. Like many others, I discovered the calming qualities of the Zentangle method while at the bedside of an ailing relative. What I also discovered was how much I enjoyed the "happening" of tangling. I had always plotted and planned my designs before starting, and I was never happy because my finished work never matched the vision in my head. With Zentangle, I just start and the art "happens." Where I used to find art frustrating, now I find it inspiring and satisfying.

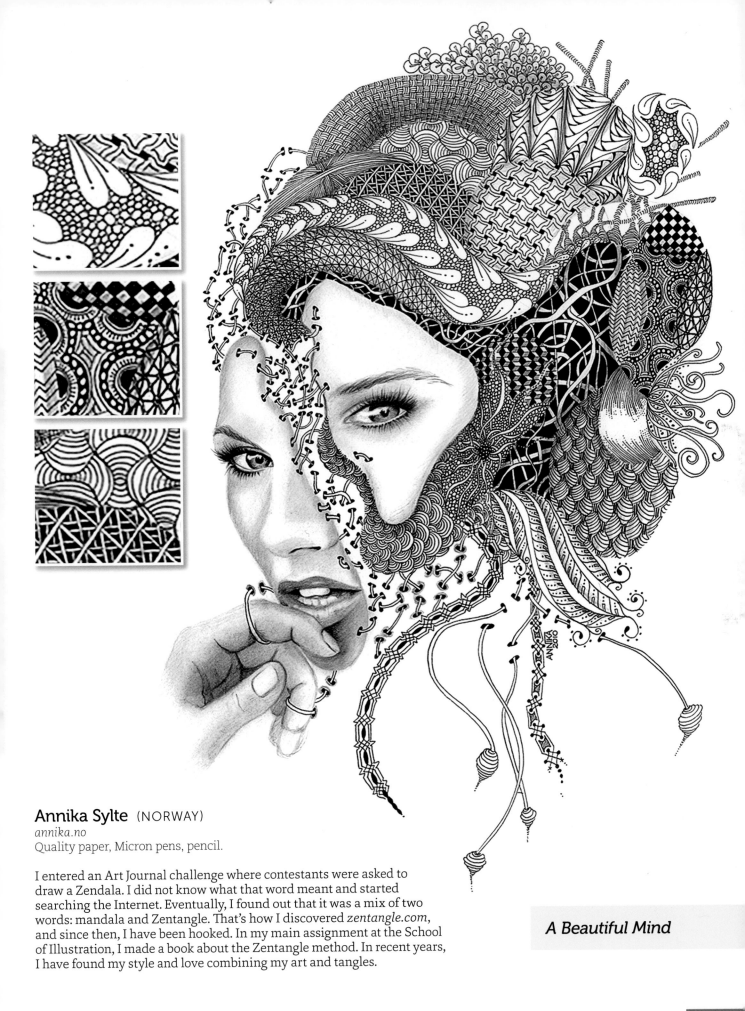

Annika Sylte (NORWAY)

annika.no
Quality paper, Micron pens, pencil.

I entered an Art Journal challenge where contestants were asked to draw a Zendala. I did not know what that word meant and started searching the Internet. Eventually, I found out that it was a mix of two words: mandala and Zentangle. That's how I discovered *zentangle.com*, and since then, I have been hooked. In my main assignment at the School of Illustration, I made a book about the Zentangle method. In recent years, I have found my style and love combining my art and tangles.

A Beautiful Mind

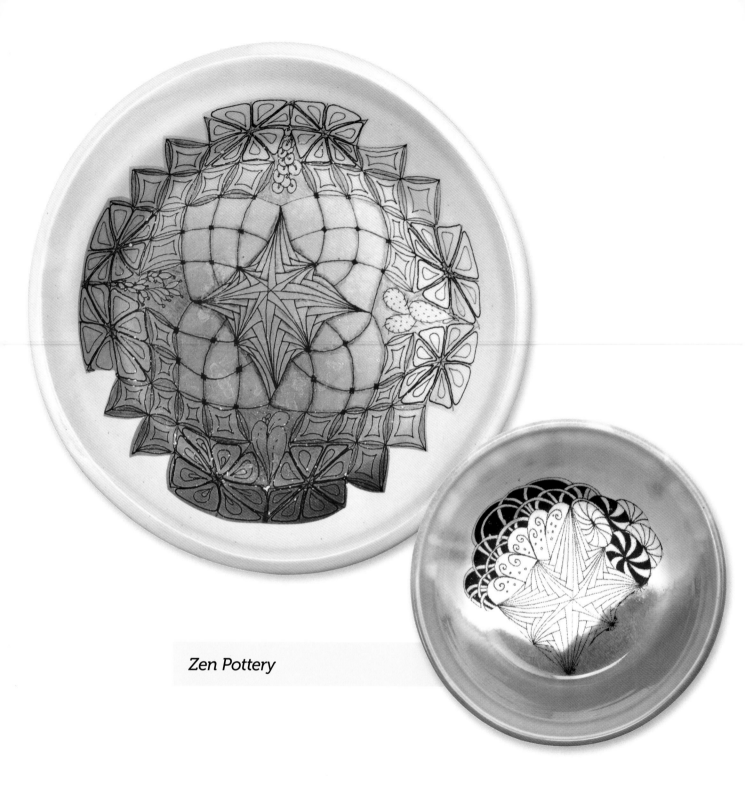

Zen Pottery

Arlene Butterworth Taylor (TEXAS)

arlenezart.com
Raw clay, decal paper for kiln firing, glaze.

I am a multi-media artist working in pastels, watercolor, acrylics, oils, and clay. I am having fun learning Zentangle patterns. Working with clay is a multi-step process and drawing tangle patterns in clay is tedious. I have discovered a special decal paper so I can work out my design on paper and then transfer it to the glaze and fire the piece again so the designs are permanent on the glaze. I am excited to explore the new possibilities with Zentangle on clay.

The Beauty of Zentangle

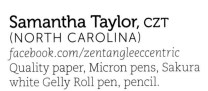

Mer and Friends

Samantha Taylor, CZT
(NORTH CAROLINA)
facebook.com/zentangleeccentric
Quality paper, Micron pens, Sakura
white Gelly Roll pen, pencil.

Zentangle has formed my
nonsensical, sometimes coffee-
splattered, whimsical sketching
into an entirely different
experience. This method has
allowed me to include more
depth and intrigue inside my
drawings, and I've gained a much
greater sense of satisfaction
and enjoyment as I've learned
the process. I focus more on the
process of creating and less on
completion. With Zentangle, I
get just as much pleasure from
embracing my "mistakes" as I do
from each deliberate stroke.

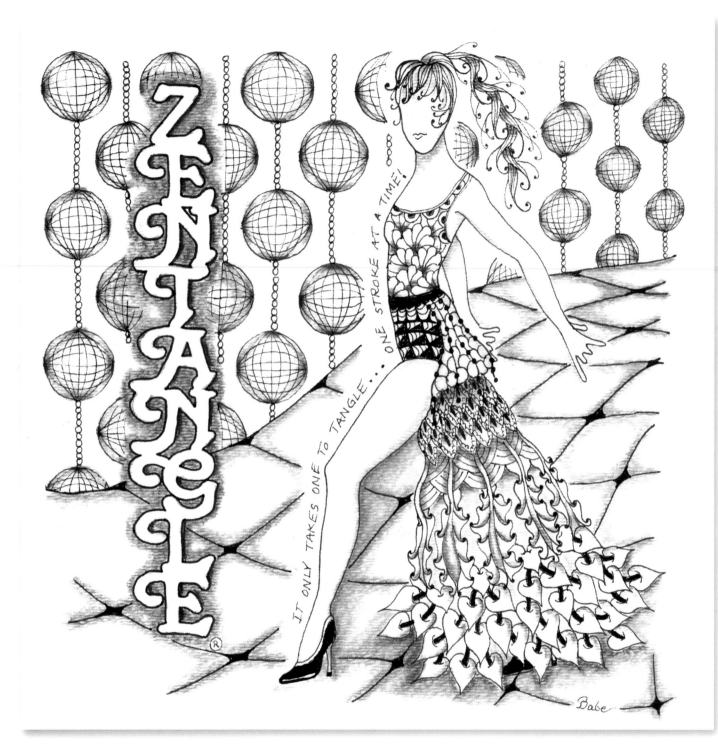

Chris Titus, CZT (NEW YORK)
jet@rochester.rr.com
Quality paper, Micron pens, pencil.

I was drawn to the Zentangle method from the first time my sister introduced me to it. After taking a class from my local CZT, it was clear that this was something I wanted to learn more about. The workshop I attended with Rick and Maria unlocked a door to someplace I had been a long time ago. It was as if I was a kid again with a brand new 64-color box of crayons! But this time the box wasn't full of colors, it was full of patterns, and I couldn't wait to use them. I still don't want to close the box!

Rhinoceros

Marizaan van Beek, CZT (SOUTH AFRICA)
Ashrad drawing paper, Micron pens, pencil, tortillon paper stump.

I have always been an artist and remember loving to draw. I studied Social Work, but moved back to art—my first love. When I saw Zentangle, I knew instinctively that it was what I wanted to do. This is a fantastic art form to help people and lift their spirits. I traveled to America to take a workshop from Maria Thomas and Rick Roberts, and just love to teach this relaxing method of drawing.

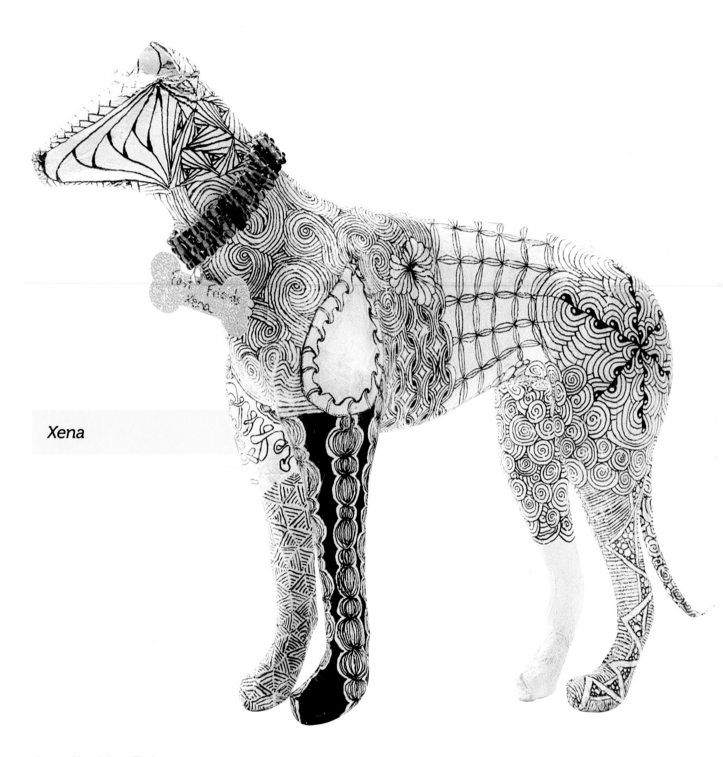

Xena

Jennifer Van Pelt, CZT (CALIFORNIA)

jennifervanpelt.com
Papier-mâché dog, white acrylic paint, Sensei pens, clear acrylic spray.

Papercrafting in all forms has been a love of mine for almost twenty years. When I was introduced to the Zentangle method, I found my little slice of paradise in the art world. This was something I could do. I really liked the results, and others seemed to as well. Now I enjoy creating Zentangle-inspired art and teaching others that they too can make beautiful art "one stroke at a time." I love the "ahhh" moments when they take a step back and see what they have created and get so excited about their art! I teach at my store The Stamp Addict in San Diego, California, The Bravo School of Art, and at private functions.

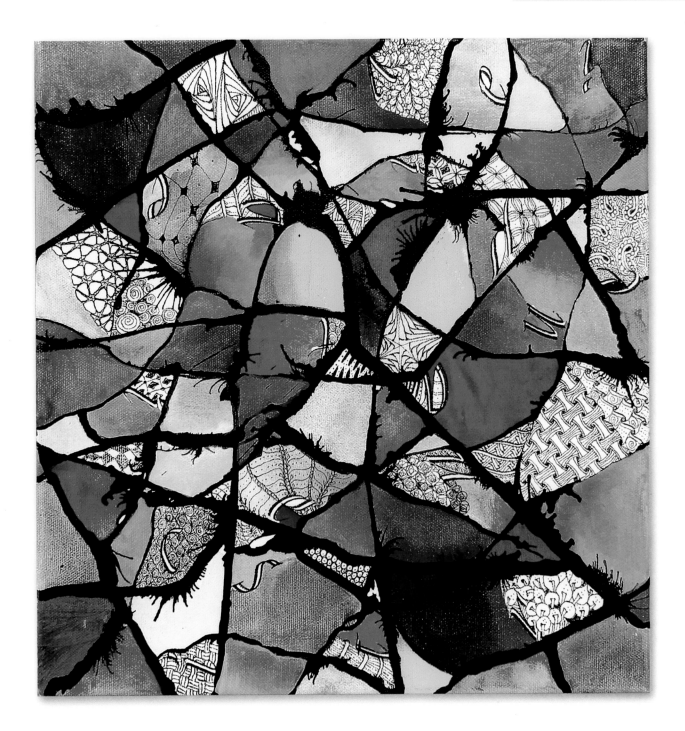

Angie Vangalis, CZT (TEXAS)

angievangalis.com
Canvas, pigment ink, acrylic ink, acrylic paint.

I was so fortunate to grow up with creative people all around me. It is no wonder that making something from a vision continues to be my inspiration. Zentangle is a way to introduce a drawing technique to my students. Tangling brings a sense of peace and focus within seconds of starting a pattern. This place of relaxation is priceless.

Tangling also provides a way for me to introduce other creative disciplines, including calligraphy and painting. Zentangle continues to take my creativity to new levels. I think the most challenging project for me has been tangling on a glass door with a white enamel pen.

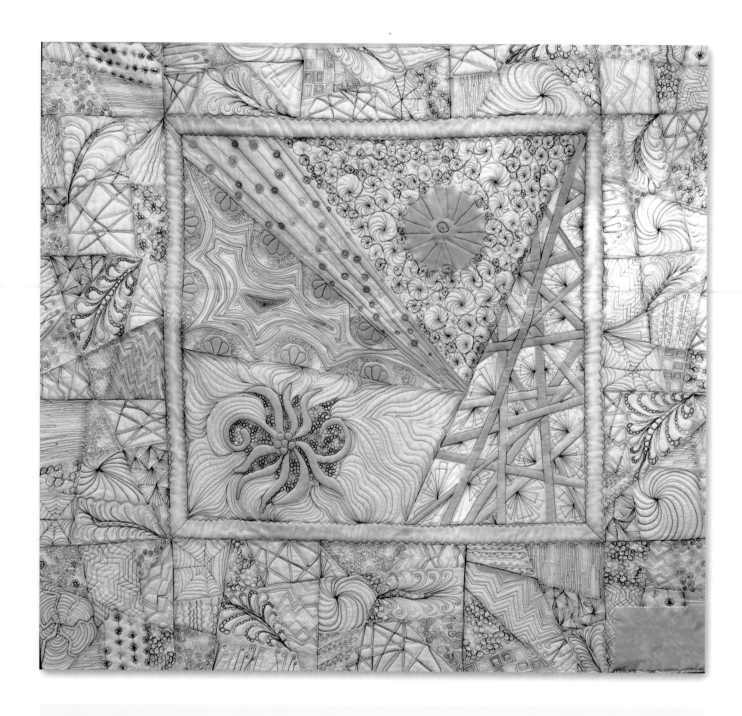

All in a Tangle

Lee Vause, CZT (AUSTRALIA)

threadsandtangles.com.au
Cotton fabric, fabric pens, thread, batting.

I took a Zentangle class at the inaugural Australian Machine Quilting Festival without any prior knowledge of the Zentangle method, or any perception that I had any drawing ability. I was hooked from the beginning. Immediately I saw that tangles could be translated through the quilting process. With a background as a free-motion quilter and teacher, I embarked on creating Zentangle-inspired art. In that context, I tend to teach basic Zentangle techniques before or after a series of beginner and advanced free-motion quilting classes.

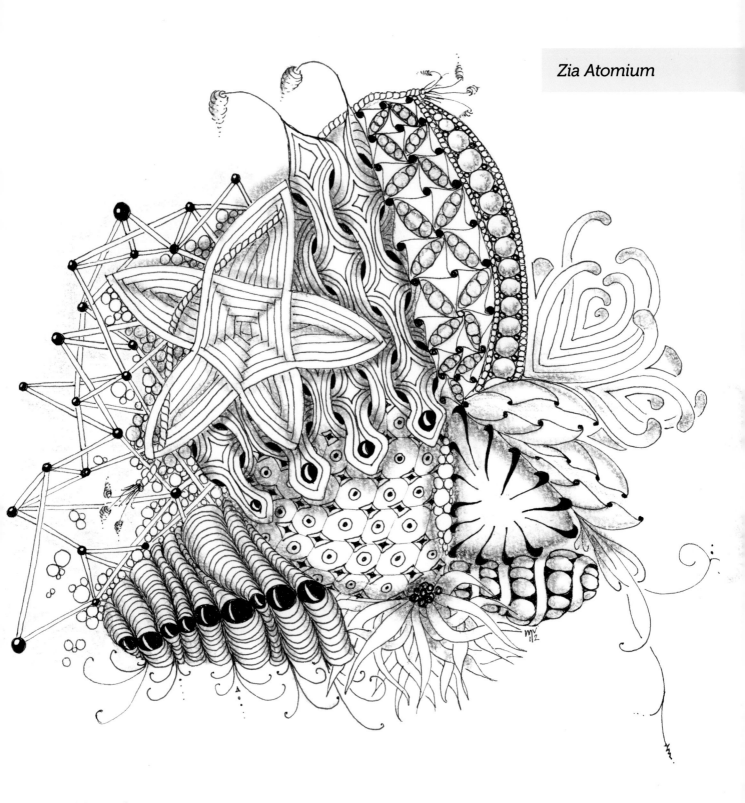

Maria Vennekens, CZT (THE NETHERLANDS)
vennekensmaria@hetnet.nl
Quality paper, Micron pens, pencil.

A fellow calligrapher introduced me to the Zentangle method. I was hooked the moment that I saw the elegant black and white patterns. I ordered a kit and started tangling. I was fortunate to be able to come to the United States to attend a workshop with Rick and Maria. Since then, I teach and preach the Zentangle method in the Netherlands.

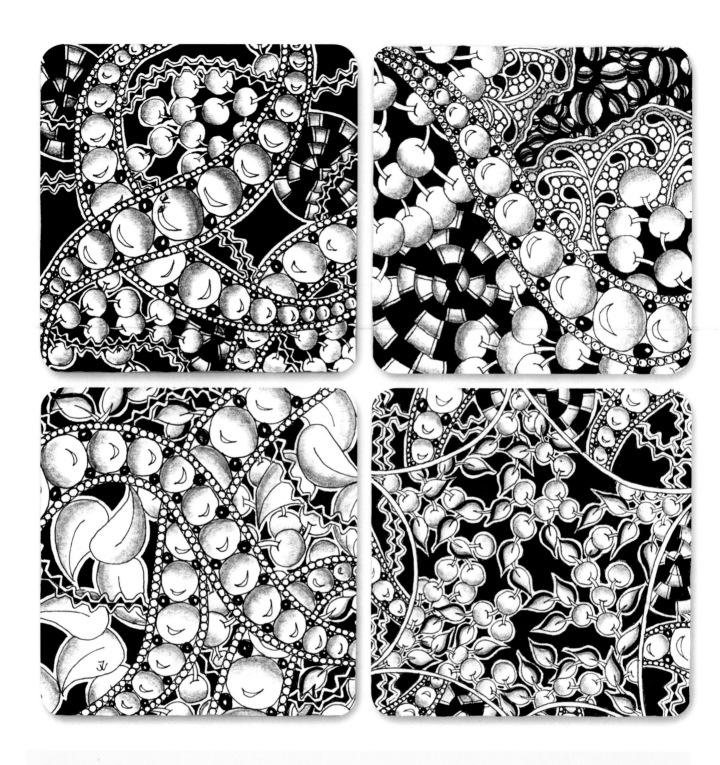

Peas and Pearls

Jella Verelst, CZT (BELGIUM)

paperartstudio.be
Zentangle paper tiles, Micron pens, pencil.

My art combines my passion for creativity, spirituality, and personal growth to assist people in accessing and using their creativity to bring greater awareness and meaning to life. I practice the Zentangle method as a daily meditation.

The Zentangle classes that I give are an inspiring journey to creative awakening through using and understanding the ritual and philosophy of the Zentangle art form.

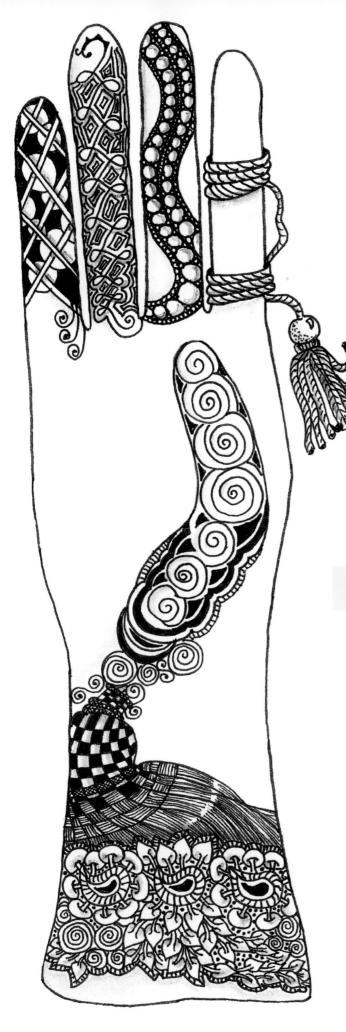

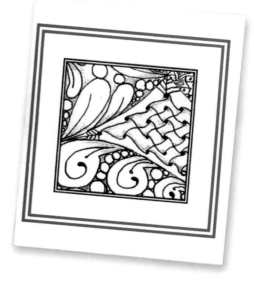

Greeting card

Marion "Mickey" Tynan Weitsen, CZT
(LOUISIANA)
mandhtanglers@yahoo.com
White cardstock (110 lb.), Micron pens, pencil,
blending stump.

I am retired from nursing management. I studied
calligraphy for twenty years and have developed a
second career as a potter. I heard the word Zentangle
and investigated the art form. I thought perhaps I might
use it in my pottery creations and signed up for a class.
What a life-changing experience! For the organized
mind, it leads you on a path of connections, one after
another. For the scattered mind, it encourages a
centering—a calmness of mind and movement. With
pen in hand, my creative spirit flows across the surface,
one stroke at a time, one pattern after another. Each
experience with Zentangle is a renewal—a minor
miracle that reveals the hidden artist in each of us.

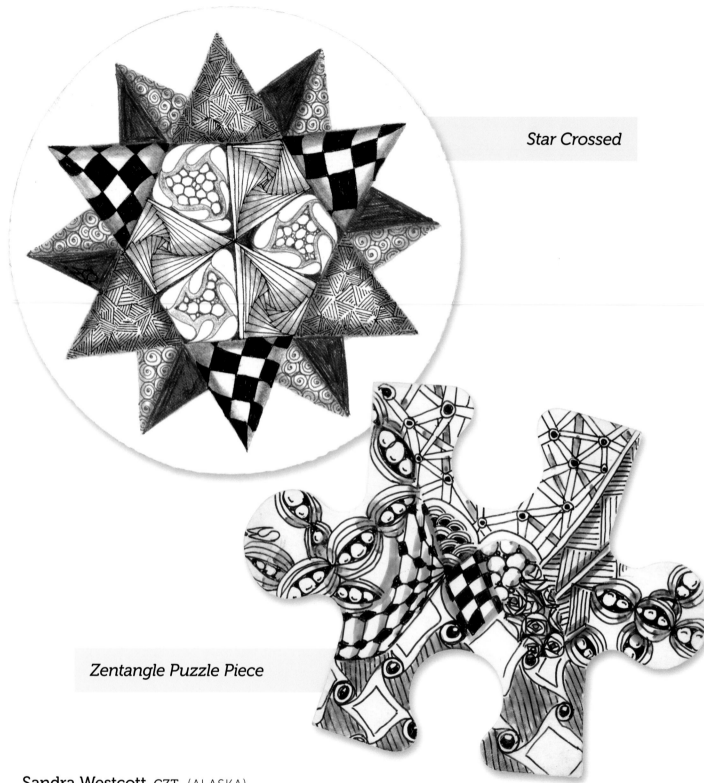

Star Crossed

Zentangle Puzzle Piece

Sandra Westcott, CZT (ALASKA)

stillwinterstudio.com
Zendala pre-strung paper tile, large puzzle piece, Micron pens in black and brown, pencil.

I am fascinated with the idea of using old art forms and techniques in new ways. There's a bit of magic in using simple techniques to create something new, particularly if the end result looks very different from its original starting point. For me, that magic is found in the Zentangle method, where a series of simple strokes, based on ancient patterns, can create an endless stream of new images. I also find it in upcycling ordinary materials to create something fresh and new, like using paper to create the beads I use in my jewelry. There may be nothing new under the sun, but how we interpret those "old" things can be new.

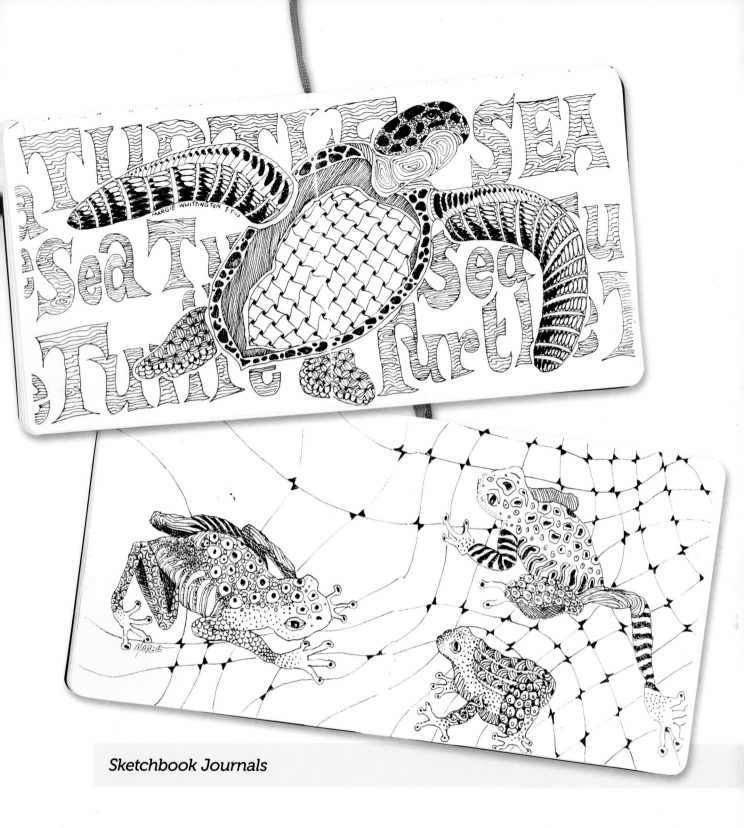

Sketchbook Journals

Margie Whittington (TEXAS)

mwhittingtonart.blogspot.com
Quality sketchbook paper, Micron pens.

I became interested in the Zentangle method after watching a demonstration by Suzanne McNeill at the Upstairs Gallery in Arlington, Texas. I bought her book *Zentangle Basics* for my grandchildren, thinking that this art concept might help inspire their creativity and keep them busy. I loved the tangles and started my own Zentangle journey!

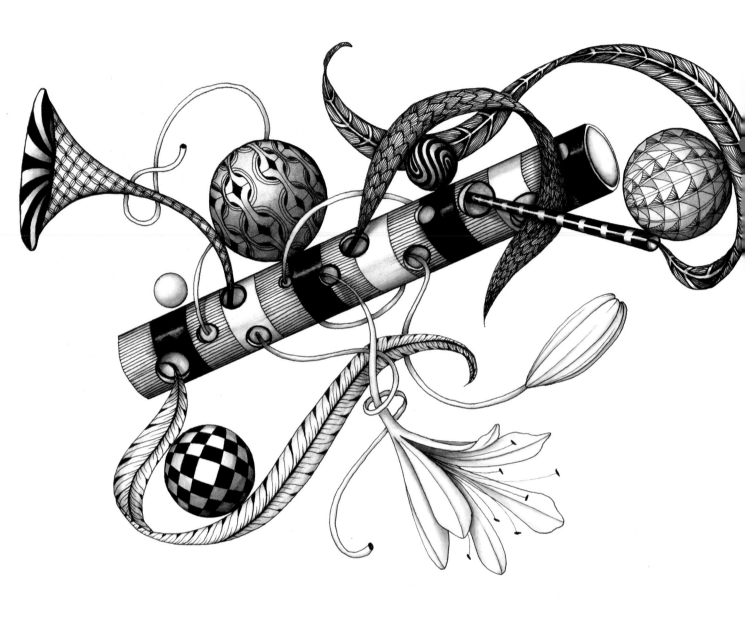

Growing Tube

Helen Williams (AUSTRALIA)

alittlelime.blogspot.com
Quality paper, Micron pens, Letraset ProMarkers.

I discovered the Zentangle method while surfing the Internet. It was love at first sight, and though I had not picked up my pencils in a few years, my passion for drawing was reignited! I like to incorporate patterns in different ways in my drawings, sometimes to create things that are a little unexpected. I am mad about flowers and love finding ways to use patterns either within the flowers, or to accompany them, while still maintaining a naturalistic look. I am a minimalist at heart, and find it an exciting challenge to be able to work with pattern-intensive designs that retain simple, clean lines.

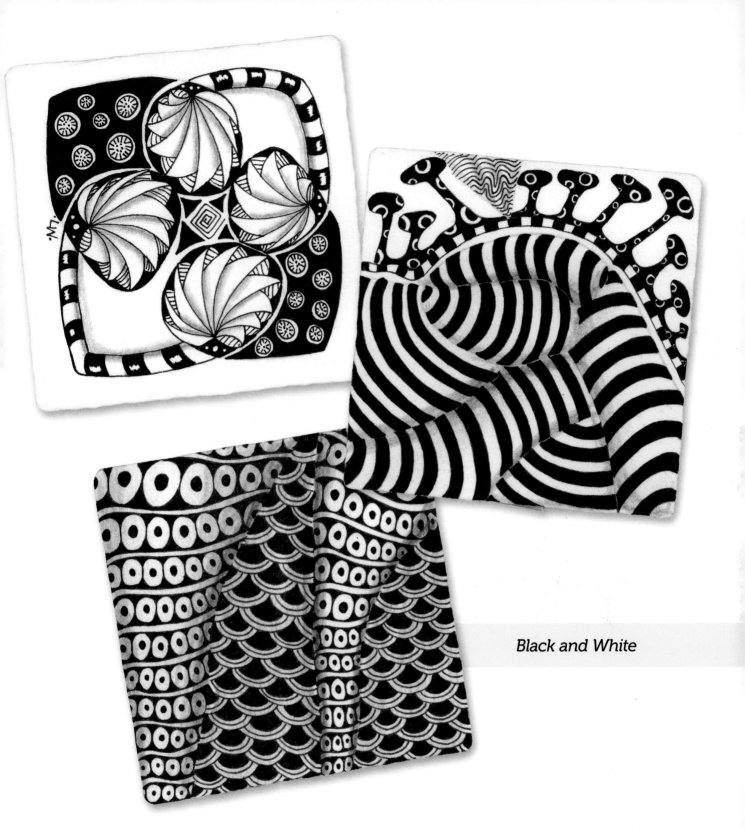

Lara Williams, CZT (INDIANA)
laralina-tangleware.blogspot.com
Zentangle paper tiles, Micron pens.

I am a mixed-media artist and crafter. I have been practicing the Zentangle method and attended a workshop with Rick Roberts and Maria Thomas. I have developed Zentangle workshops for the general public, as well as individuals in recovery from mental health illnesses. I enjoy traveling and discovering the new tangle patterns that await us around the world.

Black and White

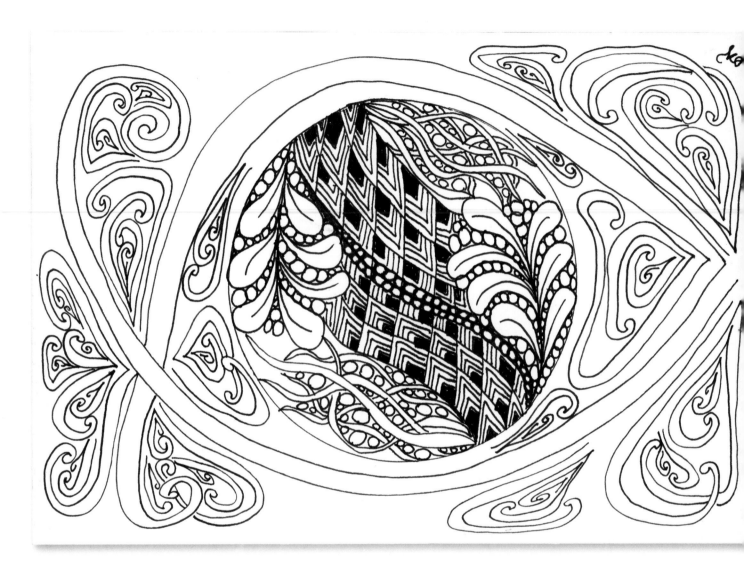

Darla Williamson, CZT (ALABAMA)

tangledstones.com
Quality paper, Micron pens.

After almost twenty years of climbing the corporate ladder, I jumped off to dive into all the art things I am passionate about—clay, mixed media, and Zentangle, which started it all! My mother-in-law sent a Zentangle kit to me and I was hooked! I attended a workshop with Rick and Maria, quit my corporate job, and have been teaching ever since. I taught more than three hundred students in the first year and I love my life!

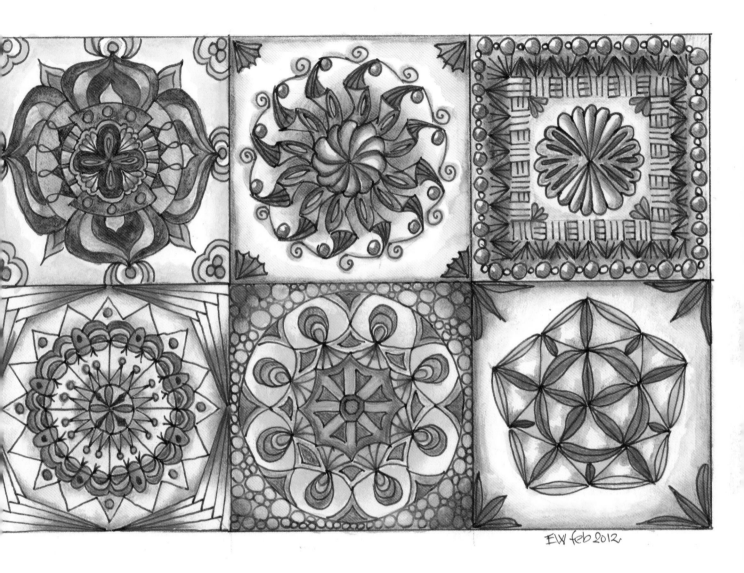

Zendala Sampler

Ellen Wolters (THE NETHERLANDS)
eaj_wolters@hotmail.com
Quality paper, Micron pens, Koi watercolors.

I discovered the Zentangle method when I read an article in a mandala magazine about Zendalas. I surfed the Internet and was amazed by the beauty and simplicity of the artwork, and the fact that everyone can draw tangles. Zentangle is a reachable art form for everyone, with basic materials: pen, paper, and pencil. It encourages people to move forward on their path of art exploring. Tangling almost daily makes me aware of my surroundings and gives me a better outlook on things. When I tangle I have a sign on my forehead that says "Do not disturb. This moment is mine. I am charging my batteries." For me, drawing is my fourth important meal of the day and essential for my health.

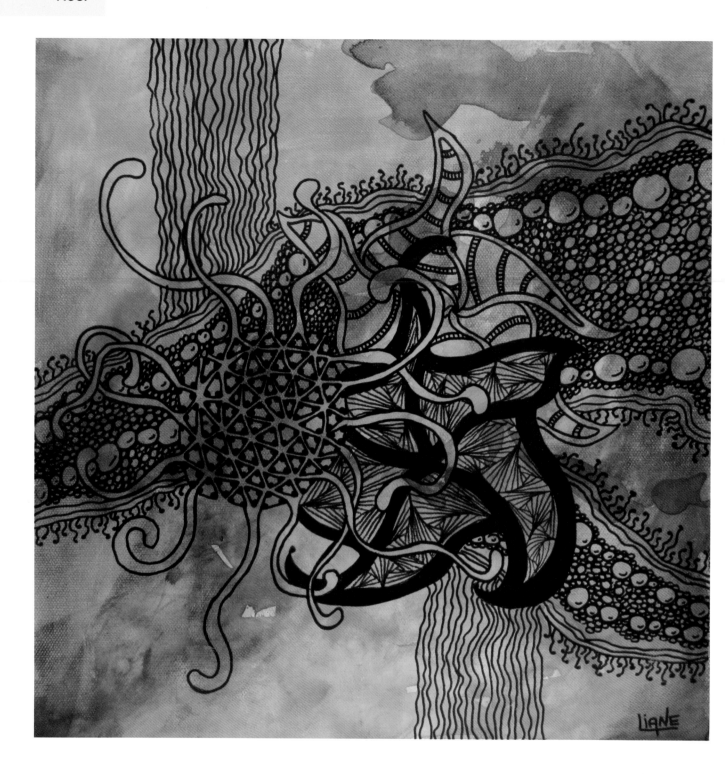

Liane Worth, CZT (AUSTRALIA)

lianeworth@hotmail.com
Canvas, acrylic ink, Micron pens, acrylic paints.

I have always had a need to create—to express myself through making gifts and items with my hands. These days, I paint with acrylics on canvas. Thanks to the Zentangle method, now I also draw—something I was always afraid to do. I love the detail, mystery, and wow factor that all come from a combination of simple strokes. That's the beauty of Zentangle.

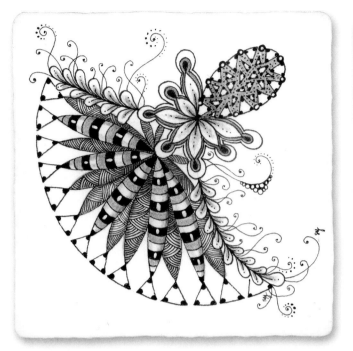
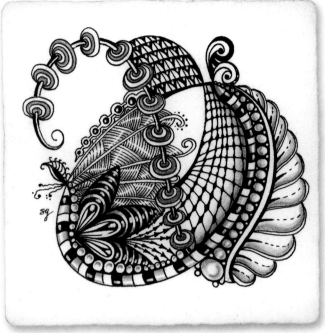
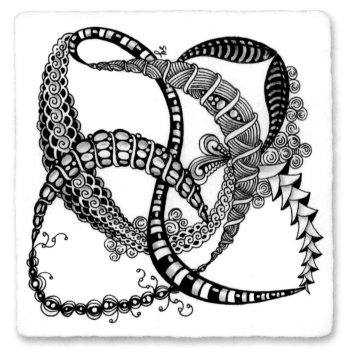
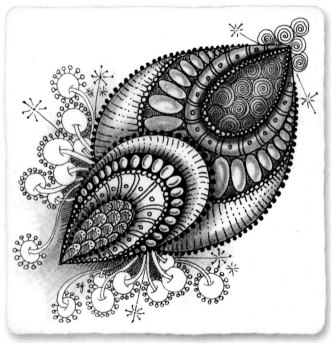

Sonya J. Yencer (OHIO)

sonya@redthreadpromise.org
Zentangle paper tiles, Micron pens, white Gelly Roll pen.

During numerous trips to Haiti, I have had the privilege of teaching the Zentangle method to children, teens, and adults with disabilities through a non-profit organization called The Red Thread Promise. As many of my students are deaf and my Creole limited, classes are generally silent, executed with the students' eyes intently watching my hands, following along with each stroke of the pen.

Each student draws passionately, reaching that much-sought-after Zen in their own time, beaming with satisfaction as they complete tile after tile. Through this experience, I witnessed first-hand how art transcends the barriers that separate us—where we live, the color of our skin, the language we speak—creating bonds that may never be broken.

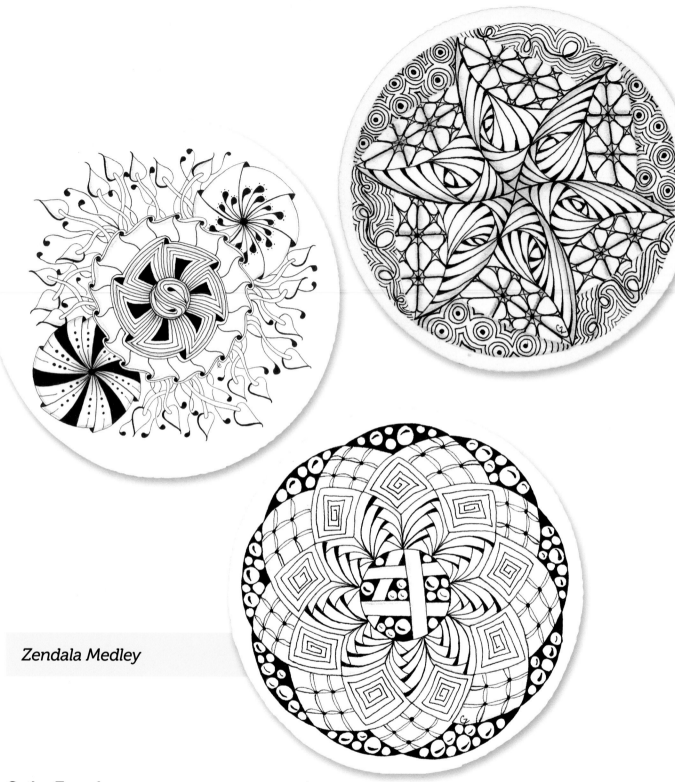

Zendala Medley

Cathy Zavodny, CZT (OHIO)
tangledink.com
Zendala pre-strung paper tiles, Micron pens.

I have been a jewelry artist for more than ten years and never considered myself a drawing artist. When I was introduced to the Zentangle method, I immediately fell in love with it! I love its creativity, the relaxation and calmness it brings, and how much fun I have with each piece I create. I have also incorporated tangles into my jewelry by creating fun and unique pendants and earrings. I attended a workshop with Rick and Maria and teach the Zentangle method.

Sacil Armstrong aka Bohemiangirl, CZT
(VIRGINIA)

mycreativemischief.com
Zendala paper tile, Micron pens, pencil.

I am super driven and have a hard time relaxing, but the Zentangle method does that for me. When I tangle, I can breathe, and my shoulders fall into place. I found the Zentangle method when one of my online bead buddies used a Zentangle pattern in a design. I learned what I could online and a year later took a workshop with Rick and Maria. My favorite thing about teaching is watching students slow down, let go of expectations, and discover what they can do!

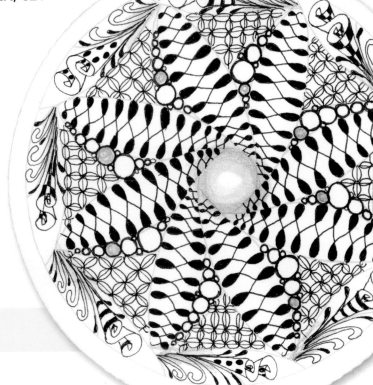

Petals

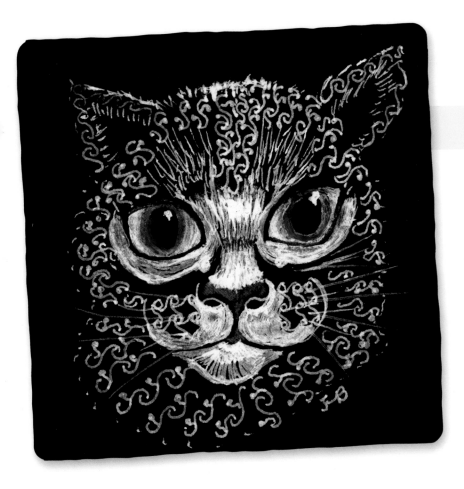

Black Cat

Jeannine Bellarosa, CZT
(MASSACHUSETTS)

jakeandjuliastoys@yahoo.com
Zentangle black paper tile, white gel pen, green acrylics, brush.

I am a dedicated tangler and attended the Zentangle Master Class, held by Rick and Maria. I enrolled in a workshop with Maria Thomas and Rick Roberts and have been tangling ever since. I often win awards for my unique and creative original designs. I am an art innovator and designer who develops nouveau art with the Zentangle method.

Dawn D. Jackson, CZT
(WISCONSIN)
dawn_temp@hotmail.com
Quality paper, Micron pen in blue.

I grew up doing various types of crafts. Drawing, however, was not one that was in the forefront. There were some attempts to draw as a result of art classes. Success was not always attained. Fast forward about thirty years. While visiting one of my favorite art supply stores, I came upon a Zentangle demonstration. I was completely hooked! Being a person with an accounting background, I think the structured approach facilitated my ability to catch on to the technique. I tangled any chance I got. I was very excited to attend a workshop with Rick and Maria. Now I enjoy seeing the amazement of others when they too are able to create beautiful motifs "one stroke at a time."

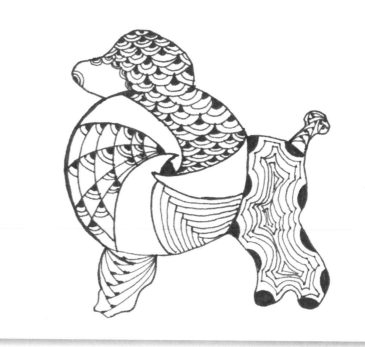

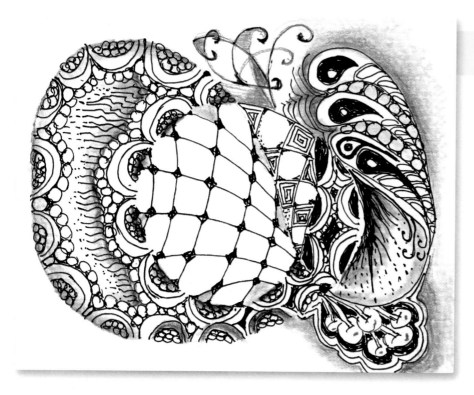

Deanna Gibson, CZT
(AUSTRALIA)
deanna.gibson@deeZtanglZ.com.au
Watercolor paper card, Micron pens, pencil.

My interests and passions are art, music, and photography. My art and teaching career includes being a K–12 Art Specialist, an Early Childhood Educator, and a Wellness Teacher. In recent times I have had opportunities to do my own drawings and paintings. I became interested in the Zentangle method because I was attracted to the meditative art process. Later, two of my dreams were realized: a trip to the United States and attending a workshop with Rick and Maria.

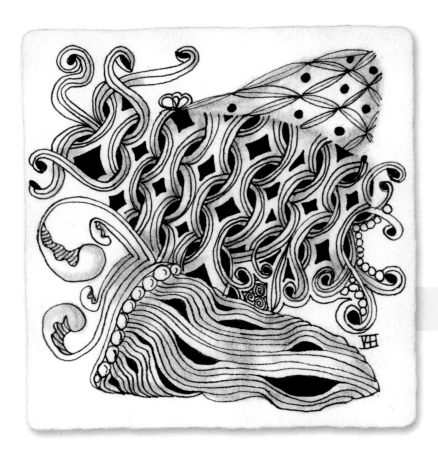

Victoria M. Hayhurst, CZT
(COLORADO)
drawzentangle.wordpress.com
Zentangle paper tile, Micron pens, pencil.

I attended a Zentangle workshop with Rick and Maria. Now, I am living proof that people with all levels of artistic ability can create beauty and magic with the Zentangle method. I look forward to sharing this art form and all it has to offer with those who come as seekers.

In and Out

Tangled

Fina Man, CZT
(HONG KONG)
Zentangle paper tile, Micron pens.

I am in love with the Zentangle method. When I first saw the relaxing drawing style, I wanted to learn more, so I visited the United States to take a class with Rick and Maria. I became the first Zentangle artist in Hong Kong. I returned to the United States the next year for the Zentangle Master Class held in Rhode Island.

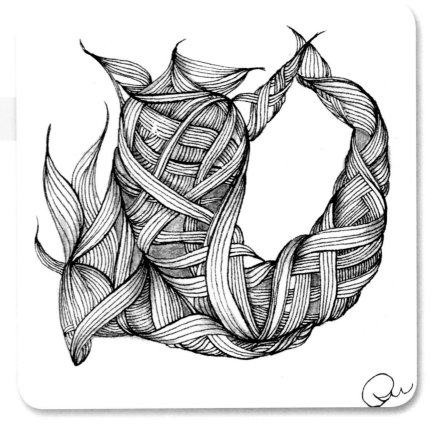

Laura Harms, CZT
(CANADA)
iamthedivaczt.blogspot.com
Zentangle paper tile, Micron pens, pencil.

I first was attracted to tangling because it was so similar to my own doodling, but I fell in love with the Zentangle method when I realized it was so much more than just doodling. Tangling helps me quiet my mind and carve out fifteen minutes in my day for myself. I use it as a therapeutic tool to help me cope with my busy life. Putting together the "Diva Challenges" for tanglers on my blog has been so much fun. Zentangle changed my life for the better.

Breathe

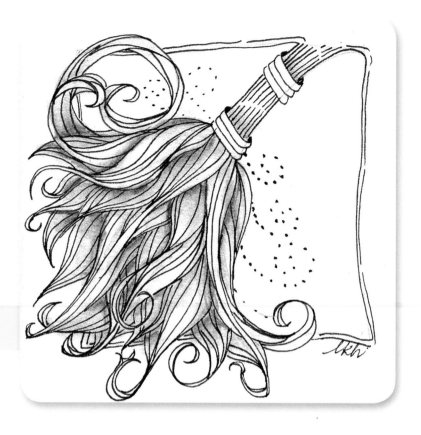

Tangled Leaf

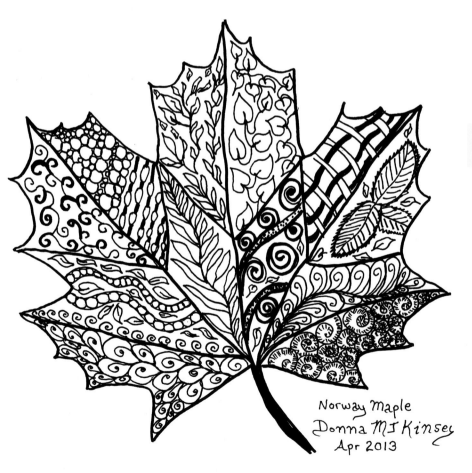

Norway Maple
Donna MJ Kinsey
Apr 2013

Donna MJ Kinsey
(TEXAS)
kinseyquilts.com
Watercolor paper, Micron pens.

I am a professional quilter and I use Zentangle designs to create custom quilting patterns. I also enjoy making cards, especially when I can apply tangles to a project. The "no mistakes" aspect of the Zentangle method and the meditative process provides an experience similar to the hand embroidery that I have enjoyed for more than fifty years.

Round and Round

Diane Masloroff, CZT
(ILLINOIS)
distangleart.blogspot.com
Zendala paper tile, Micron pens in black and sepia.

My interest in art goes back to my childhood days. Hours spent drawing with pencils and charcoal gradually evolved to painting, mosaics, pottery, and an array of crafts. I also am a decorative artist, learned art journaling, and love to tangle. The Zentangle method has enhanced my artwork and gives me an opportunity to teach an art form to people who never would have imagined they could create a piece of art.

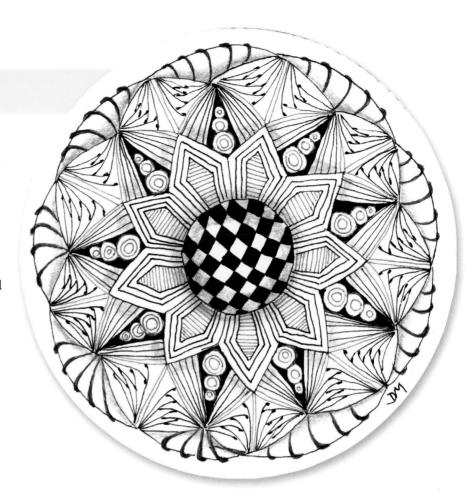

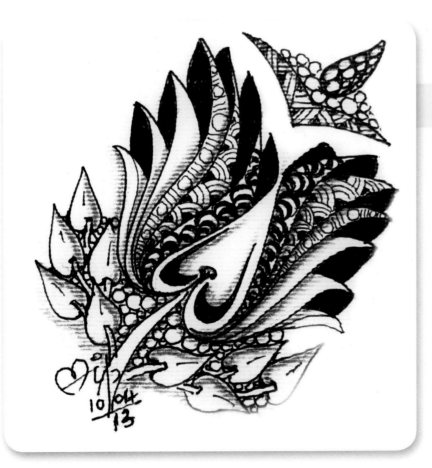

Blossom

Dilip P. Patel, CZT
(INDIA)
thingsoftenspeaktome.blogspot.com
Watercolor paper, Micron pens.

I was drawn to the Zentangle method a couple of years ago through a chance discovery on the Internet made by my wife, Malathi. We found it very interesting that the repeated simple strokes and randomly created shapes could produce amazing artwork. My out of the box "Naturetangle" led to an invitation from Rick and Maria to attend a Zentangle workshop. I believe the Zentangle method is a wonderful tool with the same benefits as meditation.

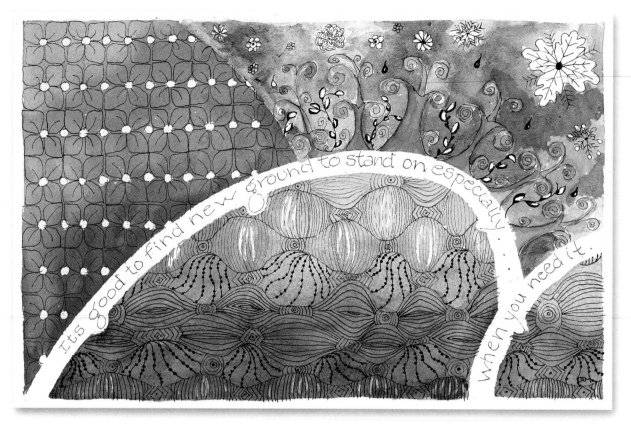

Within the artwork: *It's good to find new ground to stand on especially ... when you need it.*

Jane Menard, CZT (CANADA)

tanglejam.blogspot.com
Watercolor paper, Micron pens, watercolors, art masking fluid.

My practice of the Zentangle method brings me to a wonderful state of calm and focus. It allows me to live in the present moment. My story is a sad one, so just know that I admire the beauty of Zentangle and I am grateful to my friend Chris, who introduced me to it, and to Rick and Maria for their generosity, support, and enthusiasm.

Good to Find

My Gifts

Lois Stokes, CZT
Earl Stokes, CZT (HAWAII)

stringfigure.com
Leaves from a Hawaiian Autograph tree, bamboo knitting needle.

We are "Artists of the Spirit" living on the Big Island of Hawaii. We took a journey to the mainland to take a Zentangle workshop with Rick and Maria. We specialize in art as a moving meditation and embrace the expression of art that reflects Sabi or the beauty and serenity that comes with age and the process of change. Our tropical setting in Hawaii is filled with the beauty of nature and her multitude of patterns.

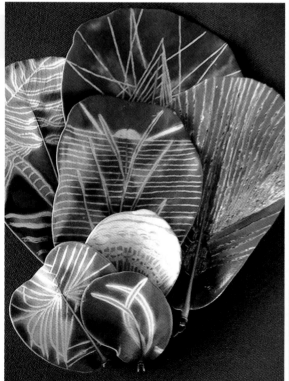

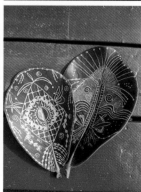

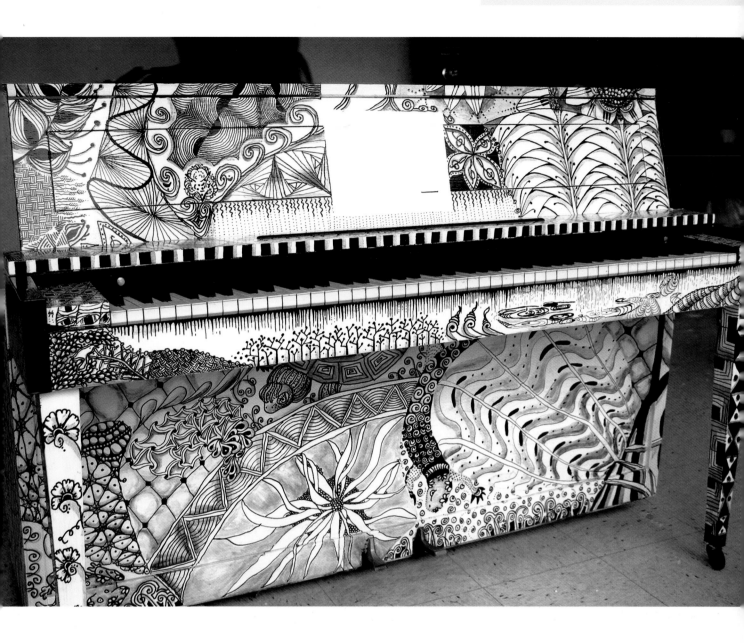

Hands-on Piano Project (NEW HAMPSHIRE & VERMONT)

Bette Abdu, CZT **Debbie Skinner** **Jane MacKugler,** CZT
Sadelle Wiltshire, CZT **Suzy Shedd,** CZT **Liz D'Amico**
Ann Coakley, CZT **Dana McNair**

Acrylic paint, oil-based paint markers, Micron pens, sealer.

We had so much fun getting together and tangling this piano for a special project. It was a labor of love; however, our knees still feel the pain of spending 3 to 4 hours squatting to get to the lower parts of the piano. If we ever do this again, we will get a winch! The piano now resides in the Mountain Painters & Artisans Gallery in Londonderry, Vermont.

As you can see, each and every one of these artists produces countless beautiful pieces of Zentangle art. Here is some late-breaking art that we just had to include.

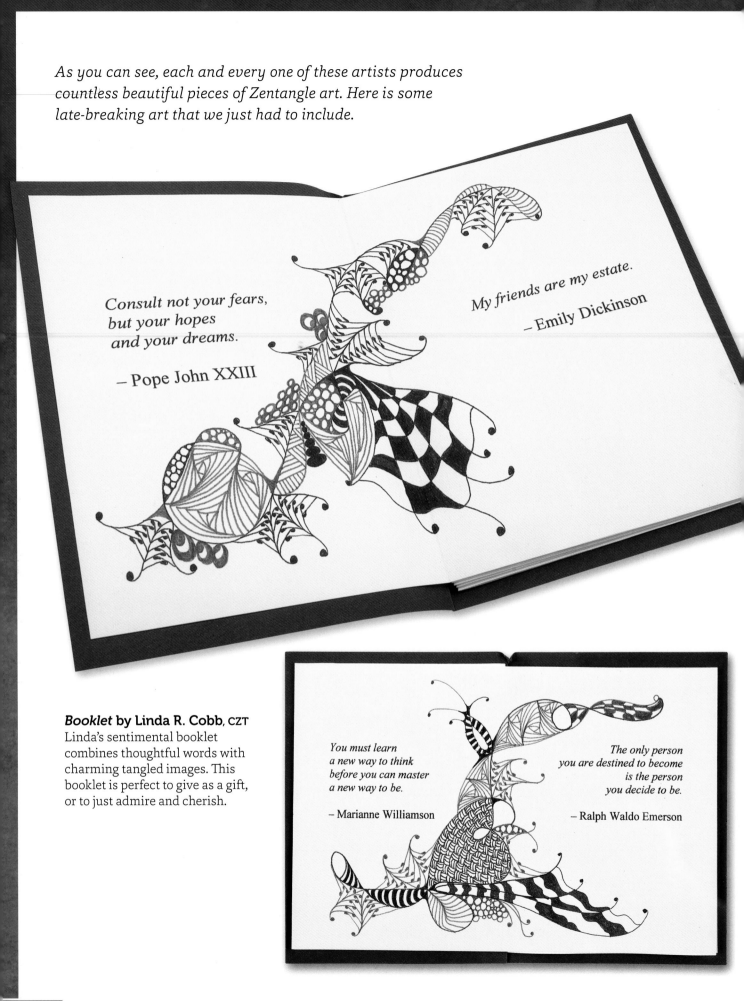

Consult not your fears,
but your hopes
and your dreams.

– Pope John XXIII

My friends are my estate.

– Emily Dickinson

You must learn
a new way to think
before you can master
a new way to be.

– Marianne Williamson

The only person
you are destined to become
is the person
you decide to be.

– Ralph Waldo Emerson

Booklet by **Linda R. Cobb**, CZT
Linda's sentimental booklet combines thoughtful words with charming tangled images. This booklet is perfect to give as a gift, or to just admire and cherish.

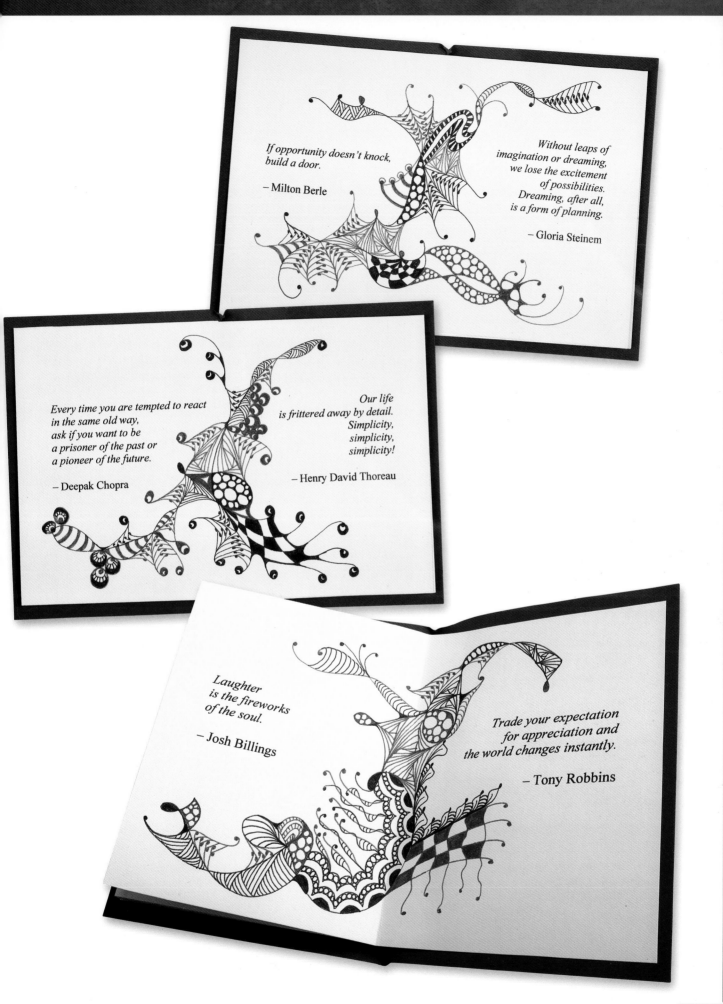

If opportunity doesn't knock,
build a door.

– Milton Berle

Without leaps of
imagination or dreaming,
we lose the excitement
of possibilities.
Dreaming, after all,
is a form of planning.

– Gloria Steinem

Every time you are tempted to react
in the same old way,
ask if you want to be
a prisoner of the past or
a pioneer of the future.

– Deepak Chopra

Our life
is frittered away by detail.
Simplicity,
simplicity,
simplicity!

– Henry David Thoreau

Laughter
is the fireworks
of the soul.

– Josh Billings

Trade your expectation
for appreciation and
the world changes instantly.

– Tony Robbins

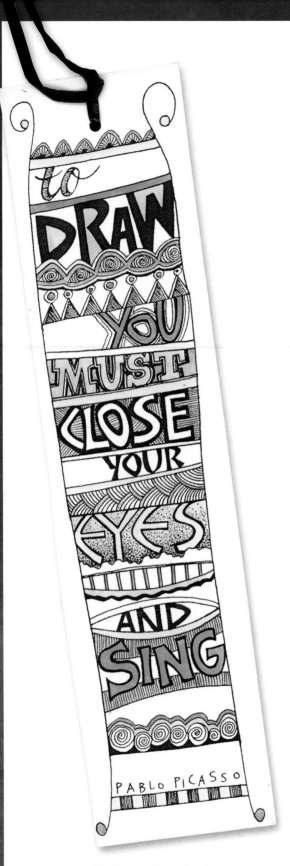

To Draw You Must
by C. C. Sadler, CZT

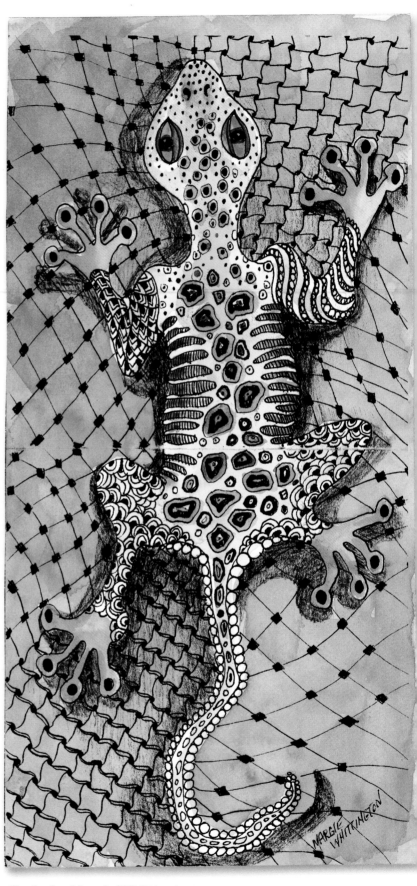

Gecko by Margie Whittington

The Beauty of Zentangle

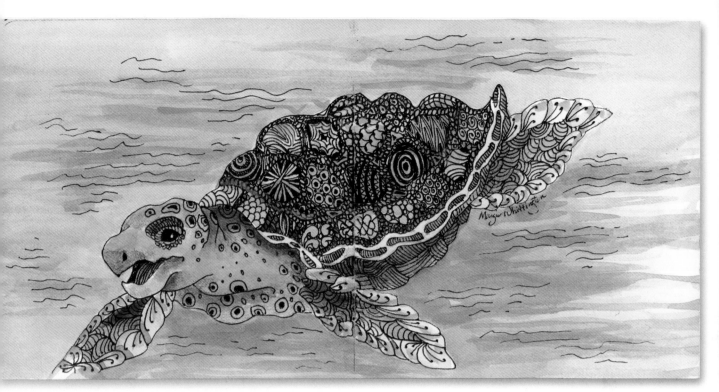

Sea Turtle by Margie Whittington

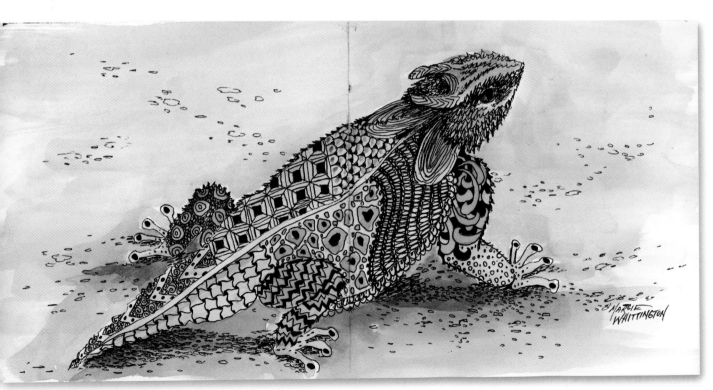

Horned Toad by Margie Whittington

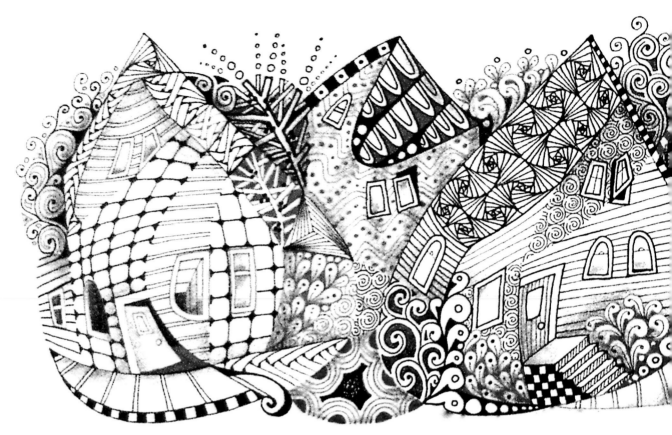

Harmony Street by Margaret Bremner, CZT

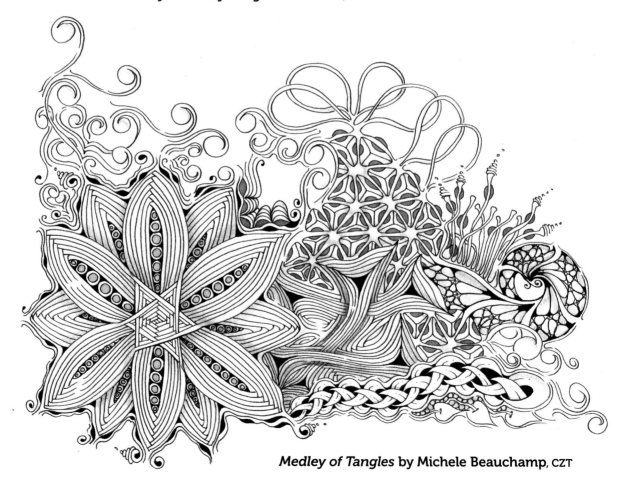

Medley of Tangles by Michele Beauchamp, CZT

The Beauty of Zentangle

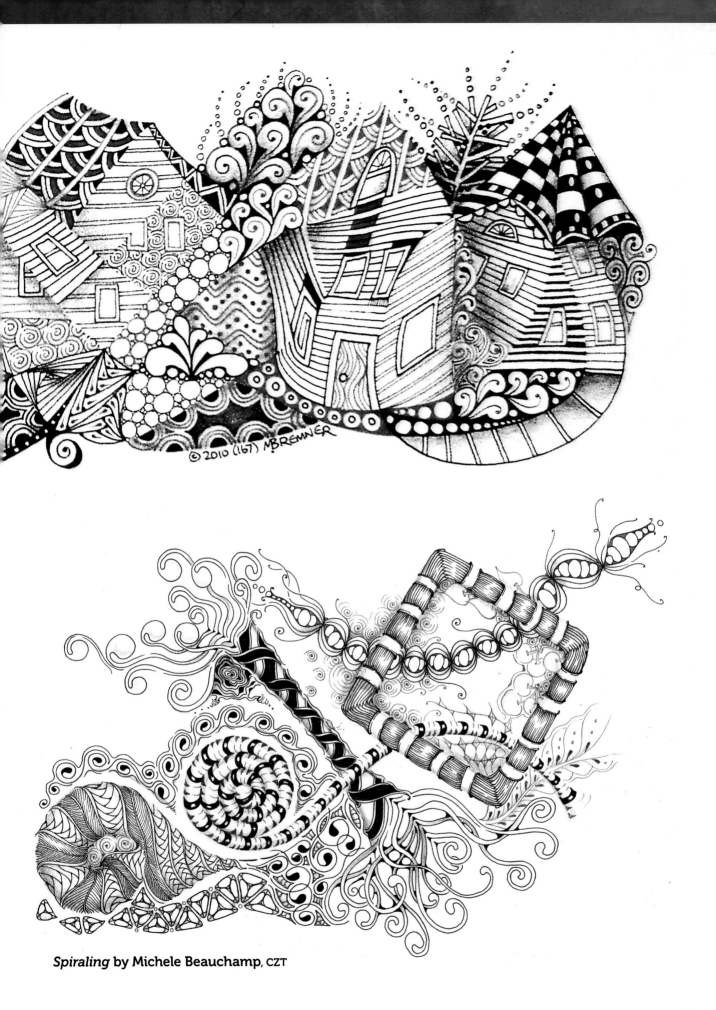

Spiraling by Michele Beauchamp, CZT

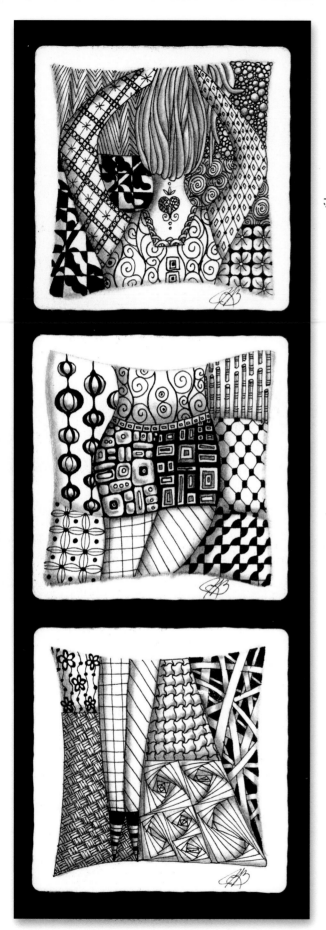

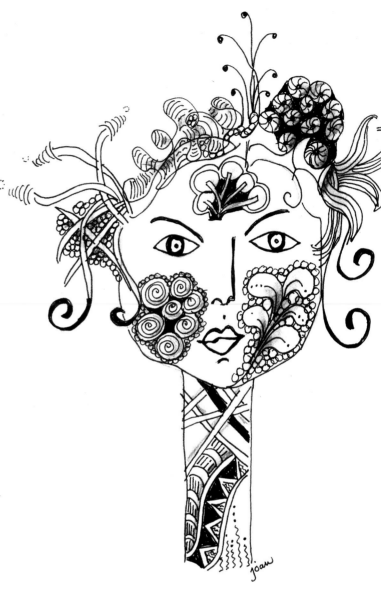

Young Girl by Joan Payton, CZT

Foxy Lady by Judy K. Burkett, CZT

The Beauty of Zentangle

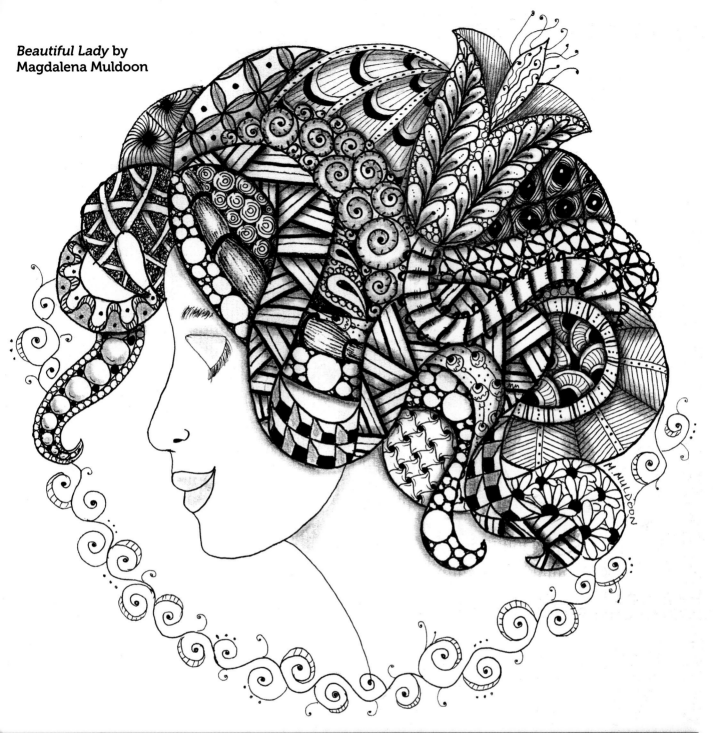

Beautiful Lady by
Magdalena Muldoon

Batik on a Silk Scarf by Angie Vangalis, CZT

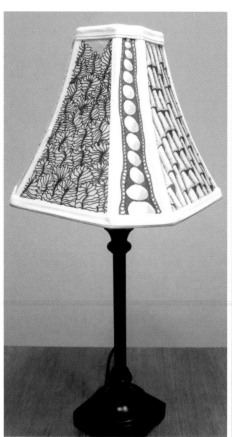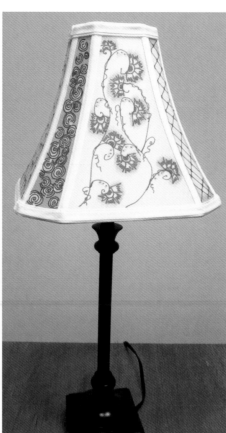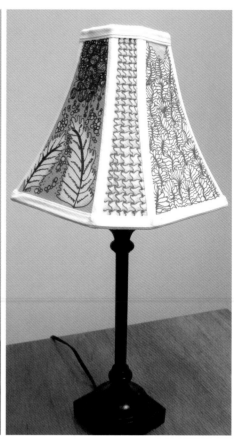

Lampshades by Marta Drennon, CZT

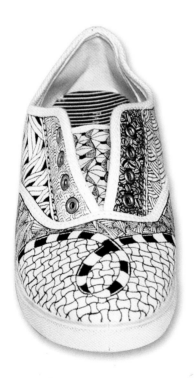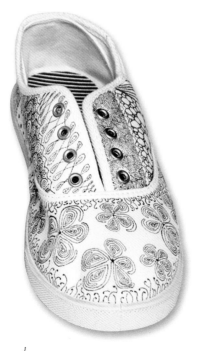

Zen Earrings by Sandra Westcott, CZT

Tangled Tennis Shoes by Jennifer Van Pelt, CZT

The Beauty *of* Zentangle

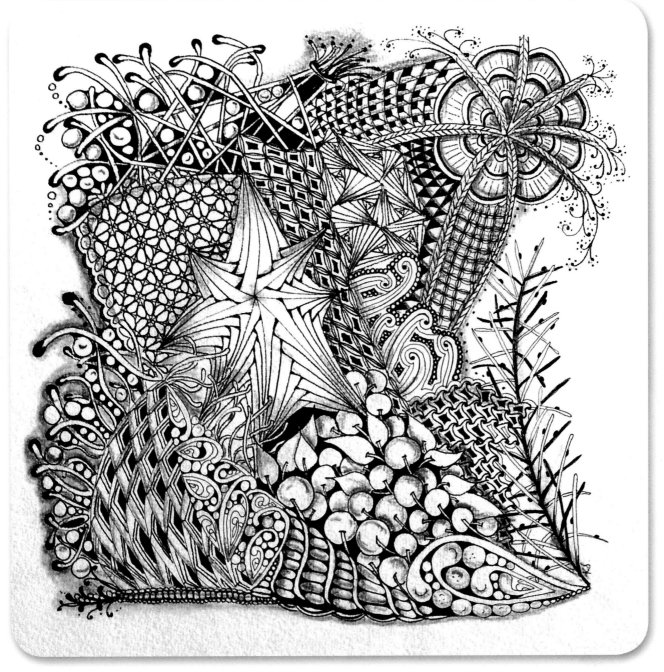

Squared Up by Karen Polkinghorne, CZT

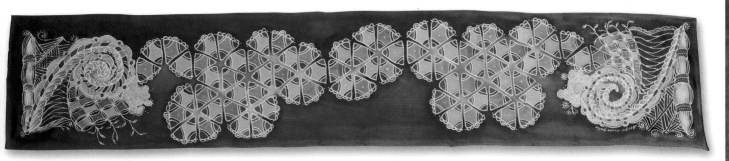

Batik on a Silk Scarf by Angie Vangalis, CZT

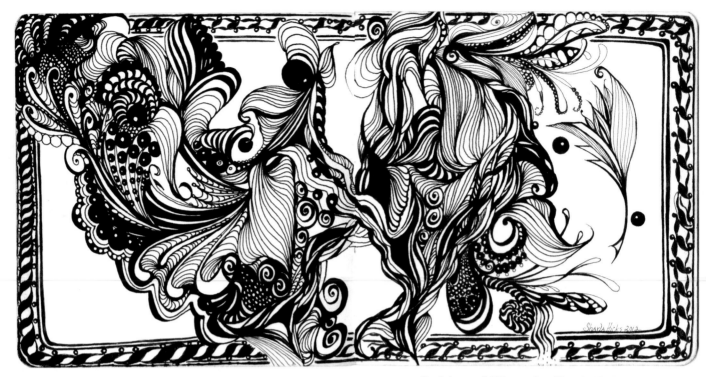

Swirls and Waves by Sharla R. Hicks, CZT

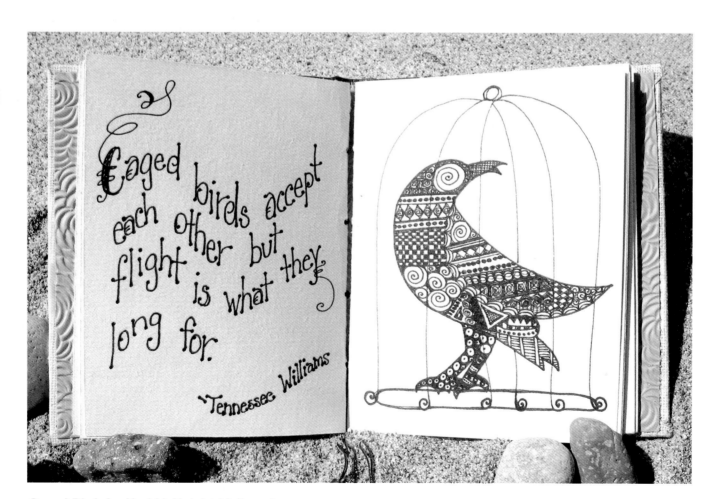

Caged each birds accept flight other but is what they long for.

~Tennessee Williams

Caged Birds by Kari McKnight-Holbrook

The Beauty of Zentangle

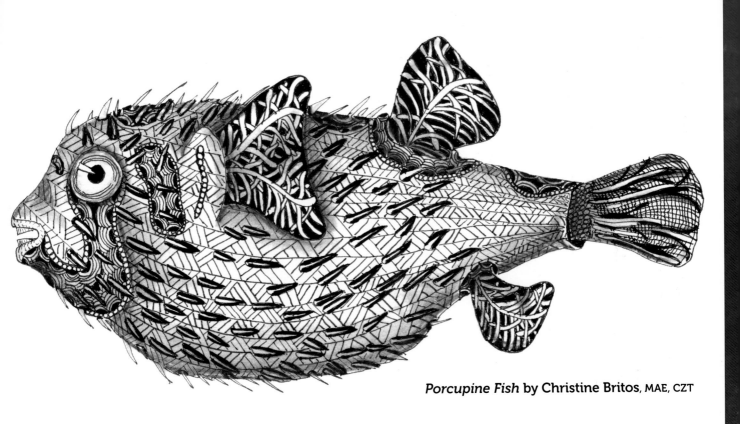

Porcupine Fish by Christine Britos, MAE, CZT

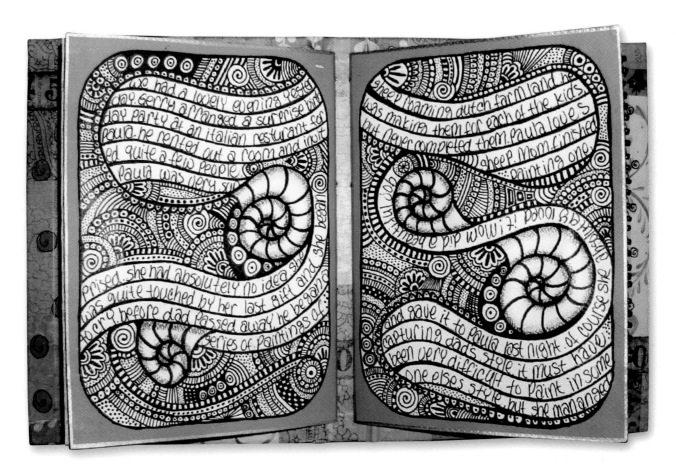

Zen Journaling by Ingrid Dijkers

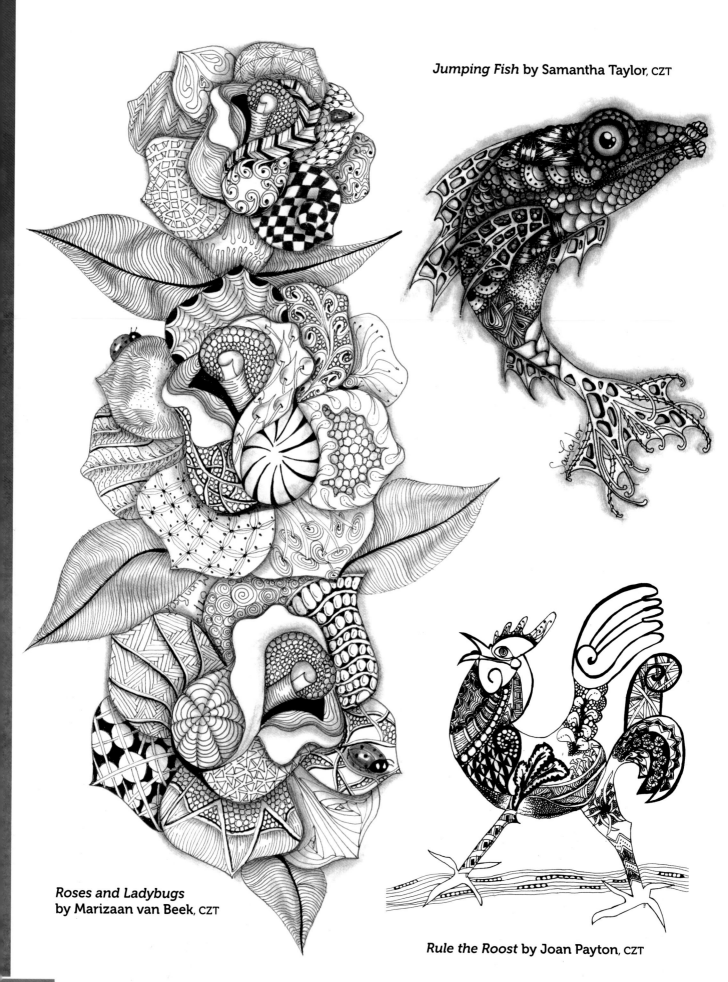

Roses and Ladybugs
by Marizaan van Beek, CZT

Rule the Roost by Joan Payton, CZT

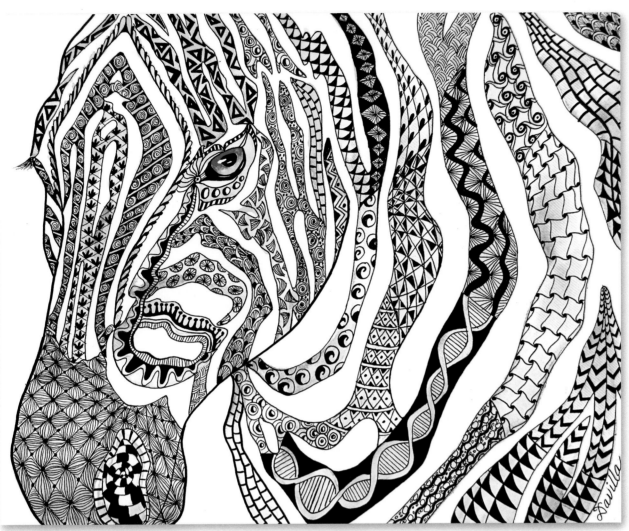

Zen Zebra by Davilla Harding

Snail by Lee Vause, CZT

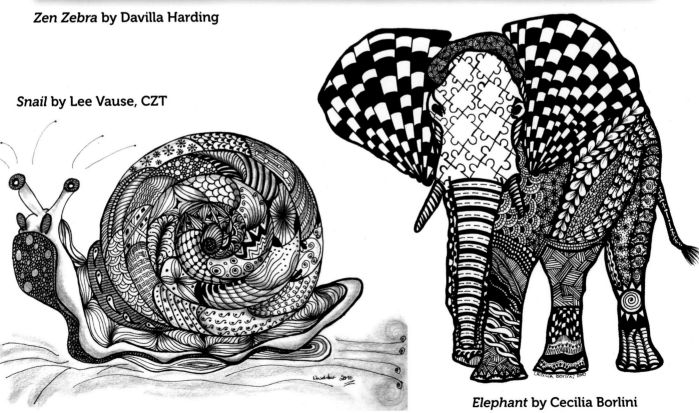

Elephant by Cecilia Borlini

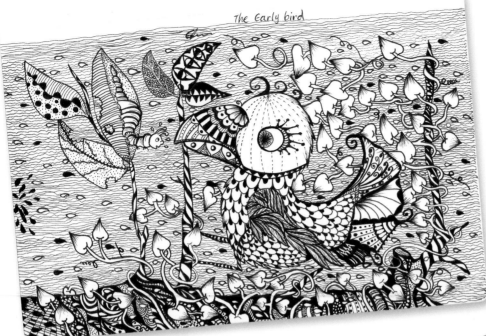

The Early bird

The Early Worm
by Goretti Lewis

Le Cirque by Goretti Lewis

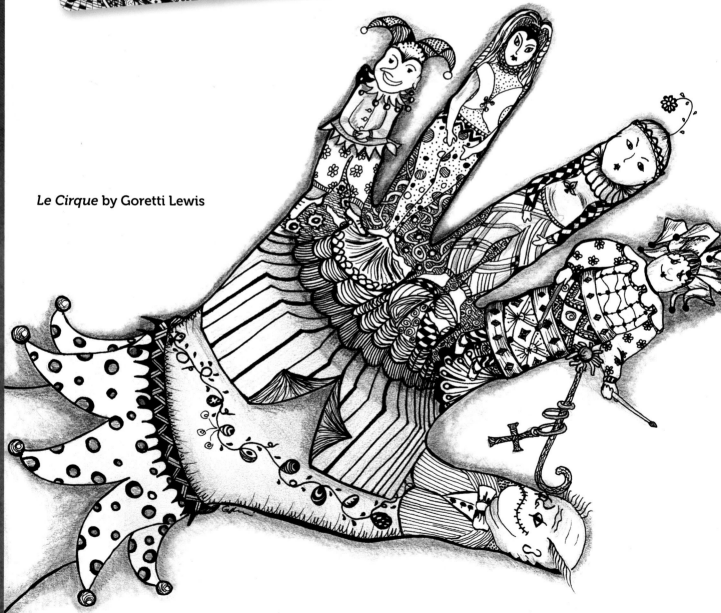

The Beauty of Zentangle

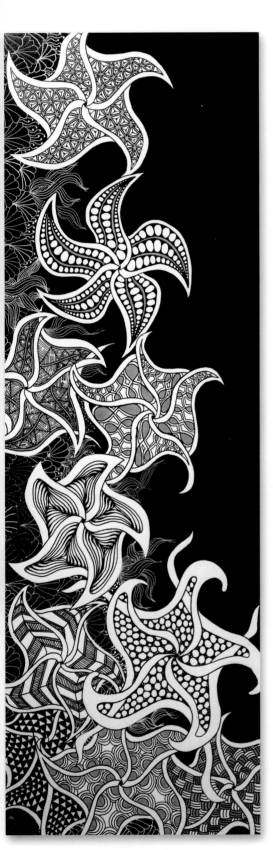

Starfish Twist by Liane Worth, CZT

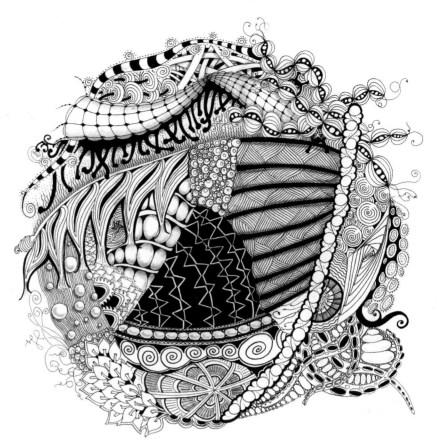

Twirling by Julie Evans, CZT

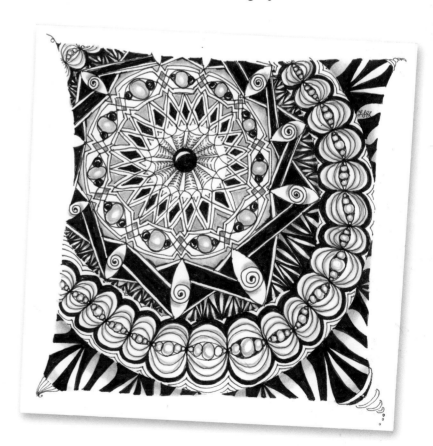

Just 4 Fun by Lesley Scott-Gillilan, CZT

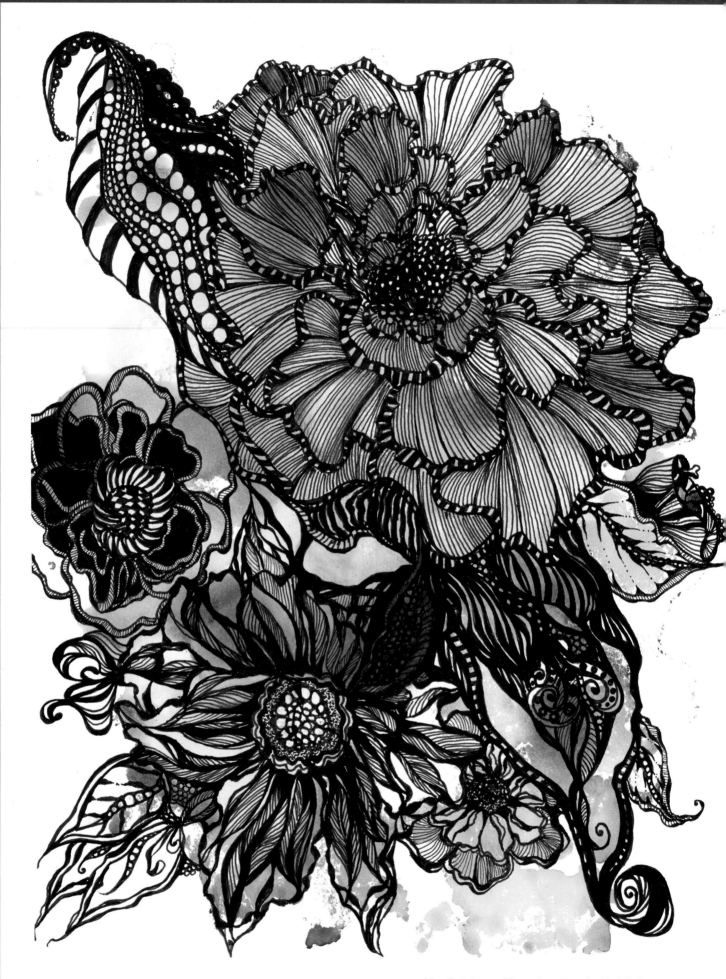

My Cabbage Rose by Sharla R. Hicks, CZT

The Beauty of Zentangle

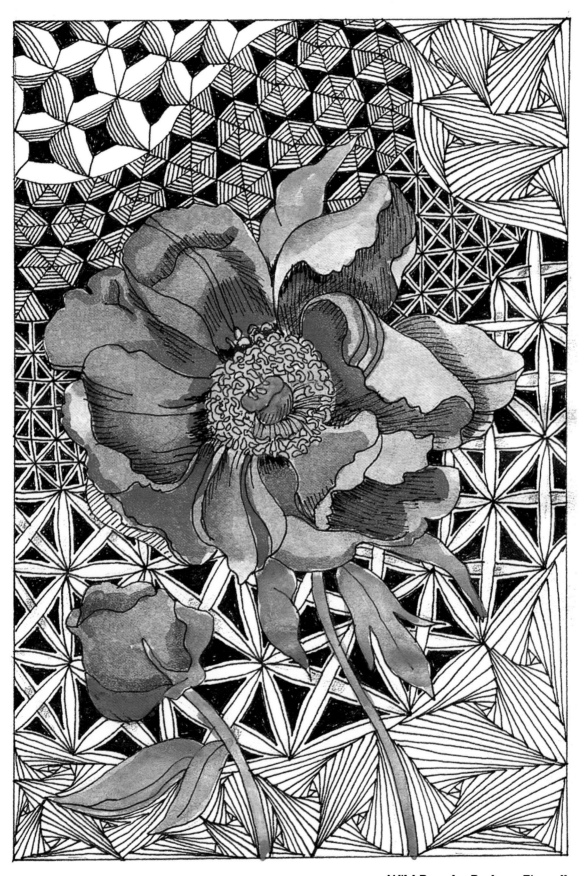

Wild Rose by Barbara Finwall

Tangles

In addition to sharing their artwork, many of the artists featured in this book have chosen to share tangles that they created. Try incorporating some of these new and exciting patterns in your own Zentangle work, or use them to inspire your own tangles.

Zentangle art by Lesley Scott-Gillilan, CZT

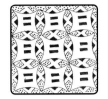

Afreeka
page 162

LEARN TO DRAW THESE
37 New Tangles

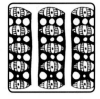

Alien Ties
page 163

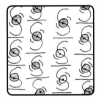

Allstrokes
page 164

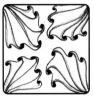

Angel Fish
page 164

Antz
page 165

Batlló
page 165

Bedo
page 166

Blox
page 166

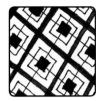

Boo Koo Squares
page 167

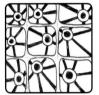

Brabs
page 167

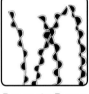

Bumpety Bump
page 168

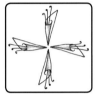

Circlets
page 169

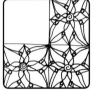

Coneflor
page 169

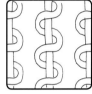

Cosmic Flower
page 170

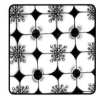

Dessus-Dessous
page 170

Dogwood
page 171

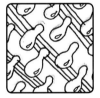

Dripdrop
page 171

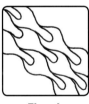

Flench
page 172

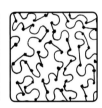

Goodness
page 172

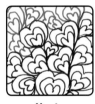

Hartz
page 173

Ista
page 173

Keenes
page 174

Kinet
page 174

Kurtinz
page 174

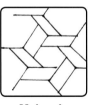

Molecule
page 175

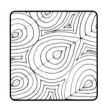

Peacock
page 175

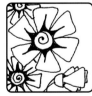

Rosettes
page 176

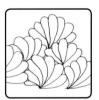

Sanibelle
page 176

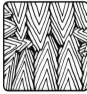

Sharky
page 177

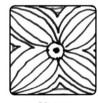

Sistar
page 177

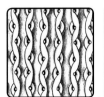

Sraith
page 178

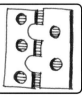

Steampunk Hinge
page 179

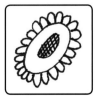

Sunseed
page 179

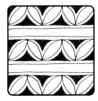

Up and Down
page 180

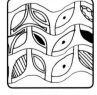

Y-flip
page 180

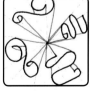

Zensplosion Folds
page 181

Zoid
page 181

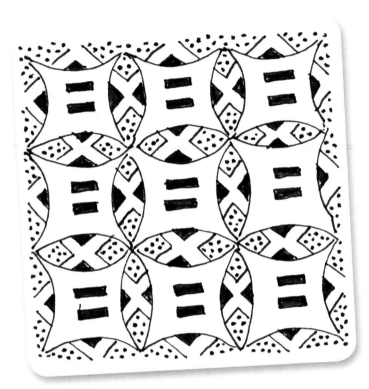

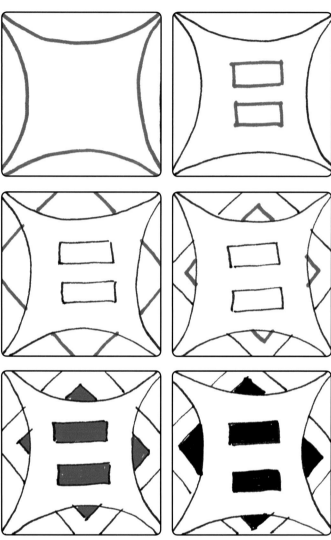

Variation

Variation

Allstrokes Tangle
Jenny Farrell, CZT

Angel Fish Tangle
Marizaan van Beek, CZT

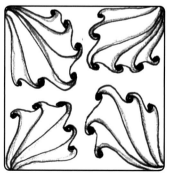

Variation

HOW TO DRAW
Antz Tangle Dilip P. Patel

Variation

Variation

HOW TO DRAW
Batlló Tangle Maria Vennekens, CZT

The Beauty of Zentangle

165

HOW TO DRAW
Bedo Tangle Erin Koetz Olson, CZT

HOW TO DRAW
Blox Tangle Alice Hendon, CZT

The Beauty of Zentangle

HOW TO DRAW
Boo Koo Squares Tangle Diane K. Ryan, CZT

HOW TO DRAW
Brabs Tangle Ellen Wolters

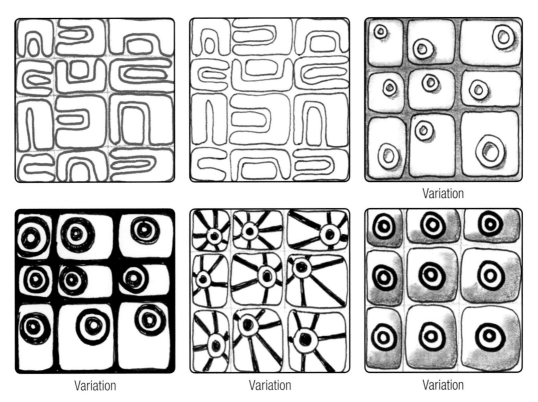

Variation

Variation

Variation

Variation

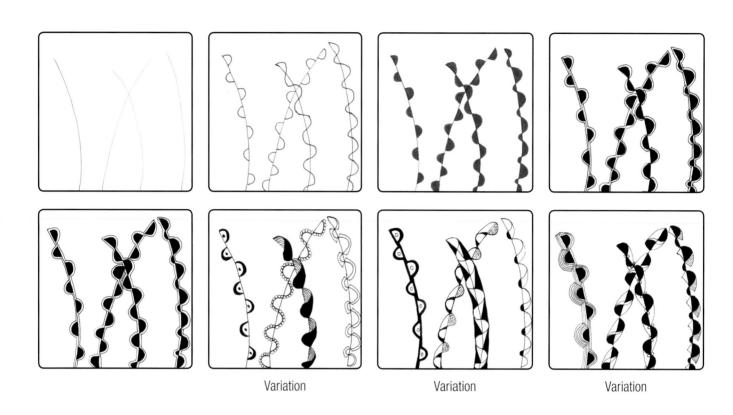

Variation Variation Variation

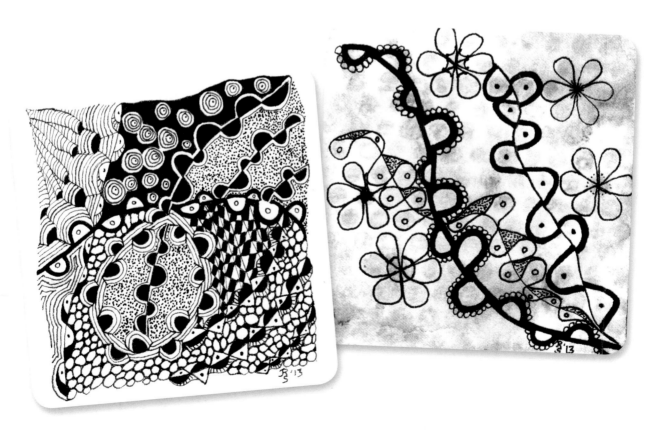

HOW TO DRAW
Circlets Tangle Judith McCabe, CZT

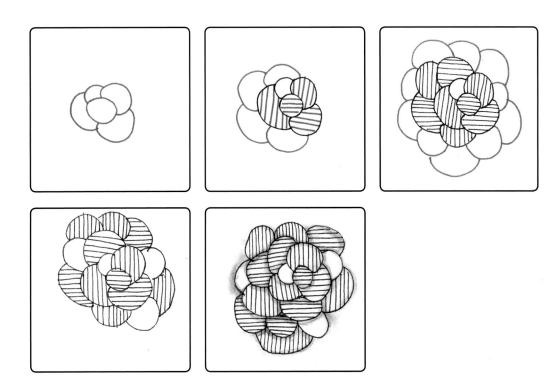

HOW TO DRAW
Coneflor Tangle Marion "Mickey" Tynan Weitsen, CZT

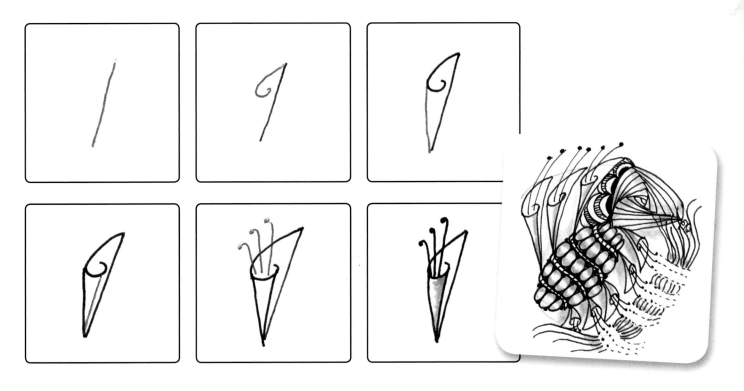

HOW TO DRAW
Cosmic Flower Tangle Chari-Lynn Reithmeier, CZT

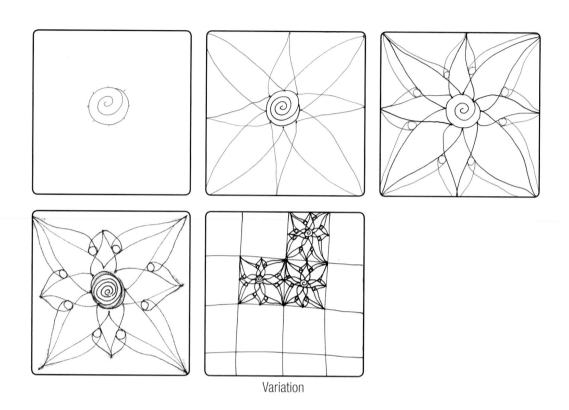

Variation

HOW TO DRAW
Dessus-Dessous Geneviève Crabe, CZT

The Beauty of Zentangle

Dogwood Tangle Judy K. Burkett, CZT

Dripdrop Tangle Arja de Lange-Huisman, CZT

Variation Variation

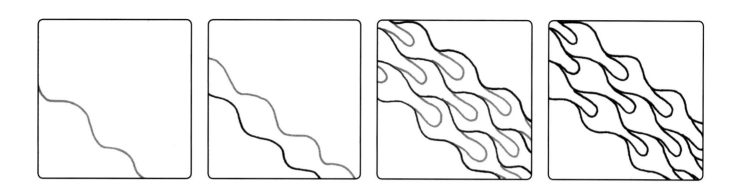

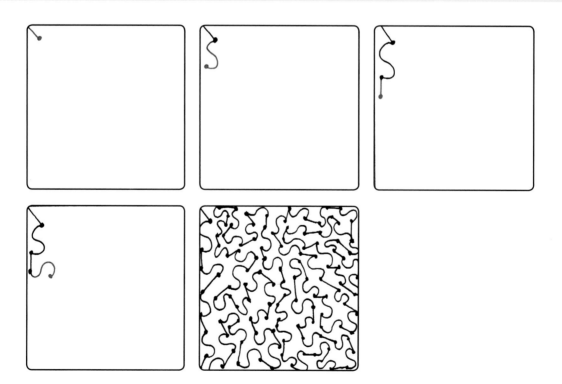

HOW TO DRAW
Hartz Tangle Nancy Smith, CZT

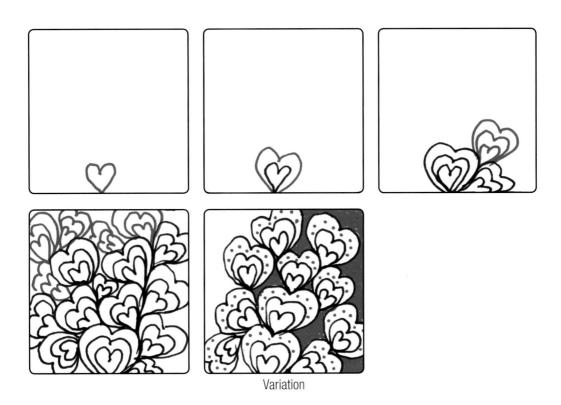

Variation

HOW TO DRAW
Ista Tangle Sandra Westcott, CZT

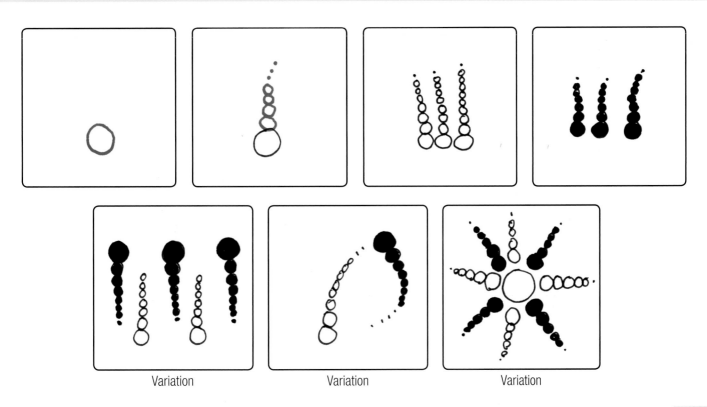

Variation Variation Variation

Keenees Tangle Donna Hornsby, CZT

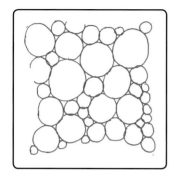 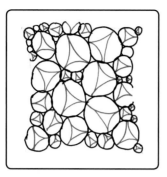 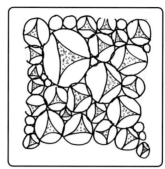 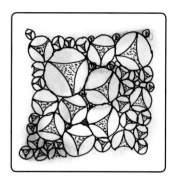

Kinet Tangle Kit Murdoch, CZT

Kurtinz Tangle Kate Lamontagne, CZT

 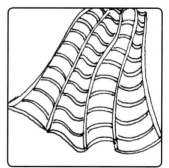

Inspired by sheer striped drapes, for me, the beauty of this pattern is the hem. It creates a lovely outside edge, and emerges nicely out of funnel-shaped spaces.

HOW TO DRAW
Molecule Tangle Kelley Kelly, CZT

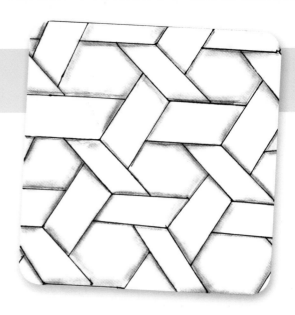

HOW TO DRAW
Peacock Tangle Michelle Rodgers, CZT

 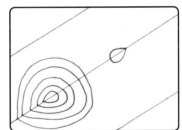 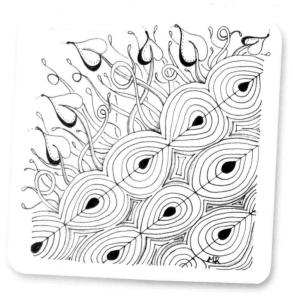

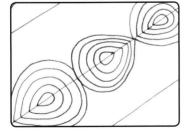 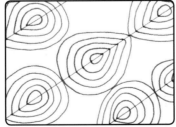

HOW TO DRAW
Rosettes Tangle by Diane K. Ryan, CZT

Rosette Buds, Step 1

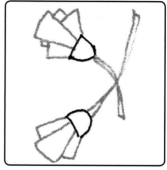

Rosette Buds, Step 2

HOW TO DRAW
Sanibelle Tangle Elaine Huffman, CZT

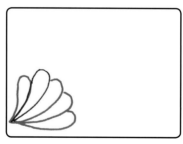

I draw CZT Tricia Faraone's tangle Sanibelle this way. It can also easily be adapted as a continuous pattern for use in quilting.

The Beauty of Zentangle

HOW TO DRAW
Sharky Tangle Jennifer Van Pelt, CZT

HOW TO DRAW
Sistar Tangle Sharon Lynn Payne, CZT

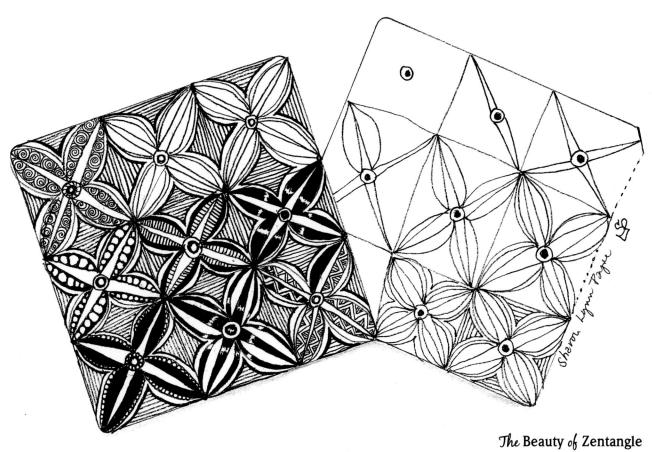

HOW TO DRAW
Steampunk Hinge Tangle Sandra K. Strait

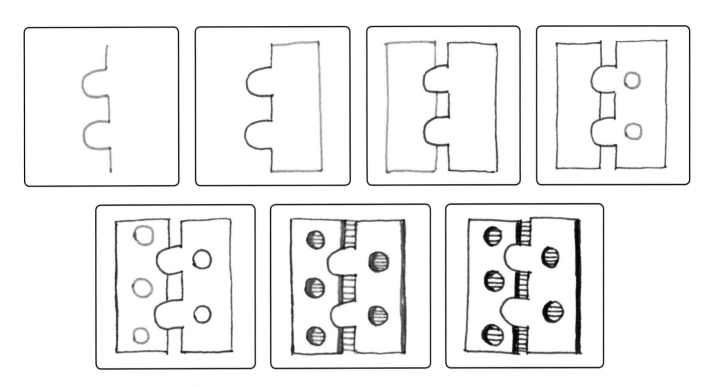

HOW TO DRAW
Sunseed Tangle Marta Drennon, CZT

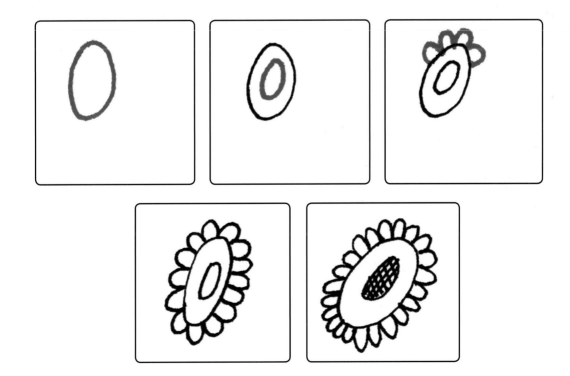

HOW TO DRAW
Up and Down Tangle Kathy Barringer, CZT

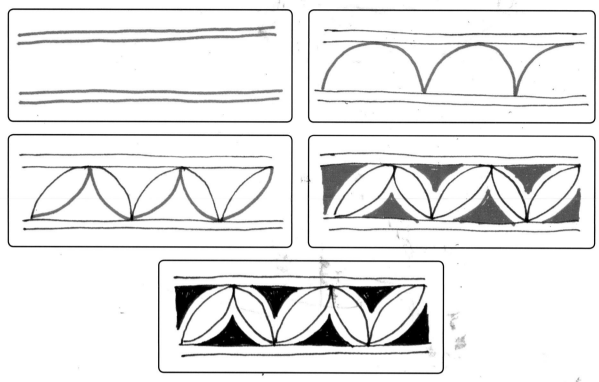

This tangle was inspired by a wood carving on an old chest.

HOW TO DRAW
Y-Flip Tangle Helen Williams

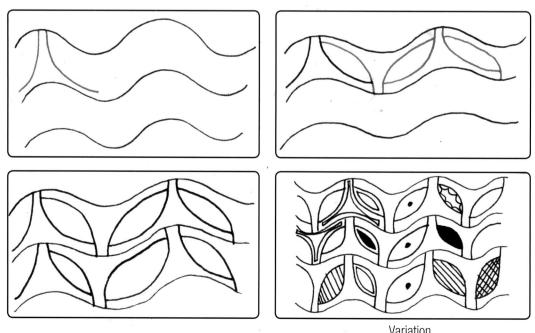

Variation

The Beauty of Zentangle

HOW TO DRAW
Zensplosion Folds Tangle Daniele J. O'Brien, CZT

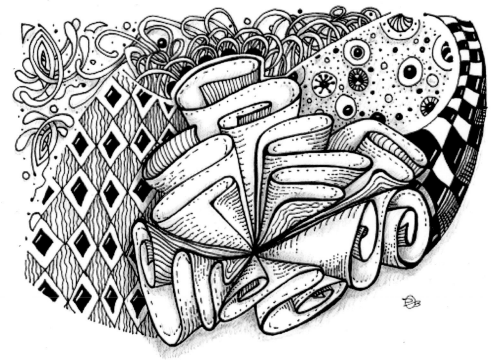

HOW TO DRAW
Zoid Tangle Denise Knobloch, PSS, CZT

Variation

Index

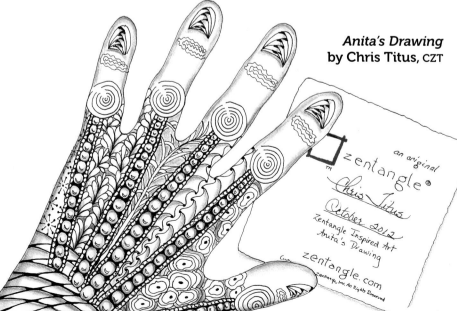

Anita's Drawing
by Chris Titus, CZT

About Suzanne McNeill, CZT

Suzanne is often known as "the Trendsetter" of arts and crafts. Dedicated to hands-on creativity, she constantly tests, experiments, and invents something new and fun. Suzanne has been the woman behind Design Originals, a publishing company dedicated to all things fun and creative. She is a designer, artist, columnist, TV personality, publisher, art instructor, author, and lover of everything hands-on. She authors top-selling books on the Zentangle method. Visit her blog to see events and a free tangle. She also shares her techniques and ideas in YouTube demonstrations. You can contact Suzanne at *suzannebmcneill@hotmail.com* or visit her online at *sparksstudio.snappages.com* or *blog.suzannemcneill.com*.

About Cindy Shepard, CZT

Cindy Shepard is an Experimental artist whose focus is on recycled and mixed-media art. Cindy has authored two successful books showcasing recycled art: *Stash and Smash* and *Bottle Art*. Her whimsical, colorful style developed further after she attended a workshop with Rick Roberts and Maria Thomas. The mindful patterns in the Zentangle drawing style find their way into her work to add energy and interest. She has won awards for her art, sold her art to private collectors, and shares her love for recycling and whimsy through teaching classes. Cindy has recently produced her own line of rubber stamps called Moustachio, featuring quirky Zentangle-inspired houses. You can learn more about Cindy by visiting her blog: *cyndali.blogspot.com*.

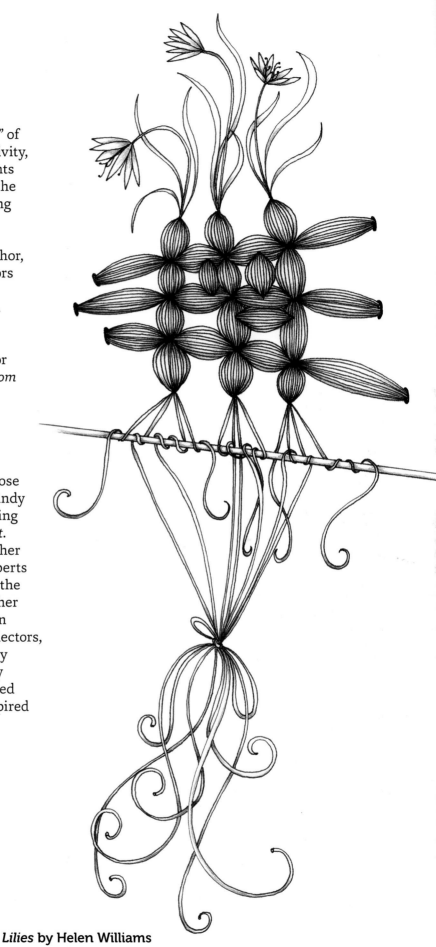

Lilies by Helen Williams

**Zentangle Basics, Expanded
Workbook Edition**
ISBN 978-1-57421-904-3 **$8.99**
DO5462

**Zentangle 2, Expanded
Workbook Edition**
ISBN 978-1-57421-910-4 **$8.99**
DO5468

**Zentangle 3, Expanded
Workbook Edition**
ISBN 978-1-57421-911-1 **$8.99**
DO5469

**Zentangle 8, Expanded
Workbook Edition**
ISBN 978-1-57421-905-0 **$8.99**
DO5463

Zentangle 9
ISBN 978-1-57421-394-2 **$8.99**
DO3517

Zentangle 10
ISBN 978-1-57421-387-4 **$8.99**
DO3510

**Zenspirations™ Dangle Designs,
Expanded Workbook Edition**
ISBN 978-1-57421-903-6 **$8.99**
DO5461

**Zenspirations™ Coloring Book
Inspirations Designs to Feed Your Spirit**
ISBN 978-1-57421-872-5 **$9.99**
DO5446

**Zenspirations™ Coloring Book
Abstract & Geometric Designs**
ISBN 978-1-57421-871-8 **$9.99**
DO5445

Look for Th